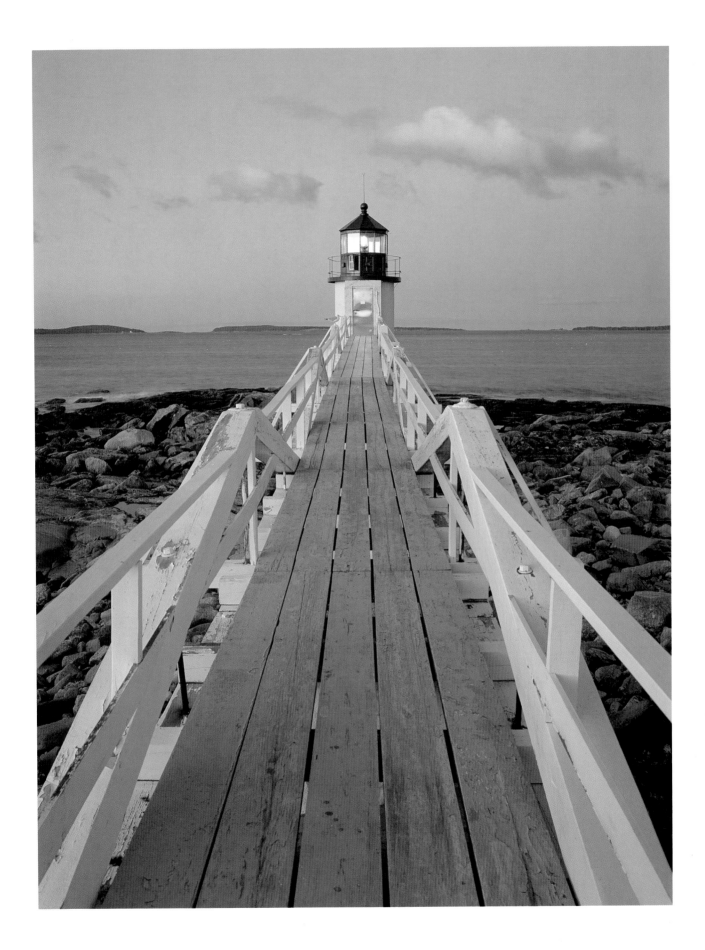

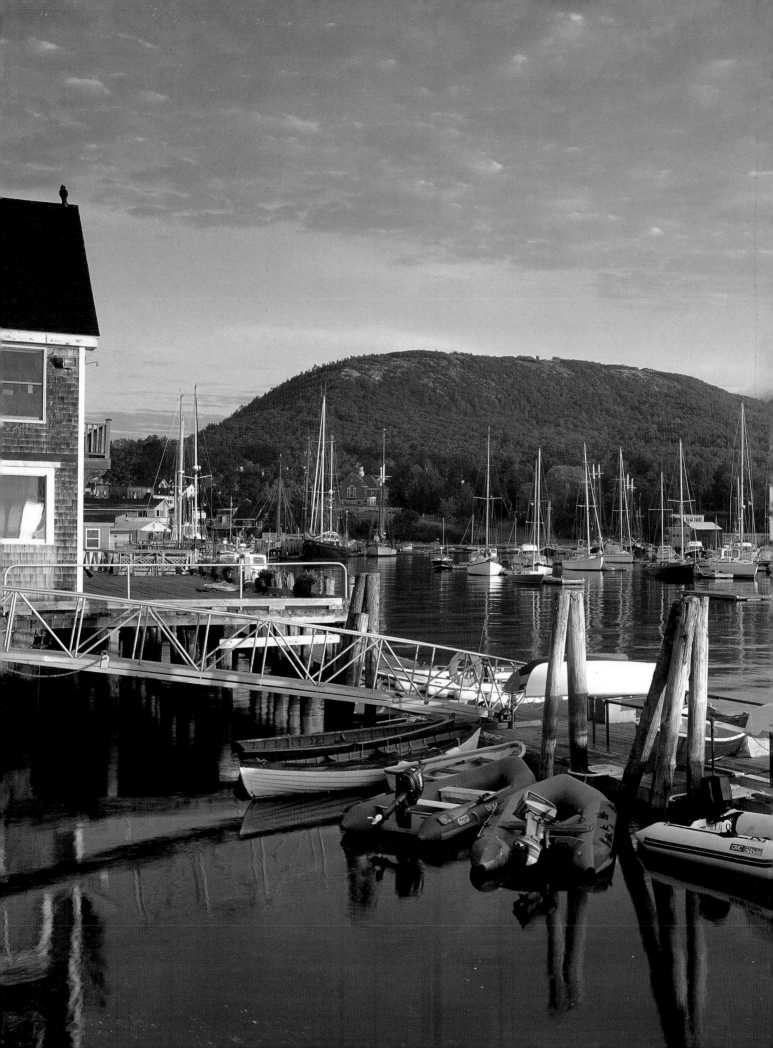

The New England Coast

The Most Spectacular Sights & Destinations

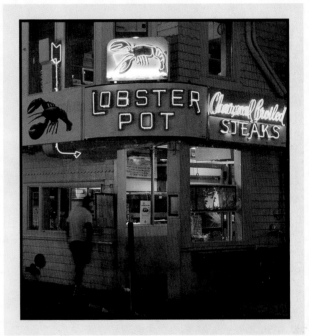

Text by Kim Knox Beckius

Photography by William H. Johnson

Voyageur Press

First published in 2008 by Voyageur Press, an imprint of MBI Publishing Company, 400 First Avenue North, Suite 300, Minneapolis, MN 55401 USA

Voyageur Press titles are also available at discounts in bulk quantity for industrial or sales-promotional use. For details write to Special Sales Manager at MBI Publishing Company, 400 First Avenue North, Suite 300, Minneapolis, MN 55401 USA.

To find out more about our books, join us online at www.voyageurpress.com.

ISBN-13: 978-0-7603-3064-7

Editor: Margret Aldrich
Designer: Lois Stanfield

Printed in Singapore

Library of Congress Cataloging-in-Publication Data
Beckius, Kim Knox.
 The New England coast : the most spectacular sights & destinations / Kim Knox Beckius ; photography by William H. Johnson.
 p. cm.
 Includes bibliographical references and index.
 ISBN 978-0-7603-3064-7 (hb.)
 1. Atlantic Coast (New England)—Description and travel. 2. Atlantic Coast (New England)—Pictorial works. 3. Atlantic Coast (New England)—History, Local. 4. Historic sites—New England—Atlantic Coast. 5. Cities and towns—New England—Atlantic Coast—History. I. Johnson, William H., 1947– II. Title.
 F4.B43 2008
 917.40094'6—dc22
 2008017105

On the front cover: *Brightly colored lobster boats rest upon the shimmering waters of Bass Harbor in the authentic Down East fishing village of Bernard, Maine.*

On the frontispiece: *Maine's Marshall Point Lighthouse was a shining star on the New England coast long before its Hollywood moment came in the movie* Forrest Gump.

On the title page: *Clouds congregate over Camden Harbor and Mount Battie like a cozy, downy blanket on a chilly, early autumn morn in Maine.*

Inset on the title page: *The Lobster Pot, a fixture on Provincetown's Commercial Street, caters to late-night crustacean cravings. With its prize-winning chowder, famous Bloody Marys, and fresh seafood selections, the restaurant's waterview dining room and deck are always crowded.*

On the contents page: *The sand dunes of the Cape Cod National Seashore are sculpted by wind and imprinted by the soles of barefoot beachgoers, eager to replenish their souls and invigorate their spirits at the edge of the sea.*

On the back cover: *Counterclockwise from top: A scenic view of Acadia National Park, Maine's West Quoddy Head Light, colorful umbrellas on a Nantucket beach, the Lobster Pot restaurant on Cape Cod.*

Dedications

To my little Lara Luna, who slumbered to the recorded sounds of the Cape Cod shore as an infant and gave the ocean an ovation when she first beheld it at Old Orchard Beach. May you always believe in mermaids, soar like the first kite you flew on Plum Island, and wake from sweet dreams to a world that cherishes and protects its seas. —KKB

To my mother, who was always there to offer a helping hand and at ninety-four is an inspiration with her attitude toward life. —WHJ

Photographic Note

I use three camera systems, and the image that catches my eye usually dictates which system I choose to use. Quality is the watch word, so everything is medium or large format. The medium format is Mamiya RZ 67-Pro 2, which gives a 2¼ x 2¾-inch transparency, or the Fuji 617, which gives a 2¼ x 6⅞-inch transparency. For the RZ, I have four lenses, from a 50mm wide angle to a 500mm telephoto. For the Fuji, I have a 90mm wide angle and a 180mm. My large-format 4x5 field view camera is an Arca-Swiss. I have four lenses for that camera, from a 90mm wide angle to a 360mm short telephoto. All of these lenses give about the same angle of view, meaning the 50 on the RZ shows the same amount as the 90 on the 4x5, so I see pictures with these lenses: I have used them for so many years. Everything sits on an Arca-Swiss ball head and a Gitzo carbon-fiber tripod. As for filters, I use just three types: split neutral density to help control the contrast, warming for gray days or open shade, and a polarizer to cut glare and bring out the colors on sunny days. My film of choice is Fuji Velvia ISO 50. —WHJ

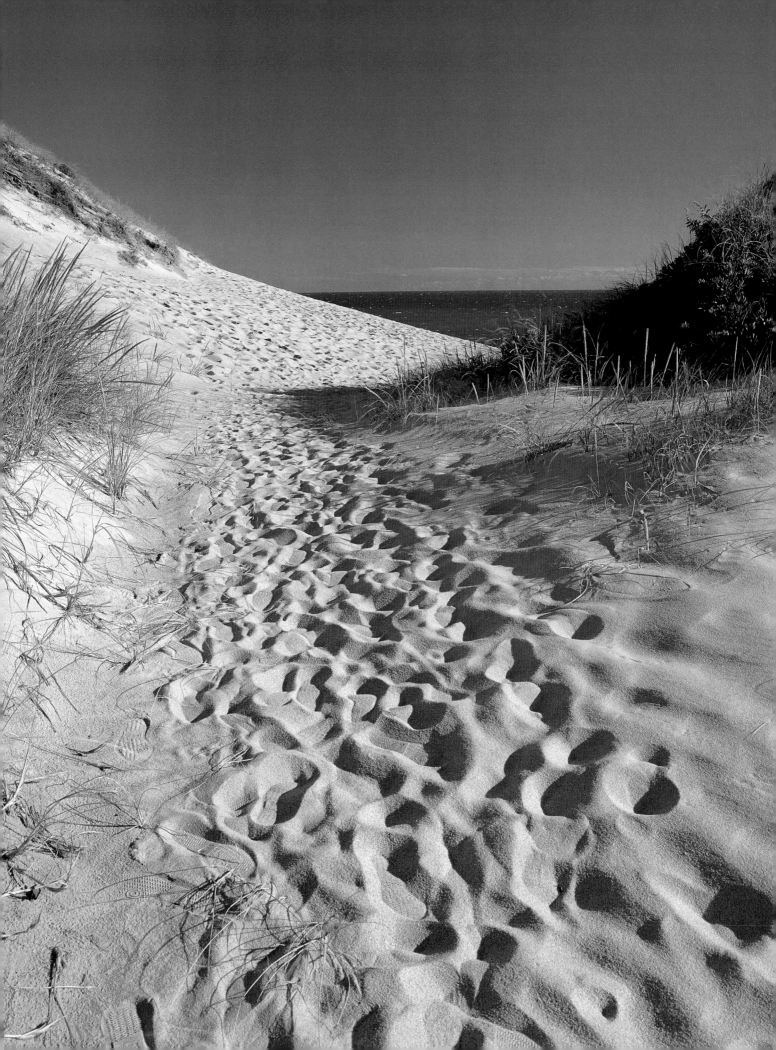

Contents

Introduction 9

CHAPTER 1 **Downeast and Midcoast Maine** 15
Bold and Bewitching Seaside Dreamscapes

CHAPTER 2 **Portland and Southern Maine** 35
Cold Water, Warm Hospitality

CHAPTER 3 **New Hampshire and the Massachusetts North Shore** 53
Immersed in the Past

CHAPTER 4 **Boston and the South Shore** 73
America's Iconic Coast

CHAPTER 5 **Cape Cod** 89
An Artist's Dream Come True

CHAPTER 6 **The Islands** 109
Nantucket, Martha's Vineyard, and Block Island
Heavenly Isles Suspended in Time

CHAPTER 7 **Rhode Island** 123
Ubiquitous Beaches

CHAPTER 8 **Connecticut** 139
Proud Maritime Traditions

Acknowledgments 156
Suggested Readings 157
Index 158
About the Author and Photographer 160

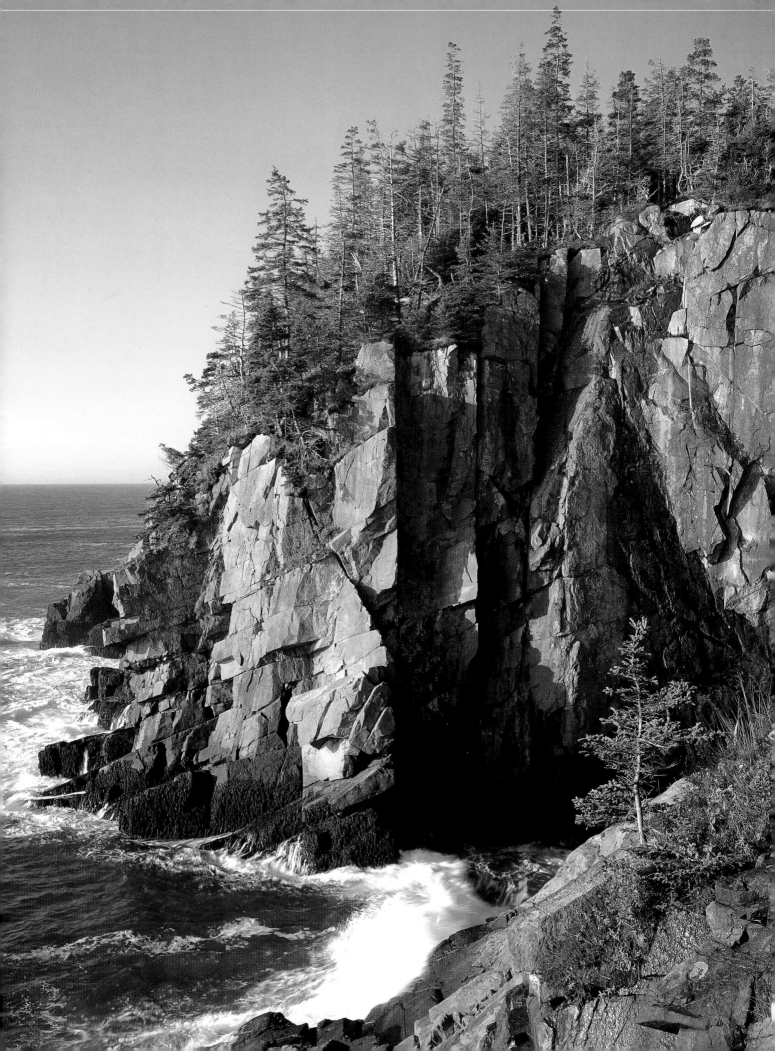

Introduction

New England's coast defies easy description. From Maine's spectacularly wild, windswept Bold Coast at America's eastern extreme, where scrawny pines cleave to the sheer, jagged rocks that hold back the frenzied and frigid Atlantic, to Connecticut's Gold Coast, a densely populated and mega-affluent New York City suburb on the shores of gently lapping Long Island Sound, land and sea intersect in contrasting and endlessly fascinating ways. This five-state coastal region is home to both fast-paced cities and sleepy villages that adhere to seafaring traditions. New England's shoreline is heavily developed, yet impressive stretches remain permanently preserved in their natural state. History has left some coastal locales, like Salem, Massachusetts, notorious, and others, such as Newport, Rhode Island, unimaginably glorious. Massachusetts has two Capes—one a world-famous vacation destination, the other a working waterfront still doggedly reliant on the bounty of the sea.

The remarkable diversity along this storied shore is largely attributable to quirks of geography and twists of fate. Early cartographers struggled to depict the coast's convoluted contours, and when Captain John Smith set out in 1614 to explore the region he christened "New England," he found his predecessors' efforts "no more good than so much waste paper." The map and detailed account the Englishman published in 1616 were the region's first collateral material. "Of all the four parts of the world that I have yet seen not inhabited," the well-traveled explorer wrote, "I would rather live here than anywhere." Thanks to Smith's map, the Pilgrims, who blew off course as they crossed

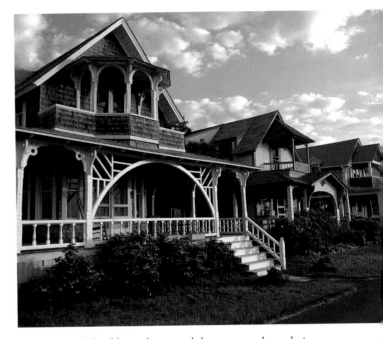

The appeal of island living has caused the year-round population of Martha's Vineyard to grow by leaps and bounds and real estate prices to soar. As of 2007, the average price for a Martha's Vineyard home was $775,000. These shingled seaside cottages in Oak Bluffs probably fetch much more.

the vast and stormy Atlantic, knew they'd arrived in "Plimouth," but they soon discovered Smith's gushing account hadn't prepared them for the realities of a harsh winter on New England's shores. By the spring of 1621, half had perished, yet not one of the surviving Separatists returned to England with the *Mayflower*. These were ordinary people, struggling to forge a new life, yet their staunch resilience, democratic ideals, and faith in the unknown would shape a new nation.

For nearly four centuries, the New England coast has provided a dramatic backdrop for events of

Left: The sheer cliffs of Maine's Quoddy Head State Park rise eighty feet above the Atlantic, and although the first light of day touches this point of land before any other in America, it cannot penetrate Gulliver's Hole the way the Atlantic can.

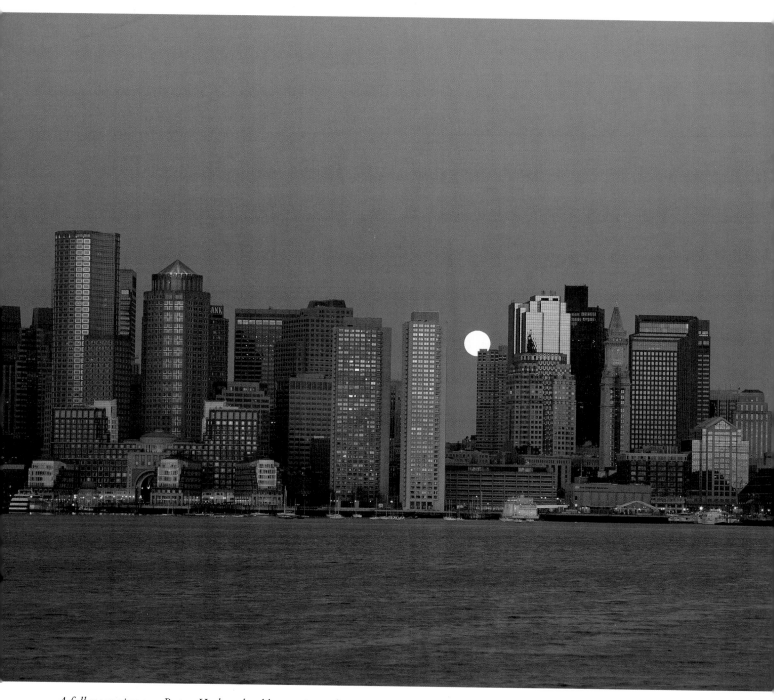

A full moon rises over Boston Harbor, the oldest continuously active major port in the Western Hemisphere.

immense significance. To walk Boston's Freedom Trail or Nantucket's cobbled streets, to converse with Strawbery Banke's costumed reenactors about life in a centuries-old waterfront neighborhood or celebrate a Victorian Christmas with the Astors at their Newport mansion, to stride the wooden decks of a landmark sailing vessel or stroll the sandy beach upon which the Pilgrims first encountered America's indigenous peoples is to become fully immersed in the nation's past.

Yet, New England's coast is ever in flux, a subtly yet constantly changing work in progress. Each season brings with it distinct colors and moods. Winter is bracing and stark. Spring is a brief yet anxiously

anticipated prelude to resplendent summer, when the shore enchants children and shields adults from the stresses of the workaday world. Autumn blends ruddy hues with the shimmering blue in a colorful curtain call. Nature provides this panoramic artistry, but it also turns ugly at times. In an instant, the shore's silhouette can be drastically altered when storms bear down on the fragile barrier beaches and delicate islands on the region's fringe.

The residents of New England's coastal communities are a product of this dynamic environment. Their biorhythms are wedded to the tides and seasons; their characters reflect both the challenges and joys of living beside the sea. As the stunning visual variations along the coast unfold within these pages, so, too, do the stories of individuals who can't fathom living inland. Those who earn their living from the sea and those who teach its history, those who paint it, protect it, and probe its depths have all shared their insights and impressions, shedding light on the nuances that make each snug harbor, each urban center, each tourist mecca on the New England coast unique.

There is a profoundness to each place that even short-term visitors sense, and memories made along New England's shores resonate for a lifetime,

Rhode Island anglers awaken early and head to Watch Hill's East Beach, where they can surfcast for stripers and blues without leaving the shore.

sparking a longing to return. The ocean has undeniable magnetism. Its salty scent and incessant roar enliven the senses, piquing an appetite for the fresh-caught finfish and shellfish served at restaurants and feted at festivals up and down the coast. Its perpetual motion and immutability nourish the soul.

By 1647, when Pilgrim leader William Bradford completed his memoir, *Of Plymouth Plantation*, New England's radiant place in the world was already evident. "As one small candle may light a thousand, so the light here kindled hath shone unto many, yea in some sort to our whole nation," Bradford realized. As divergent as New England's coastal places may be, as richly varied their recreational, historic, and cultural attractions, there is one aspect of this seaside landscape that universally enchants. Each sparkling link in New England's chain of lighthouses is an unduplicated structure with its own heroic story, yet these beacons were erected for a single purpose: to protect mariners from the perils of an unpredictable shore. New England's lights continue to shine through heavy fog, nor'easters, and inky night, yet their symbolism looms even brighter. Stationed at Boston Light since 2003, America's last lighthouse keeper, Dr. Sally Snowman, believes that lighthouse imagery resonates with all of us at a fundamental level. "When you see a lighthouse, it triggers something in every cell in the body," she says. "It's new hope. It's a new life. It's another chance."

Right: For seventy-three years, Nauset Light—stationed in Eastham and painted vivid red and white for visibility even during daylight hours—helped to ensure the safety of sailors navigating Cape Cod's notoriously dangerous outer coastline. In 1996, however, this oft-photographed beacon was itself imperiled as coastal erosion brought it within twenty-five feet of a cliff's edge. The Nauset Light Preservation Society was formed to relocate and rescue this precious landmark.

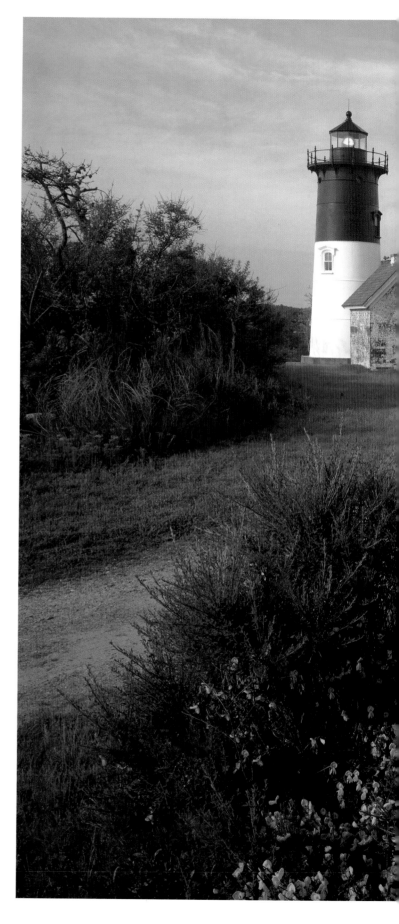

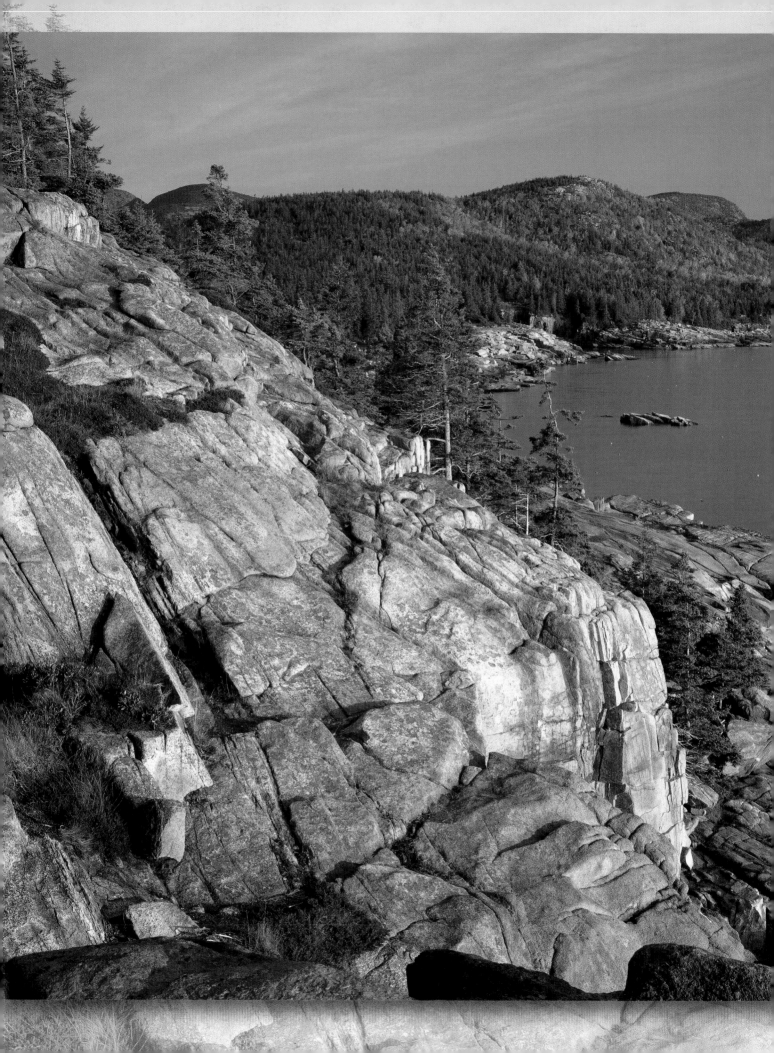

Downeast
&
Midcoast
Maine

Bold and Bewitching
Seaside Dreamscapes

Above: The attractive blooms of red pitcher plants, which grow in Lubec's boggy soil, camouflage these carnivorous specimens' sinister intentions toward flying and crawling insects that happen by.

Left: Hiking trails climb through spruce forest to the summits of Goreham Mountain and the Beehive, two glacially rounded peaks within Maine's Acadia National Park.

The erratically indented coastline of Downeast and Midcoast Maine, with its sheltered inlets and bays and jagged peninsulas extending out into the frothy blue, is New England's most diverse and pristine seaside landscape. Maine claims 3,500 miles of coast—nearly three times more than California—and in the northernmost and easternmost reaches of the state, where the sun prods fishermen awake early each day, impressive bands of land at the edge of the sea have been preserved for eternity.

To the casual observer, time seems to stand still along this working coast, but for more than a century, Mainers have seen changes that have strengthened their resolve to protect cherished vistas and sustain traditional ways of life. "People come to Maine, and the first thing they want to do is buy a piece of it," laments avid outdoorsman and Registered Maine Guide David Butler, who nevertheless believes the rate of change in Maine is "nothing compared to the rest of the country." He's also seen positive changes, such as the establishment of the Maine Island Trail Association. It's "a conservation effort that is really unparalleled," he says, providing recreational access to Maine's 350-mile chain of islands in exchange for a commitment to care for these precious places.

"This crazy, throwback, untouched, untrammeled archipelago" of more than four thousand isles, as second-generation windjammer captain Noah Barnes describes it, lies just far enough offshore both to defy development and to enchant. As a boy, he remembers discovering a fir tree on Calderwood Island that was cave-like in its enormity. "Before the environmentalist in me woke up, I carved my initials in this perfect, pine-needle-carpeted cave on this completely magical island next to this perfect horseshoe beach that we had sailed up to through the mists," he recalls. Barnes knows now that Calderwood lies only eight miles offshore, but "it was on the other end of the world in the geography of my imagination," he says. "This was Narnia."

In spite of time's passage, "It hasn't lost that," Barnes assures, adding, "I never get tired of showing people this coast."

Where America Awakens

Two seconds on, two seconds off, two seconds on, nine seconds off. Around the clock, the 1,000-watt bulb encased within West Quoddy Head Light's original third-order Fresnel lens flashes and eclipses at predictable intervals. Lubec's famous 1858 lighthouse, which marks the narrow entrance to Passamaquoddy Bay, stands on the easternmost point of land in the United States. Its cheery red and white candy-cane stripes belie its serious purpose: to warn mariners away from the fog-shrouded and perilous rocks and cliffs upon which countless boats were dashed before the first lighthouse was built on this spot in 1808.

The Passamaquoddy Indians who canoed these treacherous fishing grounds where the sun's first gentle light awakens America each morning had no such navigational aid. And yet, the coastal waters' rocky outcroppings weren't nearly the natural hazard that microbes proved to be. Maine's original inhabitants had little resistance to the diseases carried by French and English explorers and traders; a 1617 pandemic wiped out 75 percent of the native population along Maine's coast.

Still, the "People of the Dawnland" have endured. The Passamaquoddy reservation at Pleasant Point near the town of Perry on Passamaquoddy Bay is Maine's largest, and tribe members strive to preserve the art, stories, and language of their ancestors.

The Bold Coast

The headlands that abut the Atlantic from Quoddy Head to Cutler in easternmost Maine are a frontier of sorts on the New England coastline. Remote and breathtaking, the Bold Coast is remarkably intact and unspoiled. "It's this rugged, windblown coast, with little spruce trees that are struggling against the wind and a scrub blueberry cover; it's really a spectacular

Right: *West Quoddy Head Light, the easternmost beacon in the United States, has had anywhere from six to eight red bands through various repaintings.*

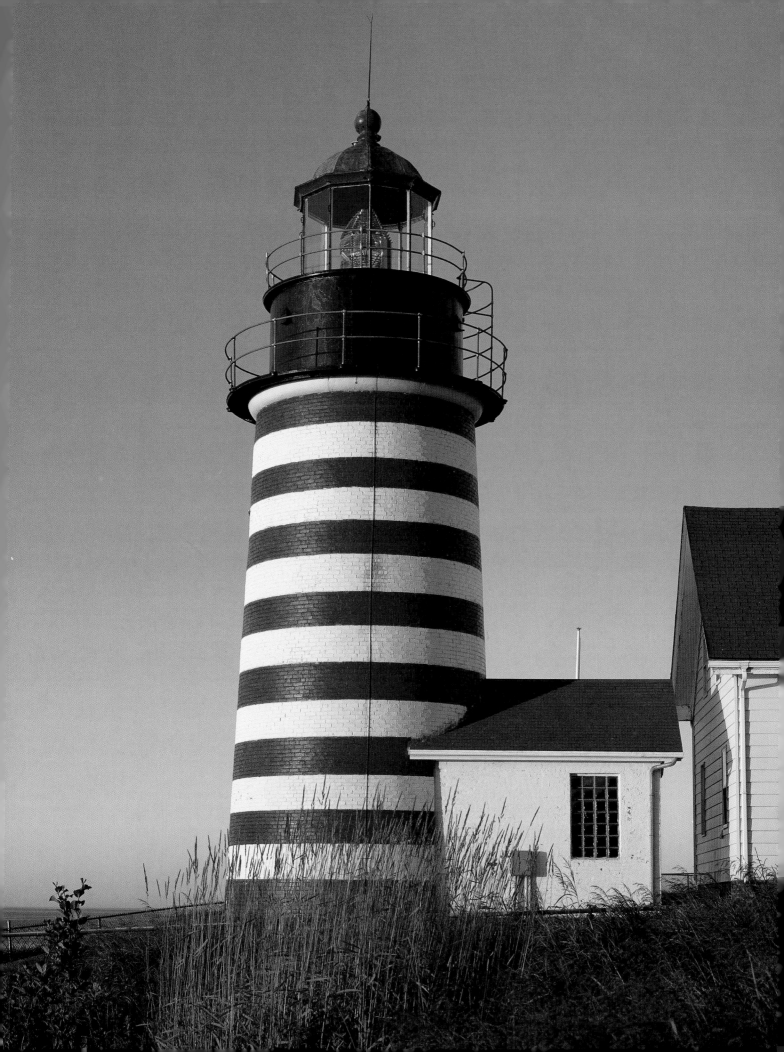

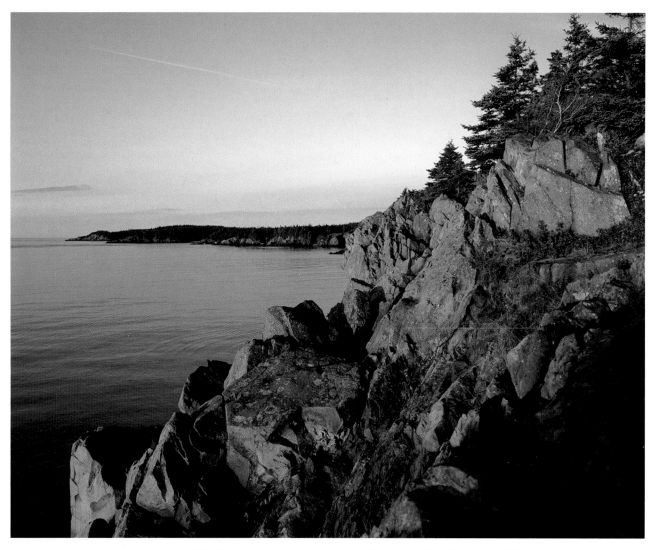

Sunrise warms the jagged, windswept cliffs that encounter the Atlantic along Maine's aptly christened Bold Coast.

place," says Registered Maine Guide and Maine MultiSport co-owner David Butler, who designs and leads outdoor adventures statewide but confesses this is his "favorite place on the whole coast of Maine."

Butler has hiked and camped within the state's Cutler Coast Public Reserved Land. It's an incomparable experience, he says, "to wake up in the morning and watch the sun rise over the Atlantic with these little islands on the horizon—and lobster boats going out to check their traps and a cacophony of birds chirping—from a bluff that's two hundred feet high with the waves crashing below."

"The most striking thing," agrees Jane Arbuckle, director of stewardship for the Maine Coast Heritage Trust, "is the series of cliffs and long stretches of shoreline that are not developed that have a particularly wild feel about them." Her organization has been instrumental in preserving tracts along this ecologically unique shore, both through its own acquisitions and in collaboration with the state. "It's a special place in Maine. It's definitely a high priority for us," she says.

Essential Acadia

George B. Dorr died penniless, and yet he endowed New England with one if its richest gifts. Yes, there were others, including Harvard University president

Charles W. Eliot and philanthropist John D. Rockefeller Jr., who poured their passions and fortunes into the preservation of Mount Desert Island—the largest of Maine's coastal isles. But it was Dorr who spearheaded land-acquisition efforts and worked tirelessly to ensure the public would always have access to the breathtakingly diverse landscape within what is now Acadia National Park.

There were no national parks east of the Mississippi River when Dorr commenced his lobbying efforts. Convincingly, he wrote that if this land of "ancient rocks and still more ancient sea" was spared from development, "the spirit and mind of man will surely find in it in the years and centuries to come an inspiration and a means of growth as essential to them ever and anon as are fresh air and sunshine to the body."

For the millions of annual visitors who flee their harried routines for the peace and tranquility of Maine's rugged coast, Acadia is indeed the restorative escape Dorr, the park's first superintendent, prophesied. From the 5,000 acres donated to the federal government in 1916 by Dorr and his fellow members of the Hancock County Trustees of Public Reservations, the preserve—which was designated Lafayette National Park in 1919 and renamed Acadia

Cobble beaches fringe the eastern edge of the Schoodic Peninsula, the lesser-known, 2,266-acre mainland area of Acadia National Park.

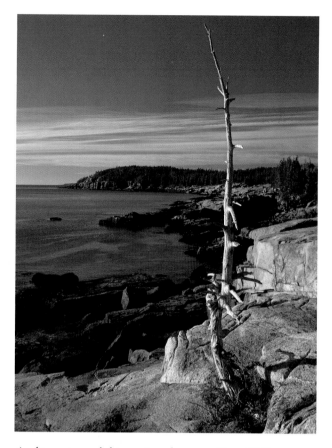

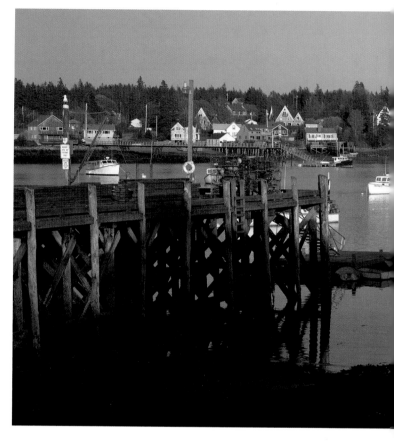

A solitary spruce skeleton points the way to Otter Cliffs, a distinctive pink granite formation within Acadia National Park that towers 110 feet above the ocean waves.

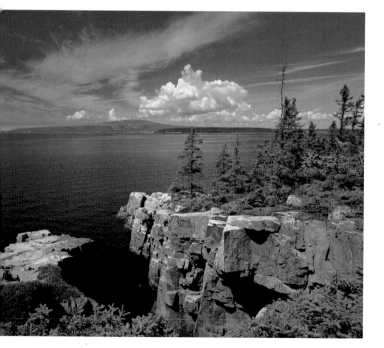

in 1929—has grown to more than 47,000 acres, including 30,300 acres on Mount Desert Island.

Still, Acadia is one of the smallest of the national parks. And with more than two million visitors each year, it is one of the busiest. Without venturing far from the twenty-mile, auto-accessible Park Loop Road, visitors can appreciate many of the park's scenic highlights, such as the spouting spectacle of Thunder Hole, where water sprays forty feet in the air when conditions are optimal, and the sheer, conifer-crowned Otter Cliffs, which stand boldly in defiance of the relentless sea.

Acadia's forty-five miles of broken-stone carriage roads were Rockefeller's pet project, and

Spruce trees cleave to the granite cliffs of Schoodic Point, seemingly determined not to relinquish their front-row seats for the double feature of Mount Desert Island and Frenchman Bay.

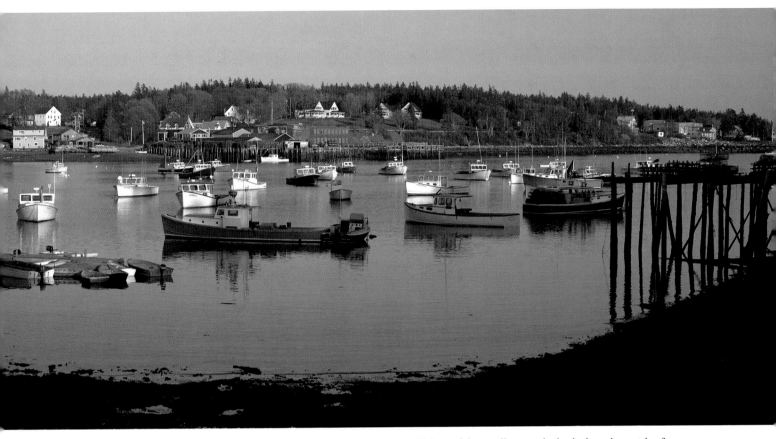

Boats stand tall in the water at low tide in Bass Harbor, a quintessential Maine fishing village on the hushed southern side of Mount Desert Island.

horse-drawn wagon rides along these thoughtfully designed routes provide an even more intimate look at the island's scenery. There are also 125 miles of historic hiking trails, some easy, some challenging, that scale seaside precipices, cross open meadows, and probe the park's forested expanses. And yet, for all of its allure and accessibility, Acadia still has secret places known only to the few who leave its well-trodden paths.

Island High Point

French explorer Samuel de Champlain, who ran aground on Mount Desert (pronounced "dessert") Island in 1604, not only left behind a pronunciation quandary when he christened it Isles des Monts Desert, or "island of barren mountains," he was mistaken in his perception that these granite domes were lifeless.

At 1,530 feet, Cadillac Mountain is not only the loftiest of the island's seventeen peaks, it is the highest point on America's Atlantic seaboard. The summit, which can be reached via an offshoot of Acadia's Park Loop Road, is a popular spot to watch the sun rise. While vegetation is stunted and sparse atop this chilly crest, spruce and pitch pine trees anchor themselves in the thin soil, and rare subalpine species grow in crevices in the pink granite.

During the late summer and early fall, rangers stationed atop Cadillac Mountain help birdwatchers spy and identify soaring raptors. Nearly 2,500 hawks and other birds of prey pass through during the seven-week migration. Since the mid-1980s, nesting pairs of peregrine falcons—the fastest birds on earth—have been successfully reintroduced to Acadia, and they and their new offspring join the autumn exodus.

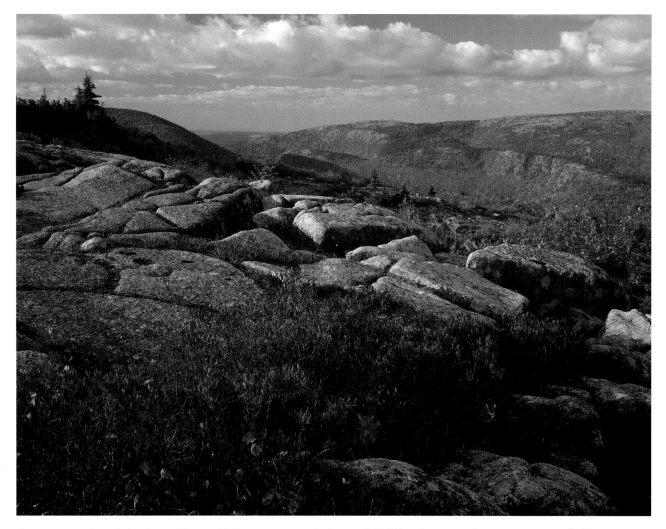

A narrow, winding, 3.5-mile road has enabled motorists to reach the top of Cadillac Mountain, the highest point on the Eastern Seaboard, since 1931. Sargent Mountain, visible from Cadillac's scarred granite summit, is Acadia National Park's second-tallest peak. Reaching its apex requires a two-mile hike.

Bar Harbor, Island Town

Bar Harbor, the largest and best known of the communities that share Mount Desert Island with Acadia National Park, was still known as Eden when notable mid-nineteenth-century painters, including Thomas Cole and Frederic Church, visited and committed the region's dramatic landscapes to canvas. Enchanted by these luminous seascapes, wealthy patrons soon wished to see this magical place for themselves, and by the time Eden was renamed Bar Harbor in 1918, it had become an elite resort replete with grand hotels and posh private estates, where the Vanderbilts, Astors, Morgans, Pulitzers, and other socially prominent families flaunted their good fortune and entertained in lavish style during the brief summer season.

Then, over the course of ten days in 1947, the character of the town was forever altered as a devastating drought- and wind-fueled fire consumed 170 year-round homes, 67 of the summer "cottages" on Millionaires' Row, and all of Bar Harbor's hotels, along with thousands of acres within Acadia National Park.

Bar Harbor reemerged as a more down-to-earth destination, with lodgings and eclectic restaurants

that appeal to campers, families, even honeymooners. Cheering for the edible competitors at the annual Fourth of July lobster races may just be the highlight of the summer entertainment season. And while it may sound decadent, the lobster ice cream at Ben & Bill's Chocolate Emporium is an affordable treat, albeit an acquired taste.

Life Imitates Art

Deer Isle dangles from the Blue Hill Peninsula, connected to the mainland by a slender, two-lane suspension bridge and a short causeway. Before the bridge was built in 1939, there were few outside disturbances to mar the tranquil existence of Deer Isle's communities. Stonington, located at the island's southern tip—a full hour's drive from Coastal Route 1—remains one of the state's most authentic working fishing villages.

Artists and artisans were among the first to discover the charms of this isolated isle, where backyard stacks of lobster traps aren't for decoration. The Haystack Mountain School of Crafts—renowned for its immersive programs in disciplines ranging from weaving and ceramics to blacksmithing and woodworking—relocated to the Deer Isle coast in 1961. The Deer Isle–Stonington Chamber of Commerce counts more than two dozen art galleries among its member businesses.

Painter Jill Hoy, who grew up summering on island and now shares a seasonal home and gallery in Stonington with her husband and fellow artist, Jon Imber, explains the allure: "This is a region of constant change—tides, winds, currents. It's a very high-energy place. I'll stand for hours watching these elements: the seasons, the boats working, light reflecting."

More than 150 years after Hudson River School painters sparked an influx of vacationers to Mount Desert Island, Deer Isle is experiencing a similar phenomenon. "The general population always follows artists; they are good for business," Hoy says. She realizes, however, that the island's character and way of life are becoming endangered. From the

To an artist's eye, these lilacs and lobster traps resemble a carefully arranged still life, but in Stonington, Maine, piled up accoutrements of the fishing trade aren't at all a contrivance.

water, a building surge along the shore is evident. "Real estate prices are booming, and rents have escalated; islanders can't afford to live on their own island," she says. Tourists crowd Stonington's Main Street during the short summer season. Groups, such as Island Heritage Trust, have sprung up to deal with issues of open-space preservation and conservation of natural resources.

The local economy benefits from the "summer people and transient tourists," even if they do tax the island's infrastructure and create traffic tie-ups, and Hoy says that while change isn't easily embraced, "islanders are very gracious."

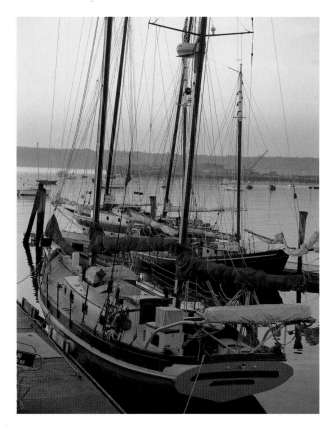

Classic wooden sailboats are a common sight in Rockland Harbor during the summer months. Several antique schooners based in Rockland offer public sails and private charters.

As she works outdoors—*en plein air*—to create the vibrant, fluid paintings that grace not only the walls of her gallery but more than six hundred private and corporate collections, Hoy welcomes observers. "People get a kick out of seeing me at work and contrasting what they see and what the painting looks like," she says. "I see the world in color, which many people don't. I have changed a lot of people's view of the world."

Penobscot Bay

There is no harsh dividing line between Downeast and Midcoast Maine. The transition occurs gently along Route 1, as the coastal highway meanders south from Bucksport to Rockland, tracing the western shoreline of Maine's largest bay. The Penobscot Narrows Bridge carries U.S. 1 over the Penobscot River, and from the bridge's tower—a 420-foot

marvel that is the only bridge observatory of its kind in the Americas—views of the coast stretch east to Mount Desert Island and south to the Camden Hills, affording an aerial overview of the subtle changes.

Penobscot Bay, the 1,070-some-odd-square-mile saltwater basin at the mouth of the Penobscot River, was the scene of many skirmishes in the 1600s as the French, English, and Dutch struggled for control of the region's sheltered harbors and access to Native American trading partners. As the river became an avenue to inland Maine's timber riches, and as the granite-quarrying industry on Vinalhaven and other islands and lime-producing operations onshore flourished, the bay's strategic and economic importance grew. At Maine's oldest maritime museum, the Penobscot Marine Museum in Searsport, art and artifacts housed within the historic buildings of a preserved seafaring village tell the story of nineteenth-century industry and trade in the region.

As the demand for wooden ships and granite building materials diminished, the twentieth century saw the rise of new enterprises: poultry farms in Belfast, woolen mills in Camden, sardine canneries in Rockland. All faded into history by the century's close. Rockland lobsterman Steve Hale explains: "People don't eat canned fish anymore. Young girls don't want to pack sardines; they'd rather work in Wal-Mart."

While lobster fishing remains one of the region's economic engines, technology enables a variety of businesses to compete in global markets from these picturesque shores. Jewelry designer Etienne Perret shuttered his Camden shop after twenty-five years; now, he ships his award-winning creations to fine retailers nationwide and sells them direct to consumers via his website. Even Captain Hale confesses to posting lobster exoskeletons on eBay in the winter; they fetch about forty bucks.

On the shimmering waters of Penobscot Bay, the only skirmishes these days are the organized and impromptu races between the historic windjammers that anchor off Camden, Rockport, and Rockland. Atop the quartzite summit of Mount Battie in Camden Hills State Park, which can be reached via

The Luckiest Lobsterman

IN 1999, STEVE HALE fell off a wharf and fractured his back. "The doctor said I wouldn't lobster anymore, that I was all done fishing," he recalls. "I had to sell my lobster boat and my traps to pay the medical bills."

He couldn't haul traps, but he could change diapers, so when his grandson was born, Hale knew there was still something he could do to help his family—"I could watch Jack."

Hale had been fishing since he finished high school in 1972. He'd gone to college at night to earn a business degree and held several management jobs in Midcoast Maine's fish processing industry, but something always lured this first-generation lobsterman back to the sea. "I thought that fishing wasn't a way to make a living, but I was wrong. It's a good life," he says.

Maine lobstermen harvest fifty to seventy million pounds of lobster valued at as much as $300 million each year. It's labor-intensive, unpredictable, solitary work, but for commercial fishermen who monitor eight hundred traps—the maximum allowed by law—it can be big business. "All of my friends are fishermen," Hale says. They share a common trait: "We're too stubborn and obnoxious to work for anybody else," he says. "We have to work for ourselves; nobody else will put up with us."

"I went away a couple of times, but I always came back to fishing," says Hale. "I like the freedom. If I don't make a living, it's my own fault."

When little Jack was about three, Hale had an epiphany. He bought a lobster boat, christened it the *Captain Jack*, and began taking tourists on lobstering excursions out of Rockland, "one of the prettiest and most protected harbors on the coast," with his grandson by his side. "Smartest thing I ever did," he says.

Even the Mainers who come aboard learn something about lobsters and the men and

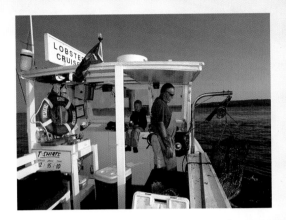

Captain Steve Hale and his young grandson share summer days aboard the Captain Jack, *providing curious tourists with a firsthand look at how lobsters are baited, caught, and hauled up in traps; which lobsters are keepers and which must go back; and why fishing remains a treasured way of life for many Mainers.*

women who make a living in pursuit of these mysterious and delicious crustaceans. Captain Hale tends three hundred traps now. "Since I started the tours, I leave the full-time fishing to the full-time fishermen," he explains. His catch can be purchased right off the boat; it's tough to buy a fresher lobster.

Jack, he says, is the "star of the show." Now eight years old, he's eligible for a student license that will allow him 150 traps of his own.

"I just love what I'm doing; I'm very lucky. I couldn't imagine doing anything else," Hale says. "Just being on the water . . . every day is different. There are never two days that are alike."

While part of the allure is meeting people from around the world and answering perennial questions, such as why the lobsters in his traps aren't red (the red pigment in a lobster's shell is only unveiled during cooking), Hale confesses, "The best part is that I get to spend the days with my grandson."

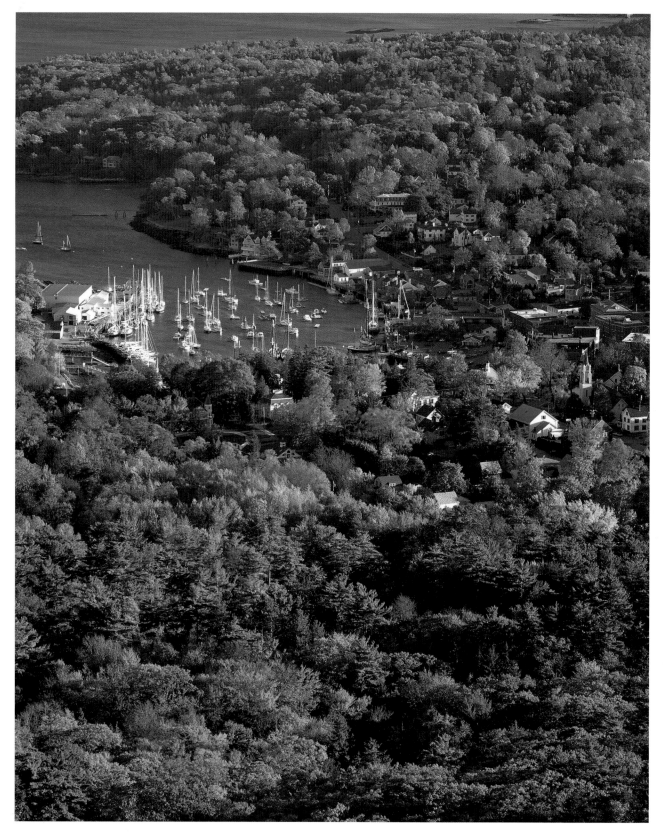

A statue of Edna St. Vincent Millay, who famously described this view of Camden from Mount Battie, stands beside the town's handsome harbor, which is home port for several of Maine's historic windjammers. As rustic shades of autumn color the Camden Hills, their captains and crews prepare to shrink-wrap these remarkable sailing vessels for a long winter's nap in this snug port.

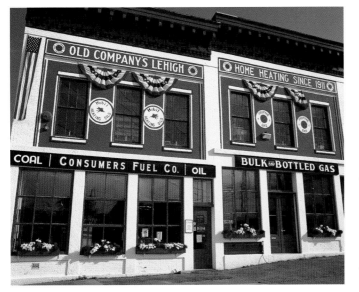

A major center of shipbuilding and maritime activity in the nineteenth century, blue-collar Belfast is undergoing a cultural renaissance as artists and restaurateurs take up residence in the commercial buildings that line Main Street. Still, this Penobscot Bay city's attractive brick storefronts, particularly the patriotic Consumers Fuel Company facade, evoke an aura of yesteryear.

Although it is not a museum building, guests are welcome to peek inside the First Congregational Church of Searsport, which is situated within the Seacoast Village at the Penobscot Marine Museum. Maine's oldest maritime museum does count eight National Register historic buildings dating from 1810 to 1845 among its collection, including several residences and a classic New England town hall.

Nothing Good Happens to a Sailor Ashore

WHEN NOAH BARNES was only five or six, his parents spent a week aboard the *Lewis R. French*, an 1871 freight schooner that now sails out of Camden with human cargo. "They had the best week of their lives," Barnes says. They returned to North Carolina and announced: "We are moving to Maine."

They arrived in Camden with plans to start a business and bide their time until another historic windjammer came on the market. "Within a day of coming into town, somebody said, 'The *Taber*'s for sale,'" Barnes recalls.

The *Stephen Taber*, built in 1871 during the Golden Age of Sail, is a National Historic Landmark and America's oldest sailing vessel in continuous service. Her new owners had to treat her gently as they learned the ropes during their first two seasons. "They took on a tremendously huge project; the *Taber* was in bad shape," Barnes explains.

Noah was nine the winter his parents undertook an 85 percent rebuild of the weathered ship. "My job was to sweep up and cart away oak chips; I was very bitter about this," he recalls. A team of talented shipwrights miraculously "materialized" when they "heard that an old schooner was being

rebuilt." By June, "she was restored" and ready to retain her unblemished record.

"The *Taber* has never missed a season; she has spent more time at sea than any other ship in America," says Barnes, who missed more than a dozen seasons while he was away "doing other stuff"—traveling the world, playing in bands, working on the West Coast and in New York City, falling in love. Then, in 2003, his parents dropped a bombshell. After twenty-five years, Captains Ken and Ellen Barnes were retiring. Noah had just sixty days to decide whether to exercise his right of first refusal and take over the boat.

Admittedly, he was conflicted. Maine "is not the most cosmopolitan place," after all, and a year would pass before he could coax his sweetheart, Jane Barrett, away from her wine industry job in New York. Barnes realized, however, that in all of his travels, he hadn't found "many places that were nearly as beautiful nor as intrinsically good as the coast of Maine. Once you get out among the four thousand islands that are our sailing ground, it puts a smile on your face," he says.

Windjammer vacations attract "an odd bunch," Barnes admits. The *Stephen Taber* is one of twelve historic schooners based in Rockland and Camden

a short drive or a forty-five-minute hike, the words penned in 1912 by Rockland-born poet Edna St. Vincent Millay still resonate: "All I could see from where I stood was three long mountains and a wood; I turned and looked the other way, and saw three islands in a bay."

But as more travelers, part-timers, retirees, entrepreneurs, and speculators discover the tranquility and charm of Midcoast towns, there is an undercurrent of conflict. Gentrification threatens cherished ways of life. Folks "from away," as Mainers would

say, bring sophistication and a leisurely inclination to a coast with a long-standing working tradition.

Then again, the rhythms and rituals of life by the sea are not so easily vanquished, and it is those who resettle here who may experience the greatest transformation. Frank Isganitis and PJ Walter, owners of Rockland's LimeRock Inn, are self-described "corporate refugees" who left their "results-oriented, driven" lifestyles in New Jersey for the opportunity to "hit the reset button and slow things down a little," Isganitis says. On Penobscot's shores, they have

that collectively market themselves as the Maine Windjammer Association. All offer multi-day sailing adventures to nowhere in particular and appeal to travelers who are willing to "eschew a few creature comforts for a really interesting experience."

Some passengers are attracted to the history or to the opportunity to man the halyards and hoist away. Others appreciate the chance to see pristine places on a "green" vacation that minimally impacts the environment. Many are "looking for some kind of release and escape," says Barnes. Everybody loves the bountiful food. Jane, now the captain's wife and on-board Chief of Morale, oversees the wine-themed cruises that have become the *Taber*'s hottest ticket.

"We get a lot of mail from people whose lives we've touched; we actually get letters stained with tears written on the trip home," Barnes says. "We have reminded them of what is good and simple in life. It's immensely gratifying."

The moment he assumed the helm, any doubts that he'd made the right career move vanished on the breeze. "I've been other places, and I've done other things," Barnes says. "Coming home and running the *Taber* feels so right. I wouldn't be anywhere else."

There's no shuffleboard on the lido deck, no all-you-can-eat midnight buffet, no crooning lounge singer. There isn't even a decent shower. But as wind fills the sails of the Stephen Taber, *determining her destination for the day, passengers reacquaint themselves with the rhythms of nature, reassess their lives, and realize just how unspoiled and serene the Maine coast remains.*

found the "something more" they sought. "You can't be in a bad mood; it's just such a great place," says Isganitis. "You can just let yourself be here, and sometimes you find exactly what you're looking for."

Muscongus Bay

Just a mile or two wide and a dozen miles long, the St. George Peninsula forms the boundary between Maine's Penobscot and Muscongus Bays. State Route 131 affords peekaboo views of quiet inlets as it angles its way from Thomaston to the tiny and timeless village at the peninsula's southern end. Port Clyde so enchanted N. C. Wyeth that the noted painter purchased a summer residence overlooking the harbor in 1920. Here, his son also honed a rare talent for depicting scenes of the Maine coast; young Andrew's first one-man show in 1937 featured watercolors painted in the vicinity of his family's summer home.

Port Clyde's size disguises its status as one of the state's major commercial fishing ports. Likewise,

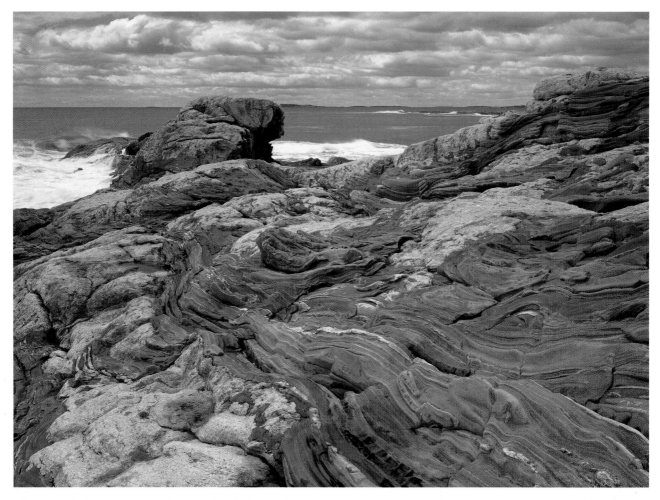

Above: The bedrock at Pemaquid Point is hundreds of millions of years old. It is composed of thin, buckled layers of metamorphic rock and pale streaks of igneous rock forced up from underground through fractured veins in the dark stone. Erosive elements continually alter this striking landscape, which is as beautiful as it is geologically intriguing.

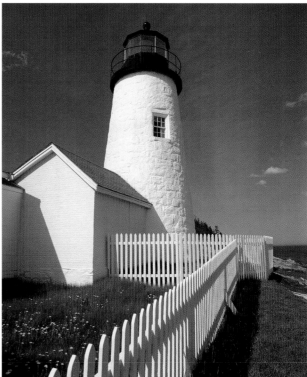

Right: Pemaquid Point Light keeps vigil over the entrance to Muscongus Bay. Its keeper's house is now a Fishermen's Museum; the top floor is available for weekly rental, and the price includes heat, drinkable water, cable TV, and unlimited, mesmerizing views.

at just thirty-one feet tall, the Marshall Point Lighthouse, located a short walk or drive from the busy wharf, appears diminutive, but its celebrity looms large. The 1858 light appeared in the 1994 film, *Forrest Gump*, in a scene where the title character, portrayed by Oscar winner Tom Hanks, reaches the Atlantic on his bicoastal, "for no particular reason" run. Visitors to the lighthouse and its gambrel-roofed 1895 keeper's quarters—now a museum—enjoy retracing Hanks's strides along the majestic, upward-sloping gangway that leads to the still-active beacon.

Another classic fishing village and an equally famous lighthouse lie across Muscongus Bay on the Pemaquid Peninsula. New Harbor's snug coves embrace hard-working lobster boats each evening after the day's catch is sold. Not far away, the ocean relentlessly pummels the streaked and striated granite promontory where the Pemaquid Point Lighthouse flashes its piercing beam. The 1835 tower is the second built on this site. In the summer months, wild saltspray roses in intense shades of pink rise up from crevices in the rocky ledge. It's nature's congratulatory bouquet for a remarkable visual display. The lighthouse and its dramatic setting are so cherished by Mainers that this scene was selected by popular vote to appear on the Maine state quarter.

Shifting Tides

"Tide pools contain mysterious worlds within their depths, where all the beauty of the sea is subtly suggested and portrayed in miniature," wrote Rachel Carson in her 1955 book, *The Edge of the Sea*. Long before Al Gore became a documentary film star, this eloquent marine biologist, who summered on the Midcoast's Southport Island, created a sea swell of public awareness about the impact of human activities on the environment. Her seminal 1962 work, *Silent Spring*, focused attention on the detrimental effects of chemical pesticides.

Tide pools emerge daily at low tide, and Carson was particularly fascinated by the many moods of these dynamic microcosms. At the Nature Conservancy's Rachel Carson Salt Pond Preserve on Route 32 in New Harbor, visitors can hike wooded trails and observe the shallow, reflective pool that inspired many of Carson's writings. The small, briny world she so carefully documented is home to diverse life, including many small creatures who find only temporary refuge—until Muscongus Bay tides rise.

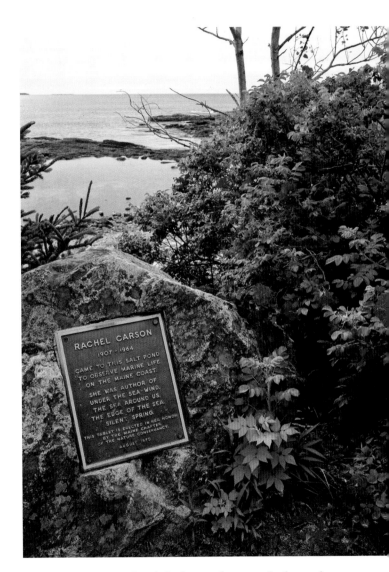

"There is something infinitely healing in the repeated refrains of nature—the assurance that dawn comes after night, and spring after the winter," wrote Rachel Carson, whose observations of this New Harbor salt pond influenced many of her musings. "The lasting pleasures of contact with the natural world," she assured, "are available to anyone who will place himself under the influence of earth, sea, and sky and their amazing life."

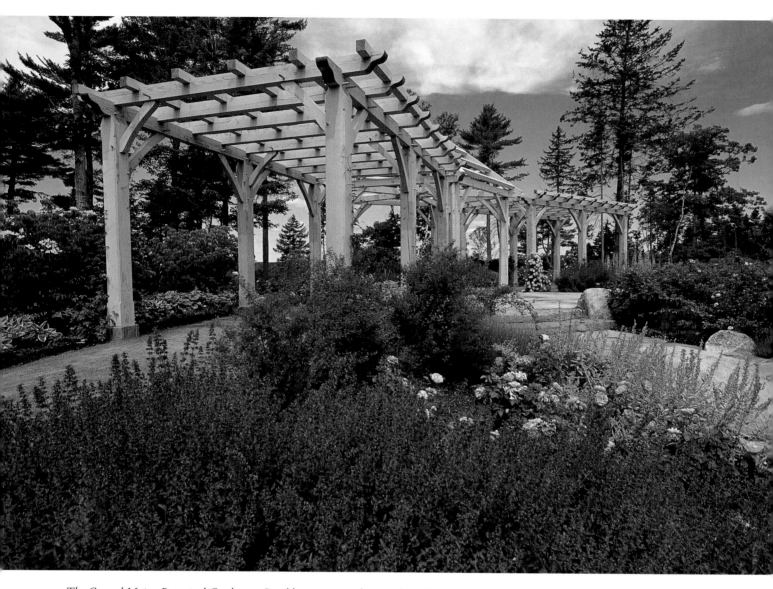

The Coastal Maine Botanical Gardens in Boothbay integrate glorious planted spaces within a coastal pine forest. The rose and perennial garden, with its giant pergolas, is a showcase for native and hardy shrub roses that thrive in this seaside environment, interwoven with vibrant perennials that bloom from spring through fall.

The Beauty and the Bounty of Boothbay

The Boothbay peninsula's first permanent settlers began to arrive in 1729, but these Scotch-Irish families struggled to eke out an existence. Their agricultural way of life proved incompatible with the region's rocky soil, salt-tinged air, and abbreviated growing season.

Boothbay's bounty lay offshore in the prolific waters surrounding Georges Bank. This enormous continental shelf, or raised plateau, on the sea floor stretches from Nova Scotia to Cape Cod and delineates the Gulf of Maine from the Atlantic Ocean. Along the Bank, the shallow, sun-warmed waters teem with phytoplankton—minute aquatic plants that serve as the vital first link in the marine food chain. Microscopic zooplankton feed on phytoplankton. The larvae of many coveted fish species—cod, haddock, yellowtail flounder—thrive on zooplankton. Within a century, the Boothbay

peninsula's protected natural harbors were home base for commercial fishing fleets, and a successful boat-building industry arose to supply the two-masted schooners employed both for fishing and for carrying the salted, preserved catch to markets.

By the latter part of the twentieth century, technological advances had given fishermen an unprecedented edge over their finned prey, but record catches proved impossible to sustain. Overfishing decimated the populations of commercially valuable species. While shipyards remain, their focus has changed. At Hodgdon Yachts in East Boothbay, for example, the fifth generation of a family that launched its first of more than four hundred boats (the schooner *Superb*) in 1816 now crafts luxury yachts. Lobstering is the only viable commercial fishery, and the restoration of the Georges Bank fish population remains a hoped for, yet uncertain, possibility.

While the fish may never return to their previously abundant levels, the region's lovely and lively towns, such as Boothbay Harbor, reliably swell with tourists each summer, just as they have since the 1880s when the area's tourism industry was established. Streets lined with shops and chowder houses and wharves crowded with sport fishing charters and tour boats—many bound for wild and scenic Monhegan Island, a tiny, road-free artists' haven ten miles offshore—are as alluring to tourists as phytoplankton is to zooplankton.

The cultivation challenges Boothbay's early settlers encountered remain, and yet a devoted team of garden lovers, landscape architects, and horticultural experts has successfully transformed a rugged, wooded, 284-acre seaside tract into Maine's first—and New England's largest—botanical garden. The Coastal Maine Botanical Gardens, a colorful attraction opened to the public in 2007, were first envisioned in 1991 by a small group of garden enthusiasts. "These were not rich people; they were just people who were committed to the idea," explains Barbara Freeman, who is not only the Botanical Gardens' director of communications but a certified Master Gardener and gardening author. When the group's search for a coastal property somewhere between Camden and Freeport led them to an undeveloped waterfront parcel in Boothbay, "They put up their own houses as collateral," she says.

From the oceanside Meditation Garden with its intricate arrangement of granite from quarries throughout Maine to the three-tiered Haney Hillside Garden built into a dramatic rock ledge, each planted space has been thoughtfully designed. "The rose and perennial garden is the most spectacular," Freeman believes, although she admits that the rhododendrons—the first to bloom—are a beloved harbinger of spring. Maine gardeners eagerly anticipate winter's demise. "We look for signs; we go out and peer at the soil," she says. At the Coastal Maine Botanical Gardens, a one-acre landscape is planted with more than one hundred rhododendron species, plus dogwood trees and thousands of flowering perennials.

Most botanical gardens begin as meticulously manicured private estates. Maine's, however, is a "quintessential old Maine forest . . . enhanced with beautiful gardens," Freeman says. "It's really a magical place; it all fits so beautifully."

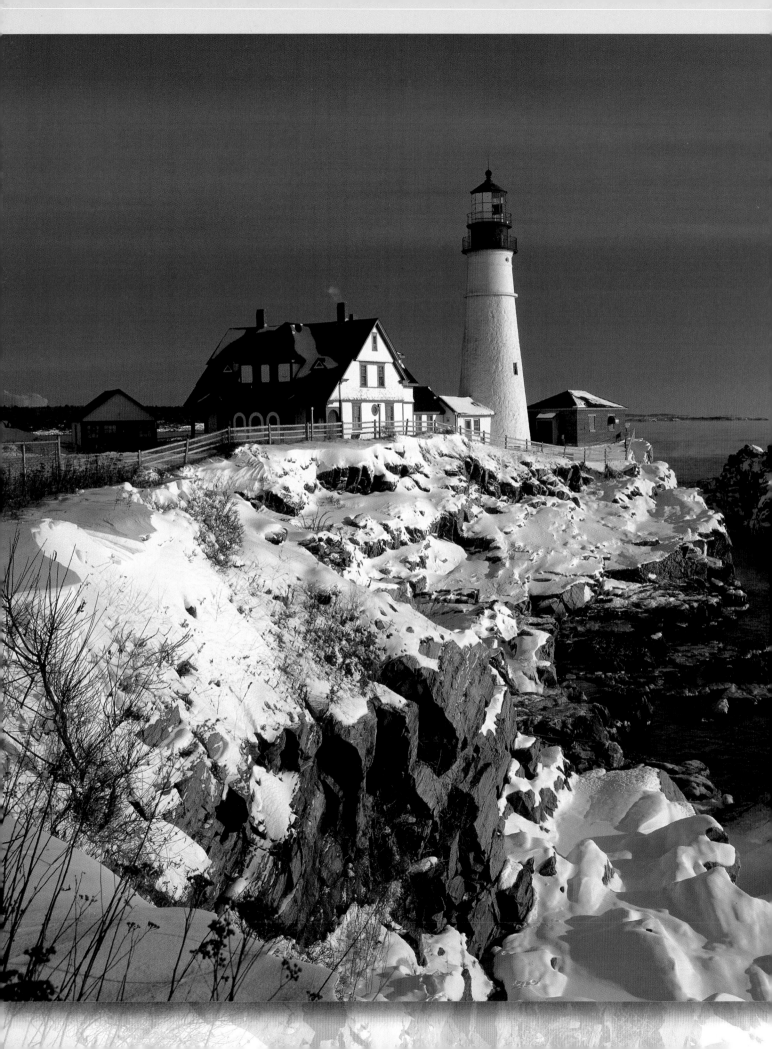

Portland & Southern Maine

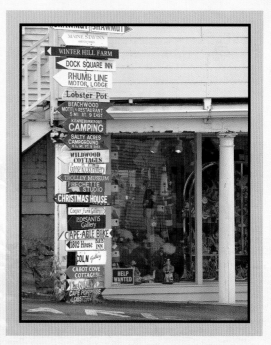

Cold Water, Warm Hospitality

Above: A crowded signpost attests to how much there is to see and do within a tight radius of the quaint coastal town of Kennebunkport.

Left: Portland Head Light strikes an imposing stance on Maine's intricately chiseled, snow-frosted coast.

There is a reasonably simple academic explanation for why Maine's coastal waters remain invigoratingly cold, even at the height of summer. Arctic currents flow into the Gulf of Maine year-round, and as summer winds push sun-warmed surface waters offshore, cold, deep seawater wells up close to the coast. The reasons vacationers are completely undeterred by brisk water temperatures are more complex: Maine's South Coast is the primary destination for the vast majority of the state's more than forty million annual visitors.

Although only fifty miles separate Portland and Kittery, half of Maine's beaches lie within this compact shoreline. They're inviting, safe places for families, where children from Maine play with those from well beyond the state's borders, constructing sand fortresses and shrieking as waves lap their ankles. The state's oldest, most iconic towns are here, as are eleven picture-perfect lighthouses. And while the opportunity to shop at Kittery's factory outlets and the L.L. Bean flagship store in Freeport bolster the region's allure, the wondrous scenery that has inspired artists since the turn of the twentieth century resonates deeper than any bargain sweater.

Summer is a short-lived phenomenon in Maine, and along the southern shore, residents embrace the season with gusto, hosting family reunions to coincide with fairs and festivals, shopping at farmers' markets, making time for strolls by the sea. In some parts of Maine, folks "from away" arouse suspicion, but tourists and transplants mix easily with the locals in this welcoming region. Tourism is Maine's largest employer and its top industry, generating upwards of $7 billion in annual revenues. Barbara Whitten, the Convention & Visitors Bureau of Greater Portland's president and CEO, says residents realize there are positive aspects to sharing their cherished coast with visitors. "The tourists enhance our own quality of life; we would not have the number of restaurants, the shops, if they weren't visiting," she says. Admission fees, highway tolls, and lodging and dining taxes "help replenish, restore, and maintain wonderful treasures that we get to enjoy every day," she adds.

Kathryn Weare, a twelfth-generation Mainer and fourth-generation innkeeper, says two more factors contribute to the region's magnetism. "Our greatest assets," she notes, "are the wonderful fresh local seafood you can get here" and "the atmosphere, in which you can truly relax and reassess yourself." If nothing else, a stay convinces most to alter their diet and habits: to include more lobster and more Maine vacations.

Beloved Casco Bay

Casco Bay's concave coastline arcs from Cape Small to Cape Elizabeth; the linear distance between these points is a mere twenty miles. Hikers who follow the Casco Bay Trail in Wolfe's Neck Woods State Park, situated atop a bluff overlooking this sparkling estuary, can observe osprey nesting on Googins Island and snowy egrets feeding along tidal flats. The two-hundred-acre park, on a wooded peninsula jutting into Casco Bay, is as wild and scenic a place as you might expect to find anywhere along Maine's coast, yet it's less than five miles from Freeport, the bustling shoppers' paradise where outlet bargains abound and famous retailer L.L. Bean keeps its flagship store open around the clock: The door locks were removed in 1951.

Portland and South Portland—two of Maine's largest cities—flank Casco Bay's western edge. Portland's deep natural harbor is more than one hundred miles closer to Europe than any competing Atlantic seaboard port, and the city has been a hub of international commerce since shortly after settlement in 1632. Portland is as urban as Maine gets, and yet, just a few miles from downtown, the emerald islands that dot Casco Bay are sparsely inhabited and pristine. Known as the Calendar Islands because an early description erroneously equated their number to the days of the year, only six of these 140 or so ocean outposts have significant year-round populations. Even passengers who disembark from the more than thirty cruise ships that dock in Portland each year are drawn to tour boats that ply the inner harbor, providing views of

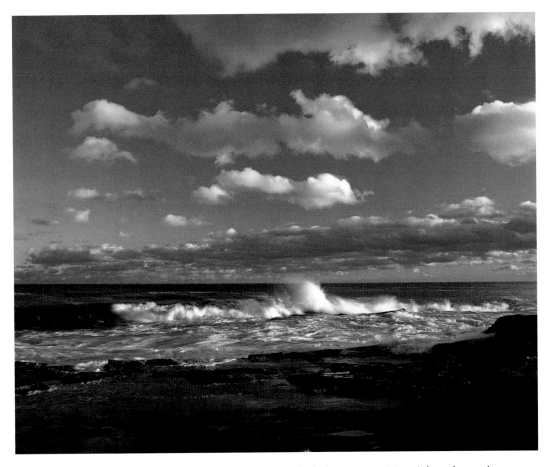

Two Lights State Park's impressive views of surf dashing and splashing against Maine's legendary rocky coast aren't the sole attraction of Cape Elizabeth, located eight miles south of Portland. The Lobster Shack Restaurant at Two Lights is an immensely popular oceanside eatery, with views of the pair of lighthouses marking the entrance to Casco Bay.

seals, seabirds, historic forts, and lighthouses, along with a glimpse of island life.

Kayak on Casco Bay, and you might see eagles soaring overhead and fish darting near the surface. "It's beautiful," says Peter Milholland, but "look under the water," and there are "real problems." The Friends of Casco Bay was founded in 1989 by "a group of local citizens who had read a few reports about the health of Casco Bay," including a Troubled Waters Report that identified it as one of the Atlantic Coast's most polluted bays, says Milholland, who became the nonprofit's citizen steward coordinator in 1995. "One-third of the population of Maine lives within the watershed of Casco Bay," he notes. Human activity as far inland as Bethel has an impact on the bay.

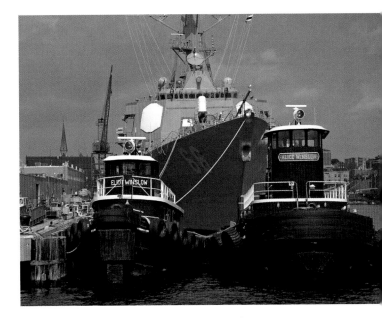

Tugboats escort a Navy ship into Portland Harbor.

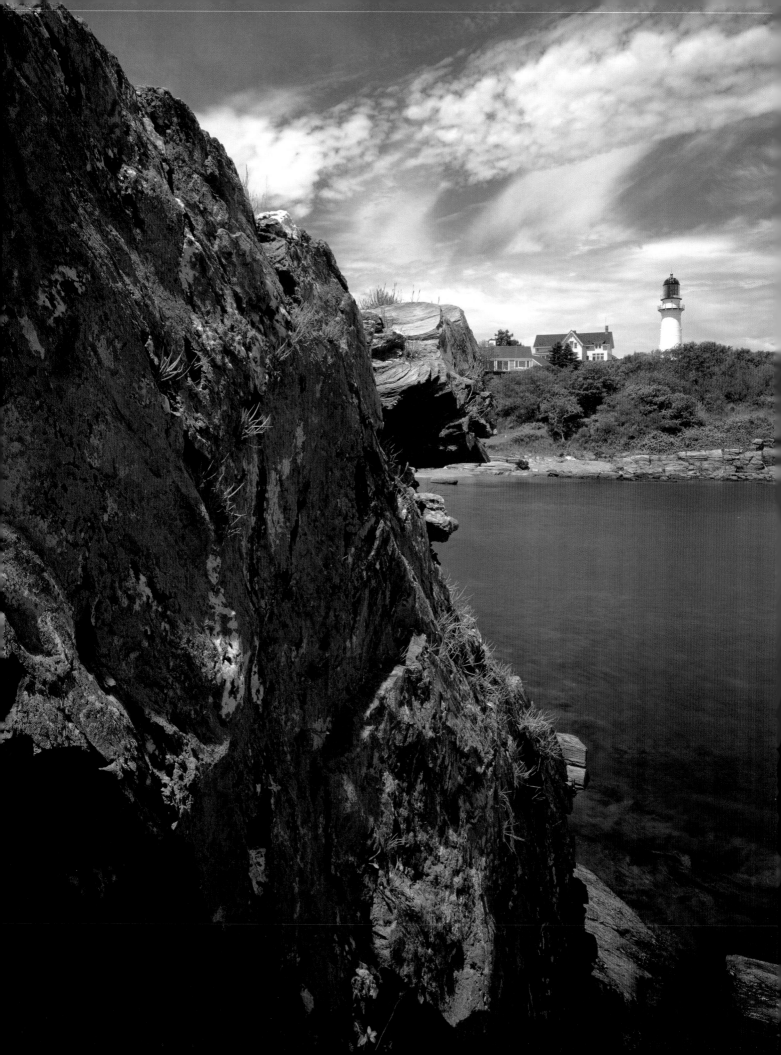

A Destination for Lobster Lovers

THRONGS OF VACATIONERS board Casco Bay Lines ferries bound for Bailey Island; others motor across the world's only cribstone bridge—gravity holds the granite slabs together—en route to this out-of-the-way Casco Bay isle. They share a singular quest: the quintessential lobster consumption experience. At Cook's Lobster House, which has expanded dramatically since Charles Cook opened a lobster shack on Bailey Island in 1955, there are water views from every angle, lobstermen ease their boats up to the restaurant's own wharf to unload their fresh catch, and the kitchen turns out thousands of pounds of tasty crustaceans year-round. It's not surprising that when a Visa commercial featuring Cook's aired nationwide in 1999, it enticed lobster lovers everywhere.

"It was a very exciting time; you could always tell when it aired because the phone would just start ringing," says Judi Dauphinais, a manager at the restaurant for twenty years. One caller who inquired about the closest airport "wanted to fly in from California for dinner," Dauphinais remembers. In the restaurant's entranceway, a pushpin map on which visitors began indicating their home locations in 1999 continues to illustrate Cook's far-reaching appeal. Dauphinais, who remembers dining there as a child, says Cook's is also a local tradition, especially come winter, when a cozy woodstove burns, servers trade their polo shirts and khakis for black and whites, and the menu is enhanced with fine-dining selections. "It's a different restaurant; it's more personalized," Dauphinais says, and almost everyone gets a window seat, which makes them "extremely happy."

In 1987, Curt and Joan Parent acquired the restaurant his stepfather founded, and Dauphinais says the owners' work ethic rubs off on the staff. It's not easy catering to boatloads of crustacean cravers, but not every job comes with the fringe benefit of incomparable sunsets. "We offer everything there is to offer on the Maine coast right here on Bailey Island," Dauphinais claims. And although the television ad warned, "You'd better bring your Visa card," there's no charge for the amazing views.

The Friends' mission is to "improve and protect the environmental health of Casco Bay" through advocacy work, educational programs, and scientific research, says Milholland, who has trained nearly five hundred "citizen scientists" to assist with the organization's water quality monitoring program. Each volunteer learns EPA-certified techniques and conducts tests at a specific location throughout the year. "The data they collect goes to Congress every three years," and it helps determine specific areas that merit focus and funding. Milholland says most volunteers are not trained scientists. They're housewives, lawyers, teachers, realtors, retirees: "Either they live near the bay or they spend a lot of time on the water; they want to be able to do something that can help preserve the health of the bay."

Portland: Serenity City

Portland is Maine's melting pot: a diverse, liberal, and sophisticated city where lawyers and lobstermen tramp the same streets. "The working waterfront continues to blend right in," says Barbara Whitten,

Cape Elizabeth Light, visible beyond a lichen-adorned ledge, is one of the duo of lighthouses for which Two Lights State Park is named. It remains on duty, but its deactivated twin, situated three hundred yards to the west, is privately owned.

A trip to the pound doesn't mean the same thing for dogs in Maine.

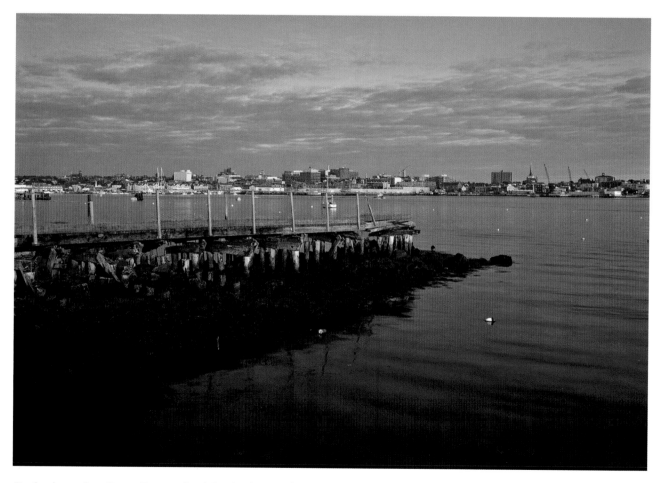

Portland, seen from Spring Point in South Portland, is as urban as Maine gets, yet it remains a seafaring city with strong ties to its past.

president and CEO of the Convention & Visitors Bureau of Greater Portland, who frequently dispels myths about Maine's largest city. "People don't believe that this far north you're going to find a world-class art museum or a world-class symphony," she says. Travel agents who ask the location of the nearest major airport are startled by the answer: Portland. "People think we're out in the sticks; we're not," Whitten asserts. It's admittedly novel, however, that some city workers commute by kayak from their island homes.

Portland's symbol is the phoenix. Its motto: *Resurgam*, "I will rise again." Four times in its history, the peninsula city was leveled by fire: twice in the seventeenth century by Native Americans, by the British in 1775, and on July 4, 1866, when a stray spark ignited the Great Fire that destroyed 1,800 structures. Rebuilt in brick Victorian style, the city remains architecturally intriguing thanks to concerted preservation efforts. Portland's eighteenth-century Wadsworth-Longfellow House, a fire survivor and boyhood home of poet Henry Wadsworth Longfellow, became the state's first historic house museum in 1902.

A different type of destruction preceded Portland's most recent renaissance. When the Maine Mall opened in South Portland in 1971, it devastated the downtown commercial district. Even Porteous closed its flagship department store on Congress Street. A quarter-century ago, when Whitten, a Bangor native, relocated to the Portland area, "the Old Port waterfront district was boarded up." Then, Tony DiMillo turned an old car ferry into a wharfside restaurant in 1982, even though "everyone thought he was crazy," Whitten says. "Slowly and surely, the boards came off the windows," she recalls. The Old Port was transformed by artists, boutique owners, and food manufacturers; DiMillo's Floating Restaurant is now one of the state's top-grossing eateries. In 1993, Porteous became home to the Maine College of Art. The mythological phoenix always emerged from its flaming nest a younger incarnation of itself. The college, Whitten says, "adds a youthful, fun flair to the downtown area."

Year-round, Portland is an exciting arts, dining, and shopping destination. The city's chefs are known for favoring local and organically grown ingredients. "We've raised dining to a major league sport," Whitten says. While chain stores aren't expressly forbidden, Portlanders like to eat local and buy local, and tourists "want to do what the locals do," she says. At Congress Street's Homegrown Herb & Tea, Sarah Richards concocts therapeutic tea blends designed for everything from curing hangovers to boosting libido. You won't find that at Dunkin' Donuts or Starbucks. "People love going into a store like that," says Whitten. "They come downtown because they don't know what they're looking for." Usually, "they find what they're looking for."

Young professionals, artists, and entrepreneurs are finding the life and livelihood they seek in Portland, too. "It's cool to live downtown," says Whitten, who notes that the city attracts people who enjoy culture but crave "more serenity." The city's creative economy is thriving; "there's an entrepreneurial spirit," she says. Portland has even topped lists of the best markets for small business.

"Most everyone that's here is not from here; we're a very open and welcoming community," says Whitten. That spirit extends to tourists. Whitten often delights out-of-towners when she explains the city's policy of forgiving one parking ticket every six months. She's not alone in making visitors feel at home. "The people in Portland—when you meet them—you feel like you've known them all of your life," she says. That "genuine friendliness" is what "makes people want to come back."

Old Orchard Beach

Sandy beach expanses are rare along the Maine coast. Only seventy miles—2 percent—of Maine's shoreline is classified as beach. The state's second smallest town, Old Orchard Beach, is just 7.6 square miles in area, but it occupies an enviable position bordering the longest uninterrupted stretch of sand—a seven-mile ribbon of powder cradling Saco Bay. Near Old Orchard Beach's halfway section, the

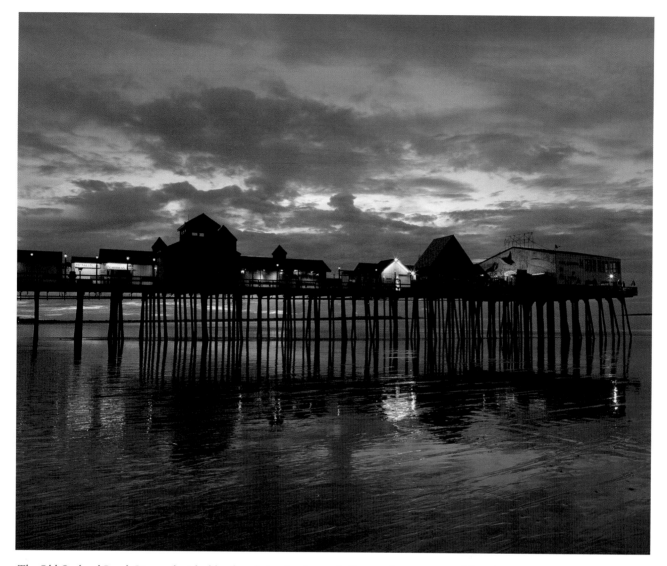

The Old Orchard Beach Pier, a cherished landmark that has been rebuilt several times since it debuted in 1898, extends out five hundred feet over the Atlantic, as if it is eager to greet the morning sun.

wood-planked Pier, a fixture since 1898, and Palace Playland's giant surfside Ferris wheel are reminders of an era when grand hotels and classic beach parks dotted the New England shore. Most of the Victorian inns have vanished; Palace Playland is the region's only surviving seaside amusement park.

Dan Blaney, who has the well-earned but unofficial title of town historian, is a bit of an anomaly, also. While it's not uncommon to encounter Mainers who were born at home, the Old Orchard Beach native admits "it's unusual to still be there sixty-three years later and sleep in the same room."

Blaney's love for local lore was sparked by an eighth-grade teacher. "For a small community, so much has gone on," he says, as he ticks off major events that shaped the town, starting with the 1873 arrival of the Boston & Maine Railroad. "Within minutes, the hotels were going up," he says. At the height of the beach's popularity, more than fifty trains per day brought the faithful to Methodist camp meetings and the Chautauqua-inspired Ocean Park, where the summer season still features diverse religious, cultural, and educational programming. The great fire of 1907 and a pummeling 1909 storm threatened

the resort's viability. "There was a lot of doubt after the fire," says Blaney, but by 1910, the town found a way to bring tourist crowds back: auto racing on the beach. The Pier, rebuilt after both the fire and the storm, was a twenties and thirties hot spot. The Pier Casino Ballroom hosted every major Big Band, and as many as five thousand people turned out to dance.

A century after the great fire, Old Orchard Beach is experiencing a resurgence. "It's taken us this long to come out of the ashes," Blaney says, acquiescing that the honky-tonk reputation the beach town suffered in the sixties and seventies wasn't entirely undeserved. The Pier is all new again, rebuilt after the blizzard of 1978. The gorgeous Grand Victorian, a waterfront retail and residential complex, opened in 2007. The town has more guest rooms than Portland, more campsites than any other Maine community. The beach—open free to all—is a play place for families, including many French-speaking Canadians: "It's the closest beach to Canada," Blaney explains. Most significantly,

after a thirty-year hiatus, trains returned to Old Orchard Beach in 2001 when Amtrak initiated its Downeaster service. As Blaney watched thousands of beach-goers simultaneously disembarking from the train, buses, and trolleys one summer day, he recalls thinking: "Wow—this town is vibrant."

Old Orchard Beach is strikingly different after Labor Day. Blaney says "you'd be lucky" if you could count five thousand people in town in January or February. He and his wife, also an Old Orchard native, aren't tempted to flee. "Most of us who live in Maine like the Maine weather," he says. "We love the summer here; we love the winter here; we love the spring and fall." Season after season, three constants keep him close to home: "family and friends and the beach." Old Orchard Beach may be "everybody's in the summer," he says, but in the winter, "it's ours."

Kennebunkport: Seaside Chic

By the time shipbuilding began to decline along the Kennebunk River in the latter half of the nineteenth century, Kennebunkport—the prosperous town on the river's northeast bank—had already forged a new and enduring identity. Summer cottages and grand hotels sprang up to accommodate trainloads of urbanites, drawn to the Kennebunk region's accessible beaches and breathtaking scenery. An early morning stroll along Ocean Avenue, the gallery- and boutique-intensive thoroughfare that follows the river's course from Dock Square—Kennebunkport's hub—to the sea, reveals this historic seaport town's timeless charms: enchanting architecture, sailboats at anchor in the still harbor, the silvery spray that flies as the ocean collides with Maine's unyielding rockbound shore. "It just oozes quaintness," says Rob Blood, owner of the Captain Fairfield Inn, one of dozens of upscale lodging and dining establishments that continue to distinguish Kennebunkport as a year-round destination for discriminating travelers.

As guests savor a gourmet breakfast at this 1813 sea captain's home turned B&B, they ask Blood and his wife, Leigh, for suggested activities. "There is

With its powdery sand and vigorous surf, Gooch's Beach is the most popular of the three beaches that compose mile-and-a-half-long Kennebunk Beach, which extends along Beach Avenue from the Kennebunk River breakwater to Lord's Point.

seldom a day that we send them more than five or ten miles from the inn," he says. "We have five amazing beaches that are very close to Kennebunkport," Blood begins. Active guests can kayak on the river or hike trails at Laudholm Farm, a National Estuarine Research Reserve in Wells. From schooner trips to whale-watch tours, there are ample opportunities to get out on the water. Half a dozen lighthouses can be viewed on a short drive. The authentic fishing village of Cape Porpoise lies just two miles out of town. Dining options range from casual clam shacks to Maine's only five-star restaurant: the White Barn Inn. And whatever your political leanings, "you have to go see the compound," Blood says. He's referring to the Walker's Point home of President George H. W. Bush, which served as his summer White House and continued to provide the setting for important international summits during his son's tenure in the Oval Office. Most visitors only glimpse the glorious seaside estate through binoculars or camera lenses.

But the Bloods had one guest—a young mother from Texas—who struck up a conversation with the Bushes while attending services at St. Ann's and wound up joining them for iced tea and a soak in their Jacuzzi.

Not everyone receives a presidential invitation. Still, a reliably high level of hospitality, coupled with Kennebunkport's easy pace and laidback vibe, make this town where the river meets the sea a difficult place to leave. Former innkeeper Dennis Rafferty, who now spends all of his time painting vibrant coastal scenes in oil and watercolor, is one of a bevy of Kennebunkport artists and photographers whose works adorn gallery walls, destined to become treasured souvenirs. Maine resonates so deeply with people that they "want a piece of it to take home with them; I provide that with my paintings," Rafferty says. "I love Maine and can't imagine living anywhere else," the Midwestern transplant adds. "For an artist, it is pure inspiration year-round."

Sea Therapy

"WE'RE A STRESSED SOCIETY," says Melanie Valliere, spa director at Kennebunkport's Breakwater Inn & Spa. The surging number of New England spas is evidence of expanding realization that pampering and downtime are "physically and emotionally beneficial," she says. While she believes "any place is a good place for a spa," Valliere affirms that a spa by the sea is exceptionally therapeutic. "The constant repetition, the flow of the waves back and forth, is very soothing," she says. The white noise of pulsing surf is "very calming, very balancing." For humans, the ocean's magnetic pull is as elemental as the moon's sway over the tides. "People find a real energetic connection with the seas," Valliere says.

Of course, in Maine, a dip in the ocean can be more bracing than relaxing. "The northern Atlantic Ocean is lovely, but it takes your breath away," Valliere says. Even on harsh winter days, treatments at the Breakwater Inn's peaceful spa offer guests the restorative benefits of the sea. Marine algae is a key ingredient in the Thalgo products the spa utilizes for body wraps and facials. "It helps to detoxify and remineralize the skin," Valliere explains. "People notice immediate results: a nice glow to their skin, an instant feeling of firmness," she says. The supreme indulgence is an in-room Aroma Sea Bath, which alleviates aches, aids digestion, and prepares guests "for a good night's rest." By the time spa-goers leave Maine, a transformation has occurred. "They're in that more blissful state," Valliere observes. "The cares of the day are gone."

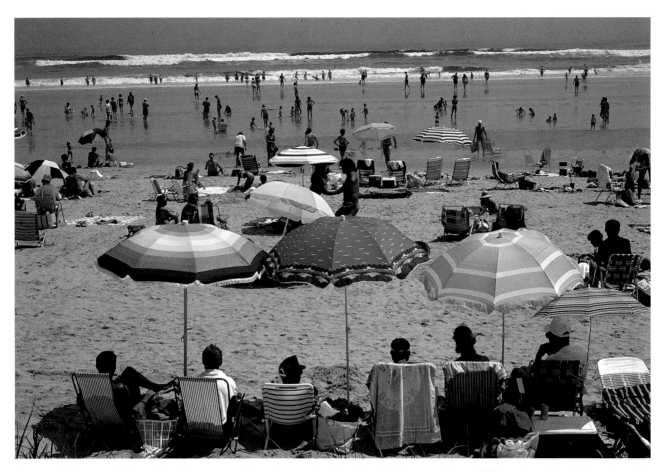

Ogunquit's three-mile barrier beach is separated from the mainland by the tidal Ogunquit River. Walk north two hundred yards and listen for Cher playing on the radio, and you'll know you've reached the beach's gay section, advises gayogunquit.com.

The Bloods, who also own Nantucket's Veranda House, "ultimately intend to buy another inn or two," Rob says. But after just four years in Kennebunkport, when he and Leigh first discussed the possibility of relocating their home base, "it evoked an awful emotional response," he says. "We feel very connected with the rest of the world here, but we get to live in a town that is small, where you know everyone walking down the street." Quitting Kennebunkport, he says, "would be like detaching part of our soul."

Beautiful Place by the Sea

Ogunquit became one of Maine's newest towns when it separated from Wells in 1980, but this "beautiful place by the sea," as its fun-to-say name translates from the Abenaki Indian language, is actually one of the coast's oldest travel destinations. Prolific Massachusetts impressionist Charles H. Woodbury first committed Ogunquit marinescapes to canvas in 1888. Nearly five decades later, the founder of the Ogunquit Summer School of Drawing and Painting told an interviewer: "Perkins Cove was nothing but a cluster of fishermen's dwellings when I discovered it on that first visit to Ogunquit. The only place to stay was the old Ogunquit House in the village. They told me it had been a great season. Four strangers had been there."

Woodbury inspired thousands of pupils during thirty-six summers by the sea, and the picturesque art colony soon blipped on tourists' radar, too. Perkins Cove has evolved into a bustling shopping and dining destination, but it still beckons to artists, who position their easels as fishing and lobster boats

Native Americans likely showed European settlers how to layer wet seaweed, lobsters, clams, corn, and a final blanket of seaweed atop white-hot rocks in a pit dug by the sea. Maine vacationers who have the opportunity to experience an authentic beachfront clambake never forget their feast.

The perfume of salt air and flowers must elicit sweet dreams for the inhabitants of this adorable Ogunquit cottage.

Right: Day's first rays illuminate the sea- and wind-worn face of Bald Head Cliff. Situated on seventy acres atop this dramatic rise, the historic Cliff House Resort & Spa has infinite Atlantic views, even from its pampering spa.

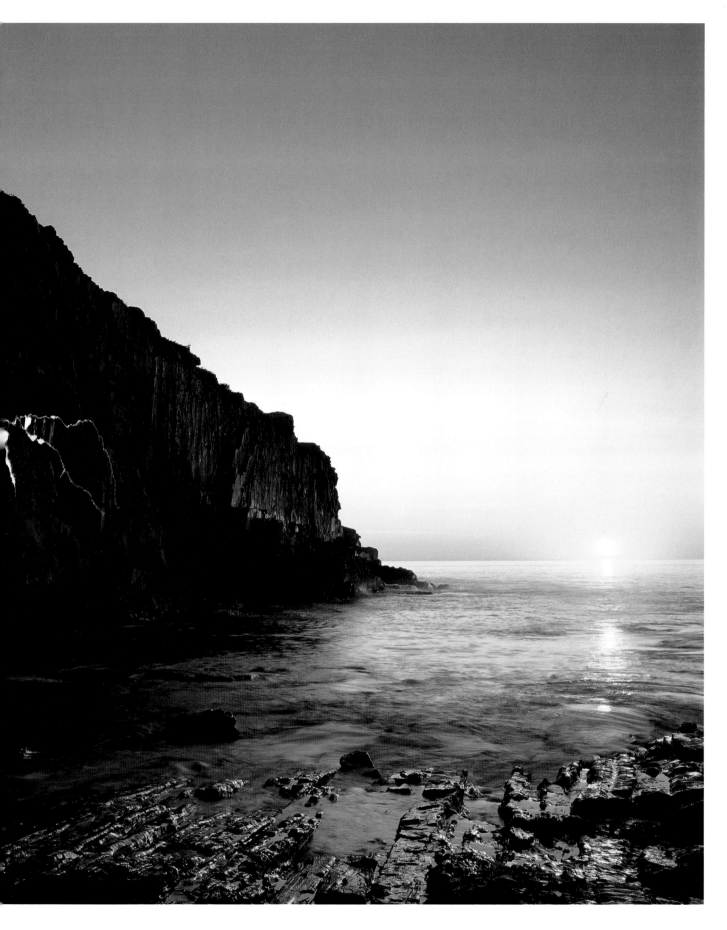

The Cliff House

WITH TWO THOUSAND feet of ocean frontage, seventy dramatic clifftop acres, and 194 guestrooms, each with a waterview balcony, the Cliff House Resort & Spa in Ogunquit is unrivaled on New England's coast for its sheer enormity. More remarkable is the number of families that have owned this enduringly popular hotel since it opened in 1872: one.

When the Boston & Maine Railroad decided to extend a line to York, Maine, after the Civil War, Elsie Jane Weare knew it would spur tourism. She purchased land on Bald Head Cliff for a grand seaside hotel where wealthy vacationers could enjoy healthy air and warm hospitality. "My great-grandmother was very sharp," says Kathryn Weare. "The keys to her success were personal hospitality and, of course, the wonderful ocean views, for which we are still famous." You can "open your front door, feel the wonderful salt breeze, and look out over the vast Atlantic."

Families came for the entire summer season, husbands for weekends, and the hotel thrived until 1942, when an uninvited guest arrived and stayed for three years. The Army Corps of Engineers took the property by eminent domain for a World War II radar station, and they were none too gentle with this strategically located site. "Most of the folks in this area believed that the Cliff House would never reopen," Weare says. Her family did try to sell the hotel. It was listed in the *Wall Street Journal* for fifty thousand dollars. "There were no takers," she says. Weare's four uncles also passed

on the property, but "my father was unwilling to give in, to be defeated," she says. Resources were so scarce, he hand-rolled the mile-long access road. Although the operation was scaled back substantially, the Cliff House was saved.

Weare was in her early twenties when her parents announced plans to sell unless she or her sister would take over the hotel. "I passionately did not want to see that happen," she says. Weare set about expanding and revitalizing the property, transforming it into a modern resort while honoring its unique place in history.

"The world is changing," Weare recognizes. "Resorts have to reinvent themselves on a regular basis to be attractive to a new generation" that is "more cosmopolitan." In 2002, the Cliff House introduced one of New England's first spas. With its oceanfront setting and treatments featuring indigenous, organic products—juniper, wild roses, blueberries—the spa caters to guests searching for relaxation, quiet, and seclusion.

As a young hotelier, Weare says, "I was known to run up and down the cliff to vent some energy when I had a frustrating guest." Now, she finds stress relief on walks out to the point, where she contemplates the sacrifices made by her ancestors and the lessons learned from her parents, who entrusted her with "the most treasured possession of their life."

"I stand on the shoulders of all my family that came to Maine before me," she says. "I am blessed to be here in this space; it's a wonderful way to spend my life."

set out for the day and sailboats ease between the graceful, upraised decks of the unusual pedestrian drawbridge that spans the harbor's entrance. Ogunquit's year-round population is smaller than it was in colonial days, but each summer, the

four-square-mile town explodes with vacationers. A three-mile-long barrier beach, connected to the village by a bridge across the Ogunquit River since 1888, is key to the town's family appeal. A toned-down version of Cape Cod's Provincetown,

Ogunquit also has a long-standing tradition of welcoming gay and lesbian visitors.

Trolley tours, gay bars, day spas, deep sea fishing excursions, eclectic Main Street shops, and Broadway musicals staged at John Lane's Ogunquit Playhouse—one of America's oldest summer-stock theaters—entice visitors with diverse interests. One Ogunquit attraction enchants everyone: the Marginal Way. An easy stroll along this paved, stroller- and handicapped-accessible, blufftop walkway, which winds for more than a mile along the coast from the center of town to Perkins Cove, is a multi-sensory experience. Each bend in the trail reveals a fresh scene of seaside mansions, scarred granite cliffs, starfish-filled tidal pools, pocket beaches, and rollicking surf. Sea roses and other wildflowers scent the saline breezes. A rest on one of thirty memorial benches along the way affords the opportunity to listen intently to the sea's hypnotic swells and percussive crashes. The town gladly acquired the deed to this former cattle path from York farmer Josiah Chase in 1923, but it stopped accepting memorial bench donations years ago—even though the waiting list has topped eighty and continues to grow.

Historic York

The York River's fertile banks and inviting harbor lured English settlers as early as 1630. York's farmers and merchants prospered through the eighteenth century, but Thomas Jefferson's Embargo Act of 1807, which closed America's ports to international trade, decimated the town's economy. York's recovery wouldn't begin until the late nineteenth century, when wealthy city dwellers discovered this coastal escape's lingering colonial charm. When these summer newcomers—accustomed to urban amenities like sidewalks, streetlights, and public sewers—began demanding improvements, local farmers voted their resistance. In 1901, however, the Maine legislature approved the formation of the York Harbor Village Corporation and the York Beach Corporation, granting petitioning residents of these resort areas a measure of self-government.

Although both corporations folded in the 1970s, the town of York is often termed "the Yorks" because each of its four villages retains distinct character. York Village, or "Old York," with its village green and collection of colonial structures, exudes early New England ambiance. The Old York Historical Society provides tours of seven buildings that predate the American Revolution, including a tavern, a schoolhouse, and America's oldest jail. York Harbor has a petite crescent of beach, an oceanside Cliff Walk, cozy inns, and grand private clubs and residences that continue to lend it an air of Victorian elegance. Families love York Beach's lively seashore scene, replete with arcades, souvenir shops, balconied hotels, and seafood shacks—even a zoo and amusement park—clustered around Short Sands Beach. When Short Sands is crowded, nearby Long Sands Beach offers an additional two miles of sandy shore. The northernmost village, Cape Neddick, is largely residential, but Flo's Famous Steamed

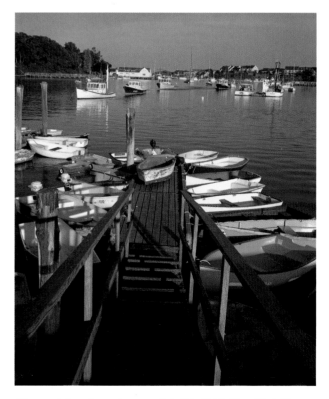

Not much has changed since a July 27, 1889, New York Times *article had this to say about "exquisite York Harbor": "In the harbor are moored boats of various descriptions. Yachts constantly run in for shelter or supplies."*

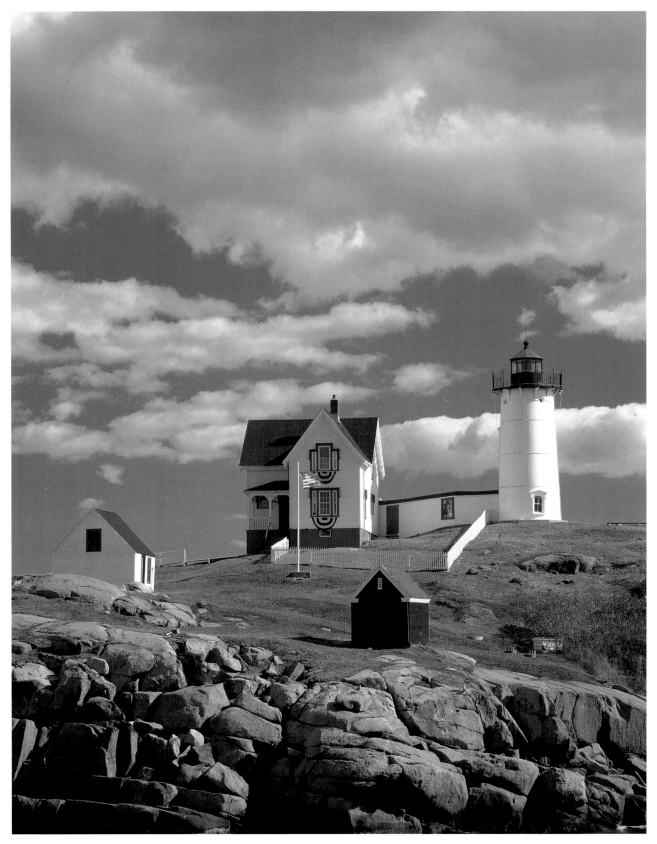

Cape Neddick, or "Nubble," Light is one of the most picturesque of the more than sixty beacons that dot Maine's rugged shoreline. The four roof points of its gingerbread-trimmed keeper's house indicate north, south, east, and west, and visitors from all points of the compass gather in York's Sohier Park to appreciate this breathtaking sight.

Hot Dogs, a tiny, unassuming Route 1 roadside stand owned by the same family since 1959, continues to draw lunchtime crowds.

Although these delectable dogs—topped with Flo's secret relish, mayo, and a dash of celery salt—have a cult-like following, their popularity pales in comparison with that of York's most celebrated attraction: the Cape Neddick Light Station. Established in 1879 on a rocky nubble of land two hundred yards off the point of the Cape Neddick Peninsula, this forty-one-foot white beacon and its red-roofed Victorian keeper's quarters are painted and photographed more than any other Maine lighthouse. Twice each year, during the York Days summer festival and throughout the holiday season, "Nubble Light" is outlined with festive white lights. Easily viewable year-round from Sohier Park on Nubble Road, the lighthouse's automated red lamp, which pierces the dark and fog at six-second intervals, is designed to warn boats away, but its romantic glow also seems to bid lighthouse lovers come hither. That's not necessarily the message meant for extraterrestrials, though. Voyager 1 and 2, twin exploratory spacecraft launched by NASA in 1977, carry on board a Golden Record featuring musical selections, friendly greetings in a multitude of languages, and images of life on Earth. Astronomer Carl Sagan headed the committee that determined the contents of this message sent beyond our galaxy. Among the 116 photos and diagrams depicting the wonders of human existence and achievement are scenes of the Great Wall, the Taj Mahal, and Nubble Light.

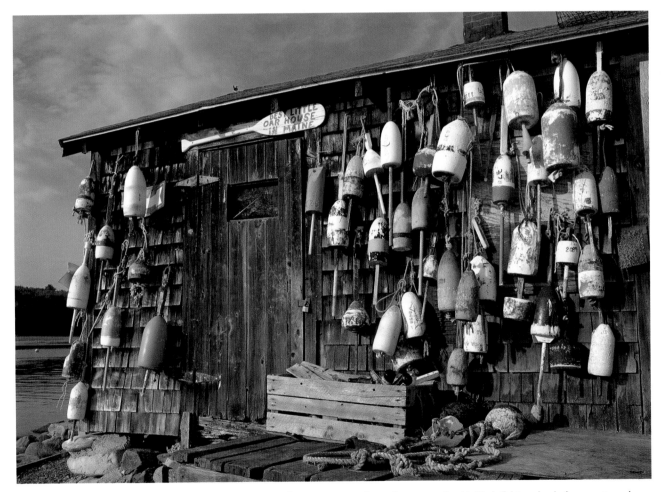

Lobster buoys, painted with each lobsterman's signature color pattern, are the perfect accent for this York fishing shack, but tourists who buy souvenir buoys may find it difficult to re-create this look back home. Don't even think about swiping a buoy. "Cutting or stealing a lobster buoy in Maine is considered worse than cattle rustling!" warn the folks at Maine-ly Buoys, who supply gift shops with convincingly distressed replicas.

CHAPTER 3

New Hampshire & the Massachusetts North Shore

Immersed in the Past

Above: Tulips bloom in brilliant color clusters at Portsmouth's Prescott Park.

Left: Gloucester's dramatic, light-saturated seascapes have inspired artists since the mid-nineteenth century.

Maine has 3,500 miles of coastline; New Hampshire has 18, the fewest of any state on the Atlantic coast. "There are people in New Hampshire who don't know we have an ocean here," says J. Dennis Robinson, editor and publisher of SeacoastNH.com. Yet, the state compensates commendably for its coast's short stature with miles of publicly accessible oceanfront and an unrivaled commitment to preserving the character of a region steeped in strategic importance, economic prominence, and leisure tradition. A mere 18 miles is multiplied many times through the lens of four hundred years of history.

Four centuries have also elapsed since the first fishing settlement sprang up on the Massachusetts North Shore, yet the passage of time has done remarkably little to focus attention on this region. Although many of its coastal towns are connected to Boston via commuter rail, there are places within and aspects of this rocky and picturesque coast that remain known almost exclusively to locals. While New Hampshire business owners have touted Hampton Beach's tourist appeal for more than a century, North Shore residents have quietly gone about protecting the ways of life they cherish. Here, the sea is not a toy. It is a provider, a muse, and sometimes a nemesis, with fierce power that is never underestimated.

The Most Remarkablest Isles

The short, fast-flowing Piscataqua River surges toward the sea, creating a natural boundary between Maine and New Hampshire. The two states divide the nine rugged isles located ten miles offshore. Appledore, Cedar, Duck, Lunging, Malaga, Seavey, Star, Smuttynose, and White are collectively known as the Isles of Shoals now, but when Captain John Smith explored northern New England's waters in 1614 and charted "the most remarkablest isles and mountains for landmarks," he deemed this island cluster worthy of bearing his name.

Smith's Isles and the larger Great Island, now New Castle, closer to shore were soon the province

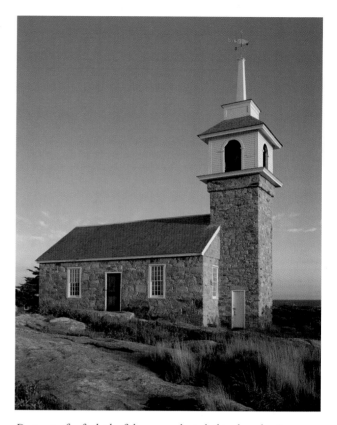

Desperate for fuel, the fishermen who inhabited treeless Star Island burned their wooden church in 1790. It was replaced by this stone meetinghouse in 1800. Gosport Chapel is still used for nondenominational services and can be rented for intimate weddings.

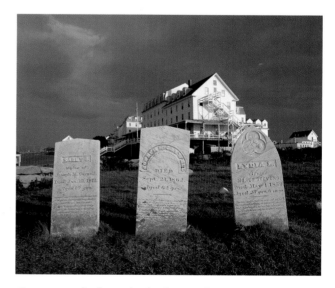

Gravestones of a few early Shoalers stand in the shadow of Oceanic House, the Isles of Shoals's only surviving Victorian-era hotel, now operated by a nonprofit organization as a retreat and conference center on Star Island.

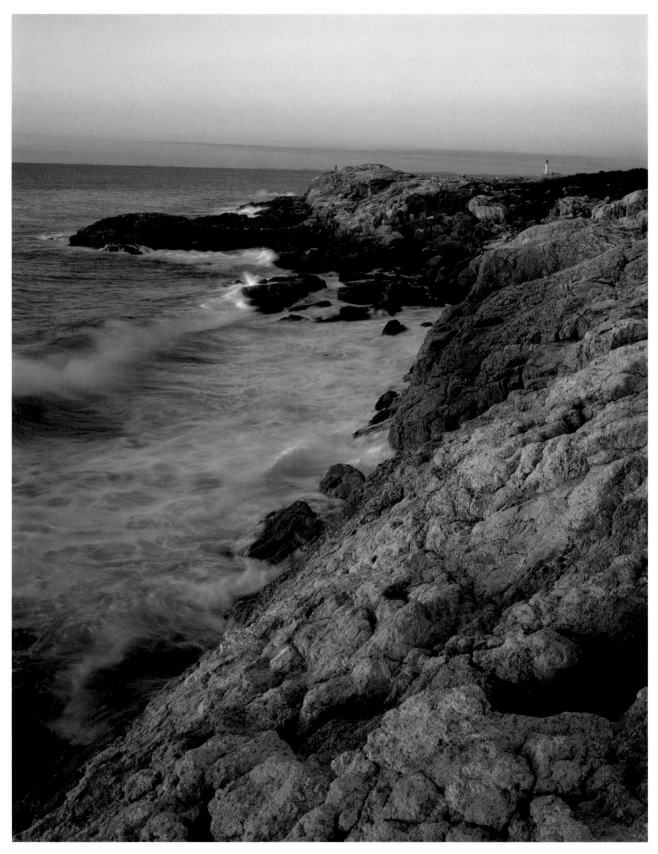

White Island Lighthouse was the first beacon established in the Isles of Shoals. The original 1821 stone tower was replaced in 1859 by the current white brick beacon, which is best viewed from sightseeing cruises originating in Portsmouth.

of European fishermen lured by waters crowded with cod. A century later, pirates lurked among the shoals. The notorious Blackbeard supposedly honeymooned on Smuttynose in 1720 with his fifteenth and final bride and abandoned her there as pursuers approached; some say her ghost still watches over his loot. Summer vacationers flocked to grand resorts on Appledore, Smuttynose, and Star Islands during the nineteenth century; only Oceanic House, transformed into a religious and educational conference center on Star Island, survives. As recently as 2001, the long-standing dispute between Maine and New Hampshire over ownership of Seavey Island—home to the Portsmouth Naval Shipyard and "The Castle," a former military prison—bubbled up to the U.S. Supreme Court; New Hampshire lost.

While the Isles of Shoals are sparsely inhabited, stories of border squabbles, notable vacationers, buried treasure, shipwrecks, and spooks ensure they remain remarkably fascinating to passengers who glimpse the treeless isles from tour boats that navigate Portsmouth Harbor.

A Well-Guarded Harbor

The island town of New Castle is New Hampshire's smallest. State Route 1B encircles the island in just five miles, anchoring it to the mainland and offering drivers views of three lighthouses and the sea, along with a quick trip through history, as it swings past the resurrected Wentworth by the Sea grand hotel and the entrances to Fort Stark,

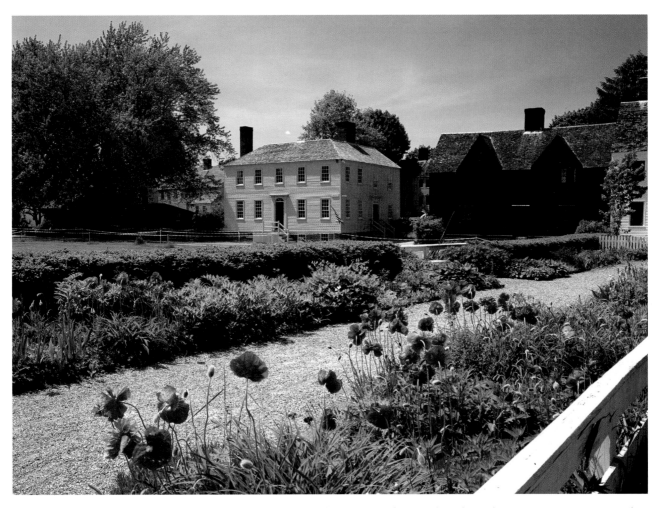

Poppies grace the gravel paths that crunch beneath visitors' feet as they tour Strawbery Banke, a living history museum in Portsmouth that preserves a four-centuries-old neighborhood.

A Return to Grandeur

FEW HOTELS HAVE biographers, but the Wentworth by the Sea in New Castle, a much-lauded member of the Marriott chain, has an extraordinary story. Situated high on a bluff overlooking Little Harbor and the Piscataqua River, the 1874 grand hotel was the most lavish of the New Hampshire seacoast's Victorian-era resorts, a place where Annie Oakley, still a sharpshooter in her sixties, taught target practice, and socially prominent families stayed for the entire ten-week summer season. By the 1890s, there was even a water closet on every floor. When Theodore Roosevelt chose the seaside retreat as host hotel for treaty negotiations ending the Russo-Japanese War in 1905—an achievement that would earn the president America's first Nobel Peace Prize—"Wentworth became synonymous with peace," says J. Dennis Robinson, author of *Wentworth by the Sea: The Life and Times of a Grand Hotel*.

After World War II, though, the hotel's clientele became less exclusive, and good help became difficult to find. Robinson says things really started to go south in the sixties, when a waitress was "caught leaving the kitchen with a Porterhouse steak in her pantyhose" and half the dining room staff quit to attend the Woodstock Music and Art Fair. It was "still 1869 in the Wentworth," he says, but it was "1969 in the world."

The sprawling hotel changed hands several times and was eventually shuttered and left to rot. By 1996, the badly vandalized, crumbling edifice landed a spot on the National Trust for Historic Preservation's "most endangered" list. In 1999, Robinson lamented in his online

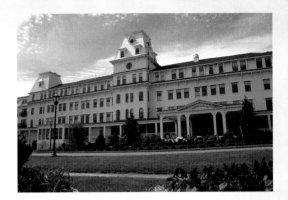

Victorian-era grandeur returned to the New Hampshire coast with the 2003 unveiling of the Wentworth by the Sea, a gloriously restored grand hotel saved from the brink of destruction after nearly a quarter century's vacancy and ruin. (Photograph by Kim Knox Beckius)

column: "the handwriting is on the wall; she's a goner."

But the Friends of the Wentworth, a determined grassroots organization, kept the wrecking ball at bay until a buyer was found. Ocean Properties, Ltd. acquired the historic hotel for $3 million and invested $25 million in her resurrection. After more than two decades of decay, the doors to the Wentworth by the Sea Hotel and Spa reopened in 2003, offering guests an opportunity to immerse themselves in Victorian elegance while enjoying modern luxuries.

There were tears in the eyes of many of the first visitors who crossed the lobby's gleaming wood floor and marveled at the miraculously preserved, hand-painted ceiling dome in the gracious dining room. America's first "endangered" hotel had emerged a gloriously restored beauty with chapters still to tell.

Fort Constitution, and Great Island Common—a thirty-one-acre oceanfront park.

Settled in 1623, Great Island was renamed New Castle in 1693; its "castle" was actually Fort

Constitution's predecessor, Fort William & Mary. Established in 1632 and enlarged in the 1690s, it was the first of seven fortifications constructed along the coast of Maine and New Hampshire to defend

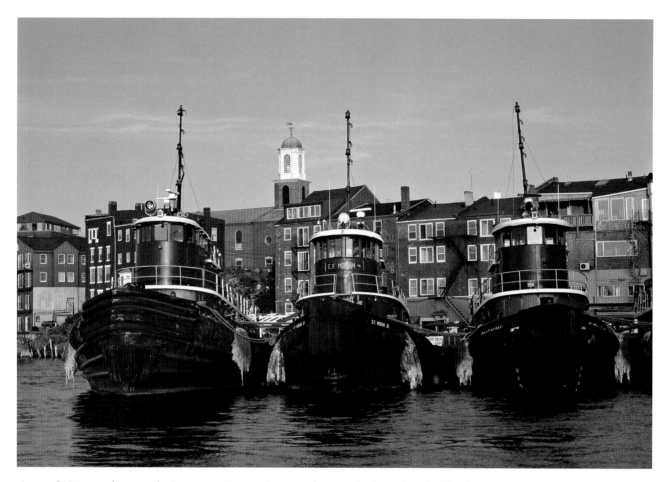

A trio of Moran tugboats on the Piscataqua River in Portsmouth retires for the night. These hard-working tugs spend their days guiding ships safely into Portsmouth Harbor, a navigational task made challenging by the river's swift currents.

Portsmouth and its vital harbor. The fort was an active military installation through World War II, but its most dramatic moments occurred on the nights of December 14 and 15, 1774. Months before his immortal Midnight Ride, Paul Revere hastened north-ward to Portsmouth to warn—erroneously—of impending British naval attack. Nearly four hundred local Sons of Liberty raided the ill-defended British fort preemptively, swiping valuable gunpowder and munitions later used at the Battle of Bunker Hill. The American Revolution had unofficially begun.

A City Moving Toward Its Future and Its Past

With each tide change, 1.2 billion cubic feet of water surges past Portsmouth, the antique city on the shore of the Piscataqua River. Some believe the force generated by the interplay of the river's cur-rents and the sea's tides might one day be harnessed as a predictable source of renewable energy. Whether or not an underwater power plant proves feasible, on shore, Portsmouth's spark is already the result of a two-way flow of energy: toward the future and toward the past.

Named Strawbery Banke in 1630 by its first English settlers for the wild berries that flourished on the Piscataqua's west bank, the coastal commu-nity, rechristened Portsmouth in 1653, was estab-lished not for religious purposes but for purely economic motives. By the late seventeenth century, Portsmouth was the most important port north of Boston and the seat of New Hampshire's royal gov-ernment. At the onset of the American Revolution,

there were few New England towns more prosperous and worldly than this thriving trade port.

In the early part of the nineteenth century, however, as inland lumber resources became depleted, seagoing trade slackened, and industrialized towns supplanted Portsmouth, the city's fortunes faltered. Ironically, this downturn would serve the city well in the long run.

Kimberly Alexander, curator of Strawbery Banke, a ten-acre living history museum that preserves Portsmouth's oldest neighborhood and interprets "the story of unfolding America," explains: "The communities that tend to be most intact are the ones that suffered economic downturn." Limited financial resources prevented residents of Puddle Dock, one of Strawbery Banke's original settlements, from refurbishing their homes. The museum's forty-two buildings date to as early as 1695; most are on their original foundations.

But saving this section of the city from demolition after World War II was no small feat. Returning veterans needed affordable housing, and urban renewal meant replacing—not restoring—old neighborhoods. An impassioned and forward-thinking group of Portsmouthers "saw that there was another story that could be told," Alexander says, and they worked to make restoration and preservation a viable path to renewal.

Established in 1958 and opened to the public in 1965, Strawbery Banke's success spawned further preservation efforts in the city. Portsmouth has "a tremendous number of house museums," says Alexander, adding, "The idea of 'legacy' is very powerful in this area."

But it is the blend of old and new—all within a compact, walkable area—that makes this seacoast city singular. Architectural treasures and the working waterfront "provide a backdrop for a very vibrant and energizing community," Alexander says. Tugboats bob on the river; concerts draw families to harborfront Prescott Park; students from the nearby University of New Hampshire in Durham give the city a youthful outlook; historic buildings house artisans' workshops, clothing stores, restaurants,

theaters, nightclubs. "There's this wonderful mix of what's funky and current in these traditional buildings," Alexander says, and a pervasive sense "of life continuing—both looking forward and back at the same time."

Redeployed for Ocean Literacy

In 1942, as America's role in the Second World War intensified, Odiorne Point was commandeered for the coastal defense. All but one of the seaside community's lavish summer homes were leveled and replaced by the bunkers and barracks of Fort Dearborn. The Sugden House, the sole survivor, housed officers' headquarters and the mess hall. The sweeping views longtime residents of the Point had cherished were now under the watchful eye of the U.S. military.

Since the late 1950s, when Fort Dearborn was declared surplus property and purchased by the state of New Hampshire, a slower transformation has occurred. With each passing year, the remains of trophy homes and coastal fortifications become more obscured by resurgent vegetation. Trails through Odiorne Point State Park allow visitors to see seven distinct habitats during an hour's walk; picnic tables entice them to linger as percussive waves and dancing sailboats provide free entertainment until the sun's colorful curtain call.

Within the 330-acre park, now the largest undeveloped tract of land on New Hampshire's petite coast, the Seacoast Science Center offers exhibits, hands-on activities, and public programs that encourage exploration of this natural classroom. The center's mission, guided by the U.S. Commission on Ocean Policy's "Ocean Blueprint for the 21st Century," is to foster "ocean literacy." President Wendy Lull says that while there's no quiz, visitors hopefully take away an important lesson: "The oceans and humans are inextricably interconnected."

"We've forgotten that we're part of the system," she says. "What we're doing here is re-creating that connection to nature. Once people understand what

the systems are, what the critters are, and how what they do is affecting them, then they can make a choice. To be an environmental steward," says Lull, "you don't have to abandon the things you enjoy in life; you just have to reassess them."

New England's Atlantic City

The number 1-800-Get-A-Tan doesn't ring on some Caribbean isle or in southern California where bronzed bodies are the norm. The toll-free exchange belongs to the Hampton Beach Village District, the organization that has worked since 1907 to enhance facilities, sponsor events, and promote Hampton Beach as New Hampshire's premier seaside playland.

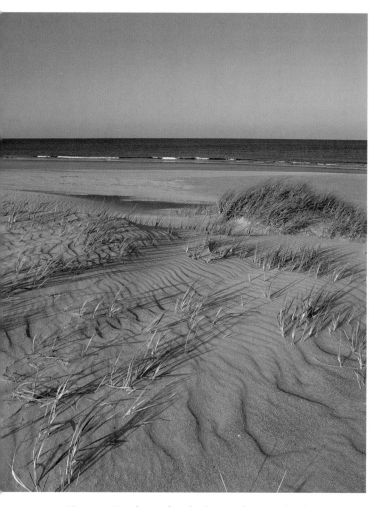

Hampton Beach is rather desolate on this May day, but once Memorial Day arrives, tranquility will be a distant memory.

The largest and most boisterous of New Hampshire's half-dozen public swimming beaches, Hampton Beach's record of entertaining summer sun seekers is uninterrupted since the 1840s, when the first hotels opened. With its boardwalk, amusements, restaurants, shops, outdoor concerts, annual festivals, weekly fireworks, and miles of soft white sand, it remains as alluring as it was at the dawn of the twentieth century, when the Hampton Beach Casino debuted and electric trolleys delivered masses of beachgoers.

By the 1920s, Hampton Beach was really jumping. "Bathing censors" kept a vigilant eye out for female bathers in scandalous suits, and the ballroom at the Casino—not a gambling establishment but a recreational emporium—was expanded to accommodate five thousand dancers, who came for the hot bands . . . and the air conditioning. Hampton Beach remained one of New England's top dance spots through the thirties and forties, when Glenn Miller, Tommy Dorsey, and other legendary bandleaders brought their Big Bands to town. In the sixties and seventies, the dance hall became a rock arena. Nationally known bands and comedians still take to the Hampton Beach Casino Ballroom stage each summer.

The Miss Hampton Beach Pageant has been an annual tradition since 1946, but even in the twenties, a queen was crowned during the season's September swan song: Carnival Week. The winner and her escort took off from the sand on a victory "aeroplane" ride.

Although there was no toll-free number to call in 1922, tourism literature from that year proclaimed Hampton Beach the "Atlantic City of New England." More than the destination's pageantry and frolic were extolled, though. "Sea bathing, as its devotees know, is a sport of endless possibilities, which never grow tiresome; a natural tonic, whose power never diminishes, or fails. Here it is at its height of power."

P. G. Lamson, who penned the pamphlet, was quite the marketer . . . and clairvoyant. Hampton Beach's natural features are the true key to its

Shine On

No two lighthouses are alike; mariners have long relied on each beacon's distinct architecture and signal pattern to confirm their position. "They're like people in a way," says Jay Hyland. "They're all different, so they're interesting. It's not like you've seen one and you've seen them all."

Hyland, founder and president of the Lighthouse Preservation Society, has become intimately acquainted with America's lights as he's traveled coast to coast, documenting these historic structures and working against time to ensure their legacy is not lost. In the early 1980s, a grant-funded initiative allowed Hyland, a freelance writer and photographer, to interview the last of the lighthouse keepers and assess the status of New England's coastal sentries. His conclusion: "Things were starting to look really bad for the lights."

Subjected to extreme atmospheric conditions and under the jurisdiction of the U.S. Coast Guard, an organization inexperienced in historic preservation, America's lighthouses were in precarious condition, and Hyland realized, "Somebody's got to do something about this, or we'll lose this heritage."

His call to action was widely heeded by lighthouse lovers, and the nonprofit he founded in the mid-1980s quickly established lighthouse preservation as an issue of national concern. Congressional lobbying efforts netted $3 million in federal matching grants for more than 160 lighthouse restoration projects

You could walk by the fifty-three-foot brick beacon on Newburyport's Water Street dozens of times without realizing what makes it unlike any other lighthouse in America: Its lantern room has been transformed into an intimate, private dining room.

and spurred passage of the National Lighthouse Preservation Act of 2000, establishing a procedure for conveying historic light stations to governmental and nonprofit entities capable of sustaining them.

Hyland, who lives in Dover, New Hampshire, says he frequently bumps into travelers who have based their itineraries around encounters with New England's lights. "New England is the most popular lighthouse region," he says. "Lighthouses are in America what castles are in Europe. They're places of great beauty. They're like exclamation points along the seacoast."

Sandwiched between the Newburyport Art Association and the Starboard Galley restaurant on Water Street, and partially obscured by unsightly utility lines, the red brick Newburyport Rear Range Light on Water Street in Newburyport, Massachusetts, doesn't appear at first glance to be a notable stop on the tour. But lighthouses, like people, can't always be judged on first impressions. Leased by the Lighthouse Preservation Society from its private owner, this deactivated 1873 beacon plays an important role in funding the organization's continuing efforts to shore up its brethren. The most romantic window table in all of New England—the site of many a marriage proposal—is nestled at the top of the tower, and although dining here requires a substantial donation to the Society (and a climb), it's booked almost every night.

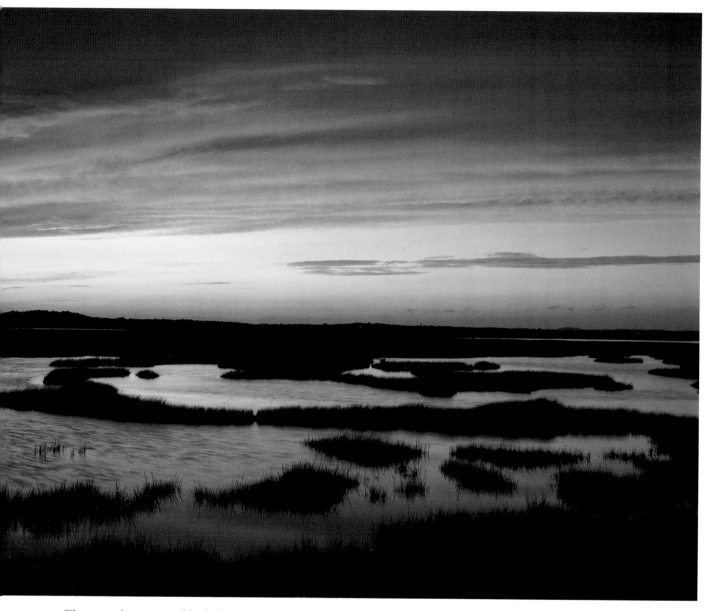

The sunset sky is mirrored by shallow marsh ponds, known as salt pannes, within the Parker River National Wildlife Refuge, which sprawls across the southern end of Plum Island and provides a critical habitat for migratory shorebirds.

enduring popularity, and summer's crowds still vanish once it's too cold to swim.

A Plum Address, A Place to Nest

To truly claim a piece of Plum Island's pristine beach, you have to be short and portly, with spindly legs, and a dark band encircling your neck . . . and feathers. The shoreline of this eleven-mile natural barrier island is public, even the stretch that runs in front of the island's exclusive and sole hotel—blue, The Inn on the Beach. From April through early July each year, however, sunbathers are banned from six miles of prime sand within the 4,662-acre Parker River National Wildlife Refuge, which occupies much of the southern three-fourths of the island. There are fewer than 1,800 pairs of piping plovers remaining on the Atlantic Coast, and when these threatened shorebirds come here to nest, their privacy takes precedence.

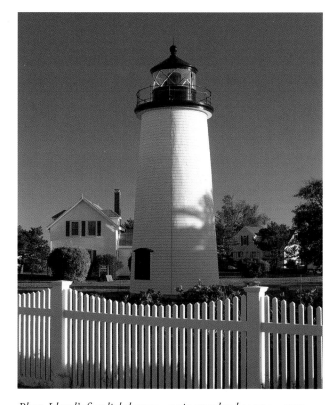

Plum Island's first lighthouses—twin wooden beacons—were erected in 1788 to mark the dangerous shifting sandbars at the mouth of the Merrimack River. The Newburyport Harbor Light at Plum Island's north end is their modern successor: This still-active aid to mariners dates to 1898.

The Refuge's diverse habitats—sandy dunes, fresh and saltwater marshes, bogs, thickets—are a haven for many coastal creatures. Recreational shellfishing is still permitted along the tidal mud flats, where the Pawtucket Indians once gathered clams. Like the rest of the three hundred winged species that alight within this birdwatcher's paradise at various times of the year, piping plovers are migratory. Most of Plum Island's residents, who inhabit the weathered cottages and grand seaside abodes clustered at the island's north end, remain year-round, though, unfazed by the storms that sometimes pummel this fragile sand strip. Longtime islander Barbara Hopkinton, who hunkered down during 2007's spring nor'easter, says, "For two days, the whole house was vibrating. It was flashing so much it woke me up. It was like a pinball game; it was incredible. I love watching the storms."

"People have been saying since I was a kid that the island was going to split in half," says Hopkinton, and yet this narrow isle named for its wild beach plum shrubs has endured for centuries. Sparsely populated before the late 1800s, Plum Island is separated from the mainland by the Parker River; the lighthouse at its northern end marks the treacherous mouth of the Merrimack River, where at least seventy ships have shattered. Connected by bridge to historic and cosmopolitan Newburyport, Plum Island was the place to find affordable housing in the 1950s when Hopkinton's parents bought a cottage. Now, even houses in need of a handyman fetch top dollar.

Without many tourist amenities, Plum Island remains largely a secret, even to New Englanders, and is often confused with the like-named island off New York's Long Island, the setting for Nelson DeMille's bestselling murder mystery, *Plum Island*. Day-trippers tend to park near the island's center, where the beach is easily accessible and the waves are tame. "The rest of the beach is not that crowded, even in the summer," says Hopkinton. "The residents think that's a good thing."

Although it is her job to attract visitors to Plum Island, Diane Beaudry, general manager of the relaxed island's chic hotel, cherishes her tranquil morning strolls around the property, when the sun sparkles off the ocean and there is rarely a soul in sight. "It's so peaceful," she says. "It's yours, and you can just breathe a little bit."

Massachusetts's Authentic Cape

Smaller and less famous than Cape Cod, the cape north of Boston—Cape Ann—is not terribly touristy. "Tourists come, and we give 'em a parking ticket," says Tom Ellis, and the captain of the schooner *Thomas E. Lannon* is only half joking.

Cape Ann's three towns do exude appeal for day-trippers. Essex, America's nineteenth-century shipbuilding capital where the *Lannon*, a forty-nine-passenger wooden fishing schooner, was crafted in 1997, has a shipbuilding museum and more than

Famous Clams

THEY'RE TENDER AND CRISP, delightful with a sprinkle of salt, a dousing of lemon, or unadorned. And they taste just the same as they have for nearly one hundred years. Ipswich clams, hand-harvested from the tidal flats of the Essex River, have always been uncommonly delicious. Essex native Lawrence "Chubby" Woodman washed these bountiful bivalves in evaporated milk, tossed them in corn flour, deep-fried them in lard, and made them famous.

Steve Woodman, vice president and one of more than fifty of Chubby's descendants on the payroll at Woodman's of Essex, says that while they've experimented over the years, they always return to the simple recipe his grandfather concocted when he invented the fried clam in 1916. According to Steve, Chubby began digging clams to "make some extra money." He began hawking additional items from his little clam stand, including homemade potato chips. In July of 1916, a friend suggested: "Why don't you take some of these clams and throw them in the frialator? If they taste half as good as your potato chips, people might want to buy them."

Chubby and his wife, Bessie, made a big sign—"Fried Essex Clams"—just in time for the Fourth of July. "That day, he took in thirty-five dollars; that was the most money they had taken in since they started," Steve says. "My grandfather was not a stupid man. He decided to keep them on the menu."

Although the menu at Woodman's has expanded over the years, Steve says that fried whole-belly clams, steamers, clam cakes, and clam chowder remain bestsellers. During a busy summer week, when the restaurant is "wall to wall people," they cook more than two hundred gallons of clams.

Fortunately, cold winters have been good for clam propagation. "Right now, there's a very good supply of clams," Steve says. "There's another generation of seed down there that the clammers are talking about." It's the nutrients in the water along the Essex River estuary, combined with soil that is more muddy than sandy, that make these clams "the best in the world."

For customers who return generation after generation, a visit to Woodman's is more than a meal. Shellfish lovers chat amiably as they anticipate the moment when an employee—likely a Woodman—will announce that their plate piled high with golden clams is ready for pick-up.

Woodman's only closes for Thanksgiving and Christmas, but every day is like a family reunion. "We have so many brothers, sisters, nephews, nieces, cousins that live in a five-mile range of each other," says Steve, whose own commute to the restaurant is just fifty paces across the parking lot from the home his grandfather once owned. He loves "seeing customers enjoying themselves," but he also cherishes the rare opportunity he's had to work with family. "I got to see my father every day," he says. "That is something you can't put a price tag on."

thirty antiques stores. Rockport's historic Bearskin Neck is lined with shops and galleries. Its wharf, which bustled with activity during the town's eighteenth-century granite-quarrying heyday, is home to the perpetually photographed and most-painted structure in America, the repeatedly weather-beaten and as often rebuilt red fishing shack known as Motif No. 1. The residential community of Manchester-by-the Sea welcomes visitors to its Singing Beach . . . if they can find a legal parking space.

But Gloucester, Cape Ann's sole city and home port for Ellis's two-masted sightseeing schooner,

clings to its heritage as a hardworking seaport, and its salty character is authentic, not a contrivance calculated to charm. "This is the oldest fishing port in America," Ellis says. Since 1623, when a party of Pilgrims from Plymouth in search of rich fishing waters settled on the shores of this safe harbor, Gloucester's fortunes have been inextricably tied to the sea. Gorton's, the nation's leading producer of packaged frozen seafood, is headquartered here. The high school football team is called the Fighting Fishermen. The Jodrey State Fish Pier is a sprawling complex covering nearly eight acres. Cape Pond Ice, a fixture since 1848, supplies the fleet with 350 tons of ice a day. And residents look forward to the annual St. Peter's Fiesta, a celebration of fishing's patron saint featuring an outdoor mass and blessing of the fleet that is as solemn as the Greasy Pole Contest is comical.

Fishing has been a blessing to many, but Gloucester's Fishermen's Memorial Statue, or "Man at the Wheel," inscribed to "They that go down to the sea in ships," is a reminder of the profession's inherent dangers. Sebastian Junger's 1997 novel, *The Perfect Storm: A True Story of Men Against the Sea*, and its 2000 movie adaptation poignantly depicted this reality while making legends of Gloucester landmarks like the Crow's Nest, a local bar.

For all of its rough edges, Gloucester has long captivated writers and artists. "Its natural beauty is as true as any place," says Captain Ellis, and his assertion is backed by the fact that Gloucester is also the site of America's oldest continually working art colony. It is in the colors and rituals of everyday life, in the juxtaposition of dilapidated marine industrial buildings against the pure blue of the harbor, in the luminous light and shimmering reflections of boats and bright sky, that artists have found inspiration since the 1840s, when Gloucester native and Hudson River School disciple Fitz Henry Lane committed coastal scenes to canvas.

The three dozen artist members of the Rocky Neck Art Colony, whose studios are clustered on a coveside spit of land, collaborate, compete, and challenge each other. John Nesta, who opened his

Between the mid-seventeenth and mid-twentieth centuries, Essex shipyards produced four thousand vessels, predominantly two-masted fishing schooners. At the Essex Shipbuilding Museum, visitors can learn about one of New England's most important maritime industries and observe shipwrights at work repairing wooden boats or crafting new vessels using traditional skills.

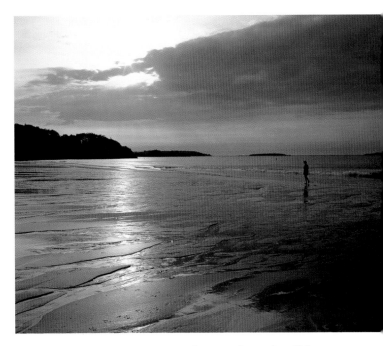

Manchester-by-the-Sea's Singing Beach is one of just a handful of "singing" beaches in the world. What makes the dry sand squeak or "sing" beneath shuffling bare feet? Scientists believe this natural phenomenon is a factor of the sand's silica content, humidity, and grain shape and size. Intriguingly, esteemed sand researcher Ralph Alger Bagnold concluded in the 1940s that when sand is removed from such a beach, it ceases to sing.

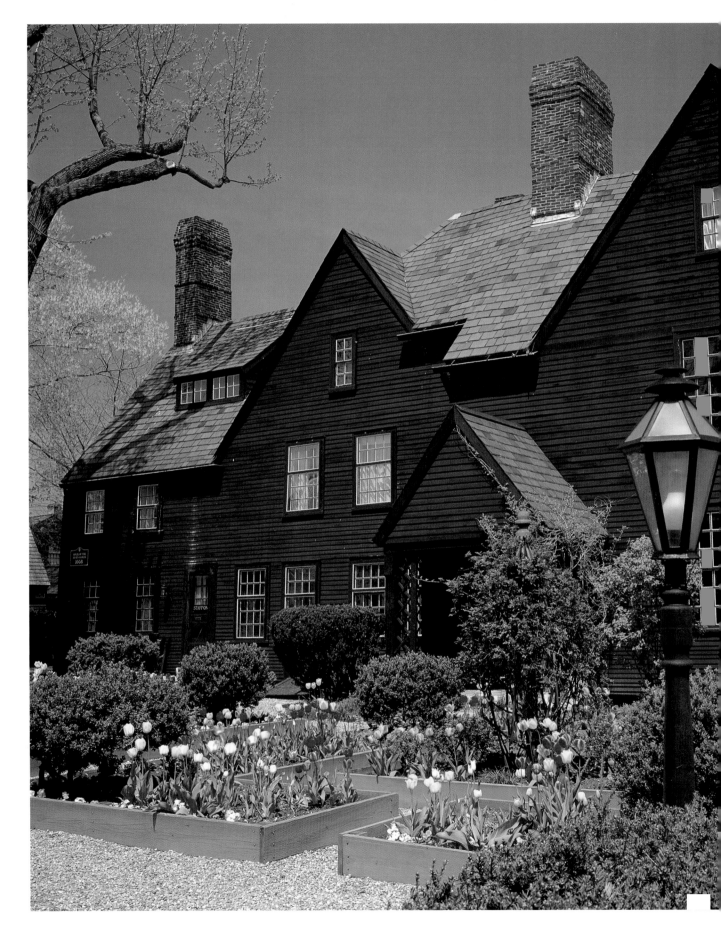

gallery in 1978, says, "That's what keeps the juices flowing; you thrive off each other. There is such a diversity of artists here. Everybody has a different way of looking at things." For Nesta, who paints outdoors even in snowstorms, Gloucester provides ever-changing scenes that he strives to capture honestly. "I lived all over the country, and I painted everywhere," he says, "and I always found that this was the place I really wanted to be."

Salem: Wicked Good Fun

Forget eye of newt and toe of frog. Popcorn is the magical ingredient that draws those who really know Salem back to this post-industrial city by the sea. Even Jack Welch, the former GE Chairman and Salem native who credits his success in part to the "scrappy" city's work ethic and competitive spirit, reportedly can't resist Hobbs's popcorn, a staple among the food stalls and amusements at the city-owned Salem Willows waterfront park since the 1880s. The fresh-popped kernels aren't remarkable at first nibble, but the rich, real-butter taste insidiously becomes an addiction.

Salem, likewise, grows on those who discover there's more to Witch City than its macabre history. Writer, lecturer, teacher, and tour guide Jim McAllister, a New Jerseyan who grew up vacationing on the North Shore with his family, began taking courses in Salem in 1972 and "never left." While the casual passer-through might only see defunct factories, an oceanfront eyesore of a power station, and touristy shops peddling potions, McAllister appreciates Salem's ages-old charm and its cultural vibrancy. "The architecture is beautiful; the downtown is increasingly beautiful," he says. "It's become a great restaurant town. Culturally, it's unreal; there are so many events."

Salem's Turner-Ingersoll Mansion was the inspiration for Nathaniel Hawthorne's novel The House of Seven Gables. *Now a museum that also showcases five other historic structures relocated to the harborfront site, including Hawthorne's birthplace, it is a must-visit stop for literature and architecture enthusiasts.*

Of course, Salem wasn't always a hospitable place, particularly for reclusive women with peculiar habits. In 1692, a largely inexplicable hysteria overtook rural Salem Village when young girls who suffered strange fits of screaming, unintelligible babbling, pain, and contortions named townspeople as the source of their afflictions. Hundreds of women and men were charged with witchcraft and jailed; twenty were executed; five died in prison.

Salem-born nineteenth-century author Nathaniel Hawthorne was famously haunted by his ancestor John Hathorne's role as interrogator of the accused

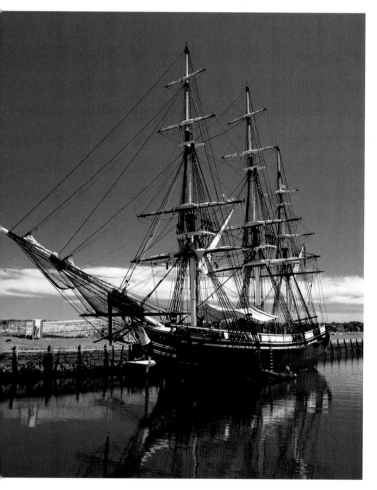

The Friendship of Salem *is docked at the historic wharves within the Salem Maritime National Historic Site, where it helps to tell the story of Salem's Golden Age of maritime trade. It is a replica of the three-masted, square-rigged merchant ship* Friendship, *which made fifteen international voyages between the time it was built in Salem in 1797 and its capture by the British during the War of 1812.*

witches. Tourists who follow Salem's Heritage Trail discover not only chilling sites like the Salem Witch Museum and Witch Dungeon Museum, but the world-class Peabody Essex Museum, with its collection of 2.4 million works of art from around the globe, and historic places tied to the city's rich but overlooked maritime and literary history, including the 1818 Custom House where Hawthorne opens his seminal novel, *The Scarlet Letter*, and the House of Seven Gables, the inspiration for another Hawthorne story and New England's oldest surviving wood mansion (it dates to 1668). Salem is also a haven for modern witches. Most, like Laurie Cabot, the "Official Witch of Salem" and proprietor of The Cat, The Crow, and The Crown at Pickering Wharf, are nature worshippers and celebrants of women's spirituality.

Salem is inarguably multifaceted, but when it comes to identity, McAllister concedes that it's witch lore that "makes us unique." Since 1983, his Derby Square Tours has offered candlelit walking excursions during October's Haunted Happenings. "Witches used to be adequate; now people need ghosts," says McAllister. His spine-tingling tales of murder, hauntings, and a schooner's phantom crew aren't the only things that transcend imagination. "My candle budget is out of this world," he says.

Marblehead Forever

Each North Shore community has a distinct character and charm, but only one has an official town anthem, a secret network of "public ways" (shortcuts across private property leading to the water), and even its own lingo, including a cussword turned greeting—"Whip!"—that is reserved for the declining number of residents who can truly call themselves Headers.

"This is what I love about Marblehead; it's so damn quirky," says historian Bette Hunt. Even though she was born in Marblehead and has lived in town for "seventy-five years and counting," Hunt readily relinquishes that she is not a Marbleheader. "Peaches, Dolibers, Goodwins: there are names in

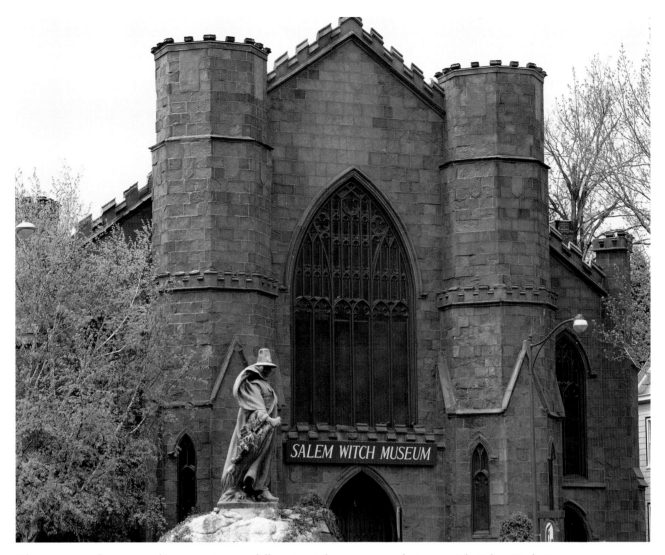

The most tragic chapter in its history continues to differentiate Salem as a tourist destination. The Salem Witch Museum, open year-round, is a good starting point for understanding the hysteria that gripped this Puritan settlement in 1692, although its presentation of events may be disturbing to young children.

town that have been here for a long time." Your family has to go back "three generations minimum before they even nod at you," she explains.

Founded in 1629 as a fishing port, ever-insular Marblehead remains mired in its past. Leaning and contorted colonial homes crowd streets that would seem narrow if they were one-way, and yet, they are two. Exquisite gardens flourish on tiny plots. Washington Street, the central thoroughfare, is reminiscent of Europe with its residences perched atop cafés and shops. The town's architectural riches are remarkably well preserved. Marblehead has more

than two hundred pre–Revolutionary War structures, the largest concentration in America, plus hundreds more homes built before 1830.

Time has been gentle to Marblehead in part because history has been harsh. By 1768, when ship owner and merchant Jeremiah Lee built his Georgian Colonial mansion, Marblehead was the second-largest town in Massachusetts and one of the wealthiest outposts in the colonies. But the Revolution took a terrible toll on the town's thriving maritime economy, as George Washington repeatedly called on Marblehead's seasoned and spirited sailors.

Just as the fishing industry began to rebound, the Great Gale of 1846 killed sixty-five Marblehead fishermen and destroyed half the fleet. Shoemaking emerged as a replacement enterprise, restoring some measure of prosperity until fires decimated factories in 1877 and 1888. The town's faltering fortunes were a disguised blessing, since many residents couldn't afford to replace or remodel their ancestral homes.

By the late nineteenth century, Marblehead Harbor was once again dotted with boats as summer vacationers flocked to harborfront hotels, built sprawling homes on the Neck, and established exclusive yacht clubs. Although it is no longer a seven-day event, Marblehead Race Week has endured since 1889, and kids too young to join Pleion, the nation's oldest junior yacht club, head to Redd's Pond every Sunday to race colorful model yachts.

Automobiles soon made the eighteen-mile commute south to Boston possible, but townspeople resisted a train connection for years. Hunt says the fear was: "You might go into town and see somebody you don't know."

With the median single-family home price now over half a million dollars, it's increasingly difficult for eighth- and ninth-generation descendents to remain on the granite shores their seafaring forebears mistook to be marble. "Marbleheaders are dying out," Hunt laments, but those who remain "know everything about the town. They love it so much, and it's been passed down through their families. Tradition is very strong in Marblehead."

"I like the old ways," she says, but change, she realizes, is inevitable. The cherished refrain of *Marblehead Forever* exhorts: "God bless the good old town. May she never shame her noble ancestry." But at the northern end of Marblehead Neck, Marblehead Light shines the eastern seaboard's only steady green light, an omnipresent reminder that it's safe to go confidently forward. After all, Hunt says, "If you don't, you break."

Right: Sailing is part of Marblehead's rich past and its glorious present.

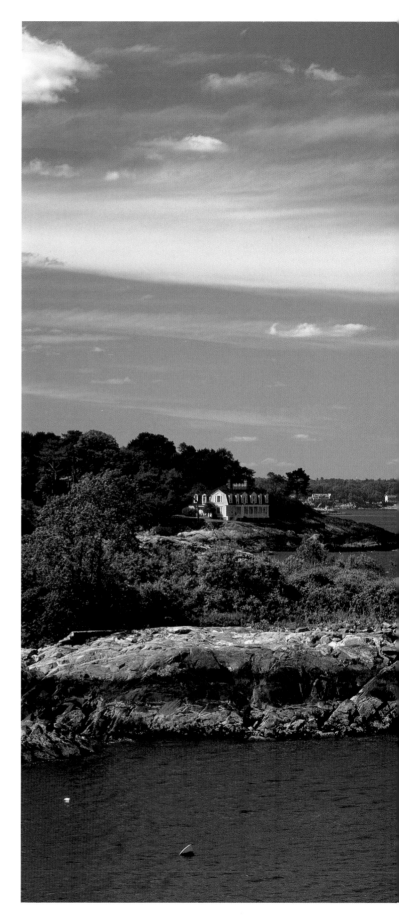

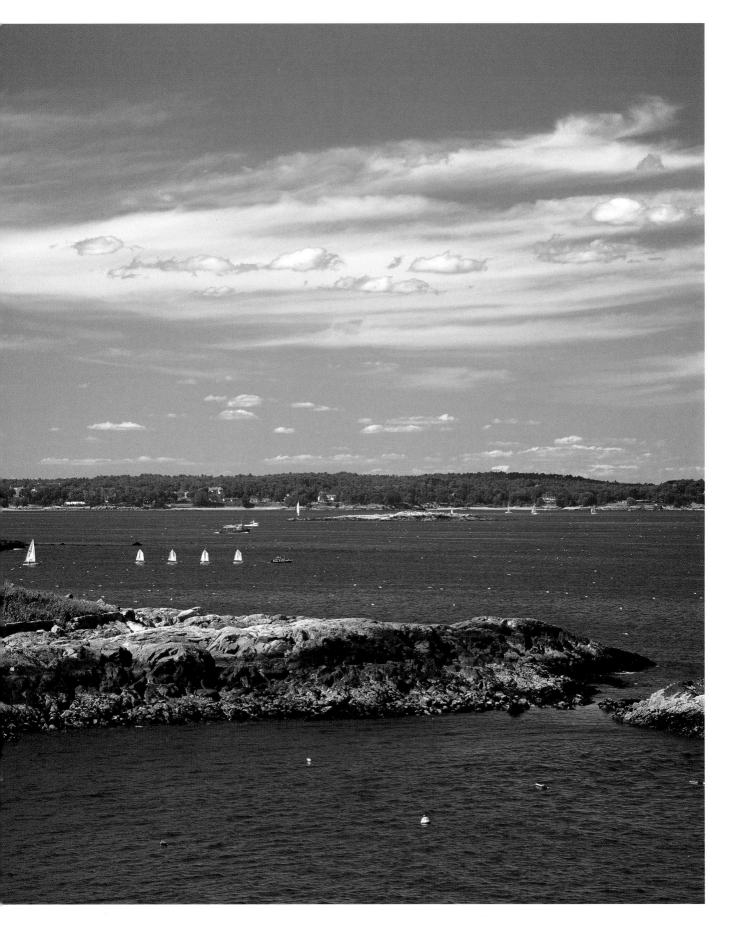

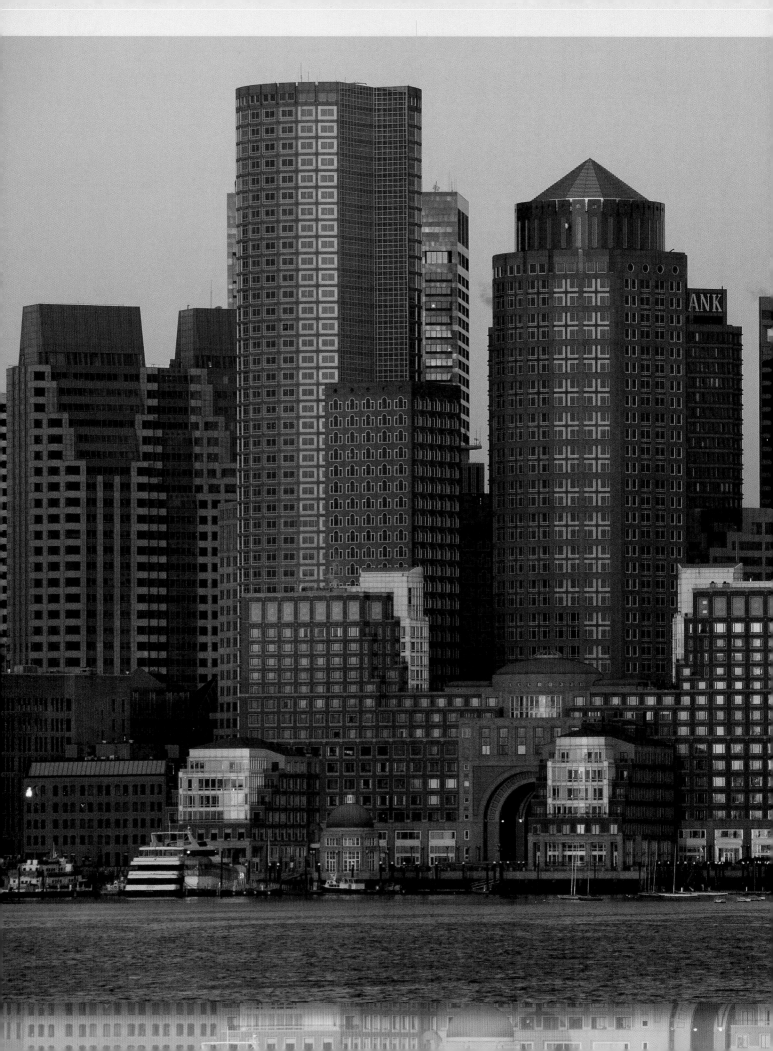

CHAPTER 4

Boston
& the
South Shore

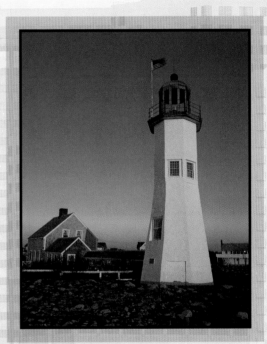

America's Iconic Coast

Above: The Scituate Lighthouse was rendered obsolete following construction of Minot's Ledge Light, which lies offshore to the north. Administered now by the Scituate Historical Society, it was relit in 1994 for the first time since 1860.

Left: The sun checks its reflection in the windowed buildings that flank Boston Harbor as it makes its daily ascent.

Mention the Pilgrims' feast, Bostonites' impassioned tea party, Revere's ride, or Captain Ahab's maniacal obsession, and most Americans instantly recognize these historical and literary allusions. From the "city upon a hill" to "the city that lit the world," the stretch of shore that runs southward from Boston to the Rhode Island line was the incubator of the nation's cultural identity. Events that transpired here—both documented and fictitious—are more than mere staples of classroom curricula. They inhabit the psyche of every American.

For residents of Massachusetts's capital city and its South Shore and South Coast, modern life

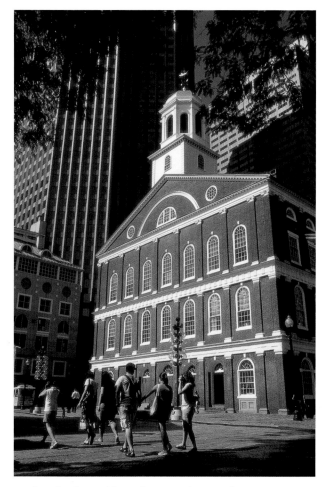

Within the thoroughly modern city of Boston, history is omnipresent. A walk along the two-and-a-half-mile Freedom Trail past landmarks such as Faneuil Hall, the town meeting hall where Samuel Adams and other eloquent Bostonians spoke in protest of British actions, is the best way to become quickly immersed in the city's legacy.

unfolds against the backdrop of these schoolbook scenes. The sea is no longer a direct source of income for most, and yet their genetic code is invariably imprinted with a longing for what lies offshore. It's perhaps a bit unnatural. As historian and professor William M. Fowler Jr. says, "We're really land creatures. The sea is a whole hostile world; it is so moody. Sometimes it looks benign, but that is a deception. It's not a stable environment. It's not a peaceful farm in the hills."

Nevertheless, the water beckons. Ishmael, the schoolteacher turned sailor who alone survived Ahab's doomed pursuit of the great white whale, expounded, "Whenever I find myself growing grim about the mouth; whenever it is a damp, drizzly November in my soul . . . then, I account it high time to get to sea as soon as I can. There is nothing surprising in this. If they but knew it, almost all men in their degree, some time or other, cherish very nearly the same feelings towards the ocean with me."

More than a century and a half after Herman Melville wrote *Moby Dick*, Fowler agrees. "There's something in us that drives us in that direction." Anyone immune to the sea's seduction is "a very dull person," he says.

"Wherever you go in New England, you'll wind up on the water," echoes Boston chef Marjorie Druker, who offers a gastronomic explanation for humans' coastal cravings. "Gorgeous seafood is always available," she says. "We're completely spoiled."

Boston : Coastal Capital

The Shawmut Peninsula, with its three thickly wooded, glacier-carved hills, must have seemed a prophetic settling spot to the English Puritans who sailed aboard eleven ships bound for the newly chartered Massachusetts Bay Colony. Before their departure in April of 1630, John Winthrop, the colony's first governor, had preached: "We shall be as a city upon a hill. The eyes of all people are upon us." Even before he bestowed the name of his hometown—Boston—on these eight hundred acres of prime real estate dangling from the mainland by a

narrow thread of land, he imbued the city with intense idealism and divine purpose.

Perhaps Boston's ascendance as New England's largest and most influential city was preordained. More likely, geography and geology propelled the city's rise to political, military, economic, and cultural prominence. As Dr. William M. Fowler Jr., Distinguished Professor of History at Northeastern University and author of many books on maritime and early American history, explains, "Geography was critically important; Boston does have a fine protected harbor." Once the new arrivals realized the region's rocky soil would not sustain them, "they had to turn to the sea to make a living; they didn't have a choice," Fowler says. "The Puritans who arrived here were hardly seafarers," but they were "men and women of vigor and intelligence," he adds. The combination of "an energetic people, a hospitable marine environment, and an inhospitable

Boston Duck Tours, which depart from the Museum of Science and the Prudential Center, offer views of Boston from land and water. ConDUCKtors regale passengers with humorous and historic anecdotes as they navigate these World War II–era amphibious craft along Boston's streets before driving them right into the Charles River.

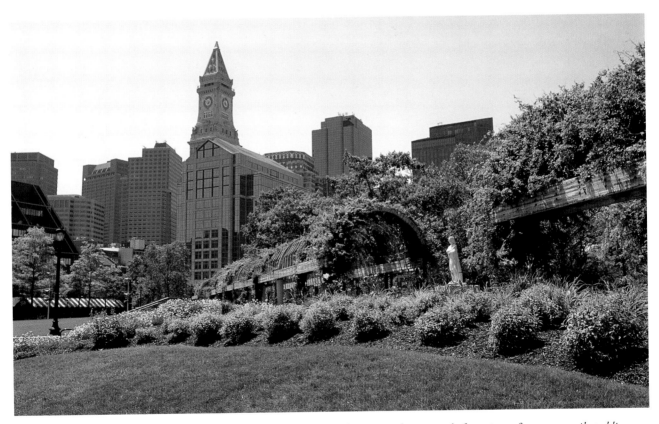

The Boston Harbor Association and Boston Redevelopment Authority have an ambitious goal of creating a forty-seven-mile public walkway along the city's harbor. Nearly thirty-eight miles of the HarborWalk are complete, including the stretch through the city's oldest harborside park, the North End's Christopher Columbus Waterfront Park, which reopened in 2003 following renovations.

75

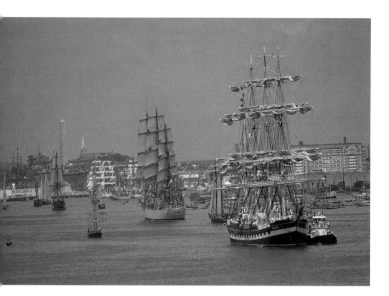

When Boston Harbor welcomes the world's tall-ship fleet, the Grand Parade of Sail is a spectacle to behold. The next Sail Boston event is slated for 2009, and the Sail Massachusetts Visiting Ship Program ensures that a few of these enchanting vessels visit Boston each year.

land" transformed this port city into one of colonial America's wealthiest commercial centers.

Reliance on the sea shaped Bostonians' personality. "One of the characteristics of a maritime community is their willingness to take risks," Fowler says. "If you go to sea, clearly you must be bold." From the Sons of Liberty to the twentieth-century founders of Fidelity and other money management firms, a propensity to venture and an inclination to trust in what lies over the horizon have shaped the city's course. Even an eighty-six-year World Series victory draught couldn't quell Red Sox fans' faith in their team's eventual exorcism of the Curse of the Bambino.

And yet, the fight to save Fenway Park, America's oldest Major League ballpark, from the wrecking ball is one of myriad signs of Boston's duality. Within this progressive, innovative, and thoroughly modern city, history is inescapable. For all of the change the city has undergone—even more than doubling in size through land reclamation in watery areas that once surrounded the Shawmut Peninsula—vestiges of the past are omnipresent. Paul Revere's humble home still stands on North

Square. Costumed guides in buckled shoes and tri-corner hats lead tours of the Freedom Trail. The Irish Famine Memorial honors one hundred thousand immigrants who crossed the sea in the 1840s, searching for new hope in the Commonwealth's capital. The USS *Constitution*, better known as "Old Ironsides," floats proudly at the Charlestown Navy Yard, as seaworthy as she was the day she launched in Boston Harbor in 1798.

While remaining mired in history "may freeze us," cautions Fowler, who served as director of the Massachusetts Historical Society from 1997 until 2005, it's undeniable that the city's historic treasures are a tourism goldmine. There are nearly six hundred thousand residents of Boston, but by some estimates, the number of people in the city is twice that on any given day, as commuters and many visitors augment the population. "They come here not for our climate," Fowler quips. "The authenticity of history is a very great engine in this community," he says. While he assures "it is not Disney World," Boston proves history can be entertaining, even though its Puritan founders would have frowned on such frivolity as shouting "Take that, Philadelphia!" from a World War II–era amphibious touring Duck Boat lumbering along the city's convoluted streets.

The waterfront remains key to the city's allure. "We spent $15 billion to put a highway underground so we can have better access to our harbor," says Fowler, referring to Boston's notorious "Big Dig" infrastructure project, completed in 2006. "There is something magical about the waterfront," he says. Walk along the water's edge, or better yet take a boat trip—even the inexpensive water taxi—for a better perspective. "Look back at the city, and see it from the sea," Fowler suggests, "and try to imagine how it looked in the seventeenth century."

When the professor sets out in his own boat, his mindset is the product of living the bulk of his life in this coastal capital, and it reflects, too, the youthful vitality that comes from interacting with some of the city's one hundred thousand college students. "Looking over the rail, I wonder what is beyond what I can see—what lands, what people," says

Steeped in History

BOSTON'S WATERFRONT WAS the scene of one of the most pivotal protests of all time. Debbie Swift collects textbooks from around the world that contain accounts of the Boston Tea Party. The story, she says, resonates universally: On the eve of December 16, 1773, angered by Parliament's implementation of the Tea Act and emboldened by a protest rally at the Old South Meeting House, members of the Sons of Liberty donned Native American disguises; boarded the East India Company's *Dartmouth*, *Beaver*, and *Eleanor*; and unloaded the British ships' cargo of ninety thousand pounds of tea into the sea.

Luckily, these patriots—whose defiant act sparked America's Revolution—didn't need a permit.

Swift, Historic Tours of America's project manager for the reconstruction of the Boston Tea Party Ships & Museum, explains that her company has been subject to a "very intense and multifaceted permitting process" since lightning sparked a fire at the attraction in 2001. In spite of the complexity of building a new facility on Boston's historic waterfront, her company believes "the story should be told." The event remains an enduring symbol of "the ability of American people to make a protest. It really touches everyone," she says.

When it reopens in 2009 with a trio of replica ships and a museum that's doubled in size, visitors will have an opportunity to relive history as costumed character guides recreate the fervor of 1773. "You actually rush the ships; you actually dump the tea," says Swift, explaining that the state-of-the-art attraction will offer many interactive learning opportunities. Before the fire, the Tea Party reenactment "was one of the top ten attractions in New England," Swift says, adding, "I think it will be again."

Fowler, who dreams of one day sailing the Arctic's icy waters. "There is a vast world out there that is mysterious." Plus, he emphasizes, "you've got this invisible, dark world underneath you. It's a place to feel very, very small."

An Urban Oasis

Boston doesn't immediately come to mind as a swimming, hiking, and camping destination, but without ever climbing into an automobile, city dwellers and visitors can dip their toes in saltwater, wander miles of trails, and even sleep under the stars at a national park (that's "pahk" in Boston, of course).

Congress granted national park status to the thirty-four Boston Harbor Islands, seventeen of which were already a state park, in 1996, but this collection of narrow isles dotting America's most historic harbor remains something of a secret. Like Boston's Beacon Hill and Bunker Hill, these islands, which lie within eleven miles of shore, are elongated mounds of glacial till, or "drumlins." Park Superintendent Bruce Jacobson explains that they constitute "the only drowned drumlin field in the continental United States." While the National Park Service does not hold title to any of these geologically unusual and historically significant islands, it plays the key dual role of protecting their natural beauty and promoting their public use. "We can easily double the number of visitors without harming resources," Jacobson says.

Why, then, aren't these offshore hilltops with their scenic landscapes, walking paths, beaches, lighthouses, and historic ruins overrun by tourists?

Three of the smaller Boston Harbor Islands, bathed in the rosy orange glow of sunrise, are visible from the Hingham Yacht Club at Crow Point in Hingham.

Tom Powers, president of Island Alliance, a non-profit fundraising organization that also coordinates island tours, transportation, and events, says Boston Harbor was horribly polluted in the 1980s, and "a joyful recreational experience in a smelly body of water was a hard sell." The sparkling waters that surround the islands are the relatively recent "dividend of an incredible environmental success story," he says. Since its creation in 1984, the Massachusetts Water Resource Authority has fulfilled its promise to clean up Boston Harbor. Now, the Island Alliance's main challenge is convincing Bostonians that "this is an extension of their backyard, rather than a place that's hard to get to," Powers says.

While public access to many of the islands is limited, seasonal ferries from Quincy and Boston's Long Wharf deposit passengers on Georges Island, which

This cedar trunk must have drifted for a long, long time before coming to rest at World's End, a peninsula within the Boston Harbor Islands National Park that affords views of the Boston skyline across Massachusetts Bay.

The Last Lighthouse Keeper

SHE HAS A house in Plymouth, a 4x4-foot cubicle at the Coast Guard base in Boston, and a tiny island where she performs a job held by no other American. Dr. Sally Snowman is the seventieth keeper of Boston Light, the last manned light station in the nation. During the busy summer visitation season, she'll often spend weeks at a time at her post, but "it's not a hardship for me," she says, "because I'm on the island. That place speaks to me."

A longtime lighthouse devotee, volunteer, and co-author of a 1999 Boston Light history book with Jay Thomson (a fellow Coast Guard Auxiliarist who she married beside the beacon in 1994), Snowman was intrigued by the 2003 posting for the job of Civilian Keeper of Boston Light. Without prior federal or state service, however, the educator considered her chances of landing the position slim. For the Coast Guard, which absorbed the United States Lighthouse Service in 1939, Boston Light, America's first lighthouse established on Little Brewster Island in 1716, is quite an anomaly. Concerned primarily with matters of homeland security, environmental protection, and search and rescue, the Coast Guard "has no other physical location like Boston Light," says Snowman. While automation rendered keepers' jobs obsolete, Congress mandated in 1989 that this historic light station remain actively staffed. Because she was already voluntarily coordinating the work of one hundred Auxiliarists who serve as Assistant Keepers and historical interpreters on Little Brewster Island, Snowman was actually a natural choice for this rare role.

The job has heightened her senses. "I can smell the fog coming in, and I can sense rain, even though rain is not predicted. I can just feel that there is a front coming in, and it comes," she says. Unable to evacuate ahead of the fast-approaching Blizzard of 2005, Snowman found

Like New York's most famous lighthouse, the Statue of Liberty, Boston Light was a welcome sight to thousands of immigrants.

getting caught in the nor'easter exhilarating. "I loved the howling of the wind and the vibration of the house. I don't fear nature; I just go with it," she says. At least one volunteer Auxiliarist is with her at all times, and each must be trained to recognize "the heartbeat of the island," she says. "The creaks and moans of the machinery" are often clues. "If something doesn't sound right, it's indicative of a possible problem," she explains.

Climbing the tower and walking the perimeter of the island, which is only an acre and a half at high tide, takes just fifteen minutes. That leaves Snowman, who is also an Earth Energy practitioner, time to pursue metaphysical studies. With the blend of the water's feminine energy and the sky's male potency, and a nine-foot "crystal" at the top of the tower sending out a two-million-candlepower beam, it's an ideal place for energy ceremonies that "send peace out to the universe," she says, adding that "Boston Harbor is a powerhouse of energetic potential," comparable to Sedona, Arizona. "When visitors come to the island," and more than four thousand do annually, "it is my intent that they can connect with that very special, magical, peaceful energy," Snowman says.

serves as the park's transportation hub. Ferry and tour boats and inter-island shuttles also offer access to Lovells, Spectacle, Peddocks, Grape, Little Brewster, and Bumpkin Islands. Deer and Nut Islands and World's End are drive-to destinations.

Each isle has a story. Native Americans feel special reverence for Deer Island, where many of their ancestors who were taken captive during King Philip's War perished during the winter of 1675–1676. Georges Island is home to the imposing remains of Fort Warren. Built starting in the 1830s as a critical component of Boston's defenses, the fort was most notably a Civil War military prison. Visitors to the beach and campground on Lovells Island can also explore the remains of military fortifications. Grape and Bumpkin Islands are peaceful, contemplative places. Little Brewster Island is the site of America's first lighthouse: Boston Light, first lit in 1716, was destroyed by the British during the Revolutionary War and reconstructed in 1783. Peddocks Island may one day be the islands' centerpiece; plans call for conversion of Fort Andrews's remnants to visitor facilities and development of a family eco-campground.

But no transformation will ever top Spectacle Island's. Used as a municipal landfill from the 1920s until 1959, it was sealed with 3.7 million cubic yards of dirt from Boston's "Big Dig" tunnel and highway project in the 1990s. Vegetation has reclaimed this debris heap, and while the dock and beach side of the isle affords some of the best views of the city's boxy skyline, Boston's fast pace and attitude seem very far away once you've hiked to Spectacle's far side . . . at least until a Logan-bound airplane whirrs overhead.

Scituate : Seaside Suburbia

Scituate's obscurity is surprising considering its proximity to New England's oldest town and its largest city; roughly twenty-five miles are all that separate this picturesque South Shore community from Plymouth and Boston. "It's not all that easy to get to Scituate; there's no direct connection to highways," offers David Ball, who began summering here in the

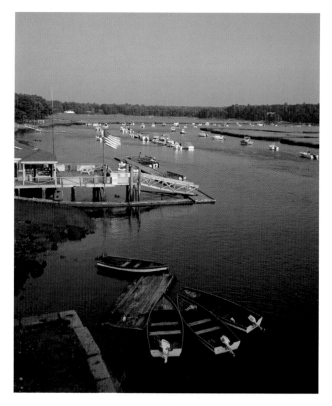

The red-white-and-blue open skiffs docked outside Mary's Boat Livery in Marshfield aren't just for show: They're for rent. From here, the bass-filled waters of the North and South Rivers and First Herring Brook await.

1960s. When he married his wife, it was a "no-brainer decision" to make Scituate their year-round home, says Ball, the Scituate Historical Society's president for more than a decade.

"It's one of the oldest towns in the country, settled in the late 1620s" as Plymouth residents migrated north, Ball notes. For more than two centuries, however, Scituate's farmers and fishermen remained utterly unaware of the town's true riches.

Growing abundantly on the same offshore boulders that made Scituate the scene of many a shipwreck is a species of red algae found nowhere else in New England. Like many of his brethren who fled famine in the 1840s, Irishman Daniel Ward failed to find work in Boston. "He somehow managed to get a boat," says Ball, and as Ward fished along the South Shore, "he noticed that the same type of seaweed that grew in Ireland was growing off the coast here. It probably surprised him."

Irish Moss, a source of carrageen used in beer brewing and pharmaceutical and food products, soon became a major Scituate export. Photos at the Maritime & Irish Mossing Museum show Scituate's sandy beaches splayed with a patchwork of drying and bleaching seaweed in shades of crimson, lavender, pale brown, pink, and cream. "Within twenty years, there were many Irish families in town; whole families became involved in the harvesting," Ball says.

Although the mossing industry capitulated to global competition in 1997, the town some call the Irish Riviera still has an impressive St. Patrick's Day parade. And although Scituate has only two inns, its population still doubles each summer as seasonal residents, renters, and day visitors capitulate to its charms.

The accessibility and scenic setting of the 1811 Scituate Light—not to mention its stature as the oldest complete lighthouse and keeper's quarters in America—make it a must-see. When Keeper Simeon Bates left his two young daughters to tend the lighthouse one day during the War of 1812, Rebecca and Abigail ingeniously fended off a British warship by playing the fife and drum loudly enough to convince the enemy a militia was approaching. The sisters swore by their story throughout long lifetimes.

Offshore, Scituate's equally fascinating but inaccessible Minot's Ledge Light guards treacherous,

New England's Soul Food

YOU'RE AS LIKELY to find New Englanders eating chowder on the steamiest day in July as on a raw, windy November afternoon. "Chowder is New England's soul food; it's extremely nourishing and comforting," says Marjorie Druker, chef/co-owner of the Boston-area New England Soup Factory restaurants, where chowder is on the menu "every single day."

Chowder, from the French *chaudière*, a term that refers to the stout crock in which the soup is simmered, is not a New England invention, but Yankee frugality and ingenuity have made it the region's signature dish. Potatoes, not clams or fish, are chowder's critical ingredient, explains Druker. "If you have potatoes and you have stock, you can make chowder."

New England's first settlers cooked chowder with whatever staples were on hand. Today, visitors to Boston could "eat chowder at eight different restaurants, and not one of them would be alike," Druker says.

New England Soup Factory patrons are especially wild about a corn chowder made with crispy bacon, cheddar, and scallions; the sweet potato corn chowder is "so magnificent that we offer it at Thanksgiving; people buy it by the gallon," Druker says. Even in pumpkin and shrimp chowder, featured in her *New England Soup Factory Cookbook*, "you will still find potatoes," she notes.

There is just one chowder variety that members of Red Sox Nation avoid. "It's immature," Druker complains, "because Manhattan clam chowder is delicious," as well as less fattening. The solution? "We'll call it Rhode Island Red Chowder or Sicilian Clam Soup . . . and it sells."

For the uninitiated, Druker assures: "There's no wrong or right way" to consume chowder. "You should eat food the way that you enjoy it the most," she believes. "If that means scooping it up with bread, that's the way you should eat it. You can really inhale chowder."

At the New England Soup Factory, "We try to take the classic idea of chowder to new levels; there is such depth, intensity, emotion in our products," Druker says. When is a soup done to perfection? "When you take a bite, and you think you're going to faint."

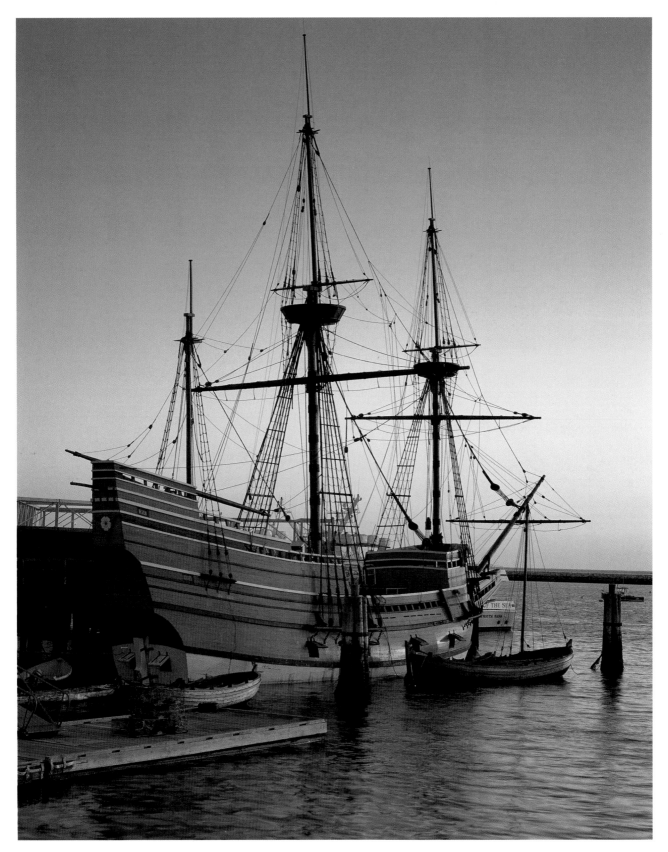

Built in England by skilled shipwrights, Mayflower II, *a full-scale replica of the Pilgrims' celebrated ship, was sailed across the Atlantic to her permanent home in Plymouth in 1957. On board, visitors get a feel for the cramped quarters these freedom-seekers shared during their stormy sea crossing.*

sea-camouflaged rocks. Vulnerable to the ocean's constant tumult, the lighthouse was an unwelcome assignment for keepers: The first quit; two perished with the beacon in an 1851 storm. Even the sturdier 1860 replacement light was an unpleasant post until it was automated in 1947. Its 1-4-3 flash pattern has been interpreted to signal: "I Love You."

Scituate's legends are much-loved, but its residents realize history will write new chapters for the suburban town. The reestablishment in 2007 of MBTA rail service along the Greenbush Line, abandoned since 1959, threatens Scituate's isolation, but Ball reveals: "Most people are looking forward to its return."

America's Hometown

They were families with children, English urbanites with few wilderness living skills, who accidentally arrived on New England's shores after sixty-six stormy, queasy days at sea . . . just in time to face the harshest of the region's seasons. Only half of the 102 religious dissidents, who crossed the Atlantic not for material gain but to establish a permanent community where their ideals might thrive, survived to see a New England spring. By the fall of 1621, their peaceful relations with the native Wampanoags cemented and their first crops successfully harvested,

Designed by the same acclaimed architectural firm that created the Boston Public Library and New York City's Metropolitan Museum of Art, the neoclassical revival–style portico that houses Plymouth Rock is much more visually impressive than what lies within.

the Pilgrims did something rather predictable: They feasted for three days with their new friends.

"Prayer and thanking God for what you have in front of you was so much a part of their lives," explains Plimoth Plantation research manager Carolyn Travers. Expressing gratitude for the Creator's gifts was also integral to Wampanoag culture. What is more remarkable is that this celebration of New England's abundance is re-created each November in almost every American home.

Nearly four centuries after the first Thanksgiving, few Americans participate directly in the harvest, and yet the desire to gather with family and friends, to dine heartily, and to count blessings remains strong. According to Butterball, 97 percent of Americans eat turkey on Thanksgiving. Historians know from Pilgrim leader William Bradford's writings that "there was great store of wild turkeys, of which they took many," and most agree turkey was likely on the original Thanksgiving menu.

The holiday wasn't always linked to 1621's secular harvest celebration, though. Nineteenth-century historians, many of whom were New Englanders,

Plimoth Plantation is frozen in 1627; its costumed staff members candidly discuss life in Plymouth Colony from the Pilgrims' point of view.

Massasoit and his people thought "they might make good friends," Travers speculates.

The attraction's mission is to debunk stereotypes and to inspire visitors—especially adults—to take another look at history. Working without a script, Plimoth Plantation's highly trained staff members portray Plymouth's residents, even speaking in seventeenth-century dialects. Really quiz them, and you'll begin to see colonial America through their eyes and to "understand more about their relationships with each other and how they tried to create a life for themselves," Travers says. "It was a different way of looking at the world," she explains. "They're not just us in funny clothes."

Buzzards Bay: The South Coast

The village of Buzzards Bay could be the setting for an East Coast version of the Disney/Pixar animated film *Cars*. Like the fictional Route 66 town of

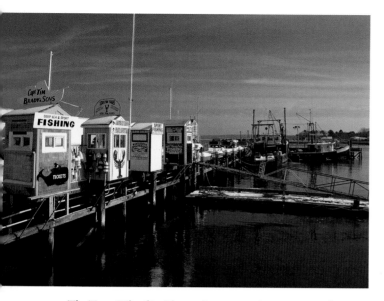

The Town Wharf in Plymouth quiets in the wintertime, but in summer, it is a hub of activity and a departure point for sightseeing cruises, whale-watch tours, and sport-fishing excursions.

helped to embed the Pilgrim story in Americans' collective consciousness and to give the Pilgrims "a great image," Travers says. It's little surprise that Plymouth, which was a center for maritime trades like ropemaking in the nineteenth century, now counts tourism as its chief industry. Even first-time visitors to the coastal town feel a sense of familiarity as they spy the *Mayflower II*, a meticulously crafted reproduction of the Pilgrims' ship, anchored in the town's sheltered harbor, or stand near the country's oldest continuously operating museum, Pilgrim Hall, on the rise of land the intrepid Pilgrims chose as their new home.

Just a short drive from the historic waterfront, Plimoth Plantation immerses visitors in the lives of the Pilgrims and their native neighbors circa 1627. Travers, who grew up in Plymouth and first worked at Plimoth Plantation as a teen tending sheep and pigs, laments that we all learn a "vastly oversimplified version of history" in school. "You're flying through history; you lose whole substories," she says. For example, the natives' interest in befriending the Pilgrims may not have been entirely altruistic. The Wampanoags had been decimated by disease; their adversaries, the Narragansetts, were much stronger. When the Englishmen arrived with guns,

The Pilgrims named them "craneberries" because their pink spring blossoms resemble the head of a sandhill crane, but Native Americans had long harvested these tart "red pearls," one of only three commercially cultivated fruits native to North America. There are 14,000 acres of cranberry bogs in southeastern Massachusetts: 5,500 people are employed in growing and harvesting the state's top crop.

Plymouth Rock: Larger Than Life

MASSACHUSETTS'S smallest state park is also its most visited. That's because Pilgrim Memorial State Park in Plymouth is home to America's most iconic rock—or at least what's left of it.

For the nearly one million visitors each year who include a stop at Plymouth Rock on their New England itineraries, the hunk of granite upon which the Pilgrims allegedly first alighted seems hugely significant. Until they step inside the stately harbor-front portico, designed in 1921 by the famed New York City architectural firm of McKim, Mead & White, and peer over the iron rails, most don't realize they've journeyed to see a stone that can only be described as puny; the visible portion is just six feet or so in diameter, and it is badly scarred to boot.

Without the intervention in 1741 of Plymouth-born nonagenarian Thomas Faunce, the venerable stone, which was originally many times larger, would have been buried beneath a wharf. Although undocumented, the feeble Faunce insisted he recalled original settlers' tales of coming ashore upon the immense beach boulder. Townspeople believed him. But starting in 1774, when only the top half of Plymouth Rock was relocated to the town square to stir patriotic fervor, efforts to showcase and promote the storied stone contributed to its destruction. By 1834, souvenir-seekers had chiseled away so many chunks that the rock was moved to Pilgrim Hall for protection. As it was transported with much fanfare, however, it was dropped and cracked vertically. In 1867, a canopy constructed to house the portion of

Its dimensions may have diminished over time, but Plymouth Rock remains boulder-sized in significance.

the rock that remained at the waterfront proved too small, so pieces were hacked off and sold. In 1880, the top was reunited with its base, and the date of the Pilgrims' arrival—1620—was cut into the rock. When Plymouth Rock made its final voyage to its magnificent columned "cage," it broke apart again.

As mangled and mortared as it may be, Plymouth Rock remains wholly inspiring. In 1835, Alexis de Tocqueville wrote: "Here is a stone which the feet of a few outcasts pressed for an instant, and this stone becomes famous; it is treasured by a great nation." Like the Pilgrims, this glacial boulder was propelled by nature's forces to Plymouth's shores, where it still stands testament to their courage and vision. Its symbolism strikes a chord with onlookers from around the globe, for this is no mere rock, but an enduring monument to human strength, faith, and longing for freedom.

Radiator Springs, bypassed when Interstate 40 opened, Buzzards Bay was a traffic-clogged Cape Cod on-ramp until Route 3 was completed in the mid-1950s. "You had to go through us to get anywhere," says Buzzards Bay Village Association

Chairman Jeff Luce, who's rechristened the business organization the "Vitalization Association." Luce remembers a time when every teen in town was employed by at least one of Main Street's five gas stations; their

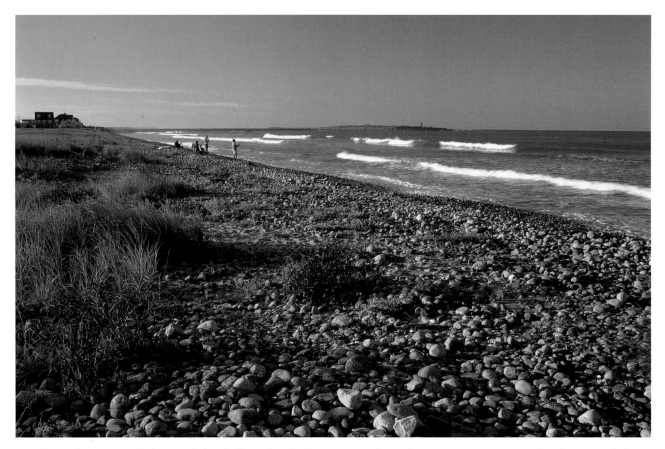

Best known for its two-mile-long sandy beach, the six-hundred-acre Horseneck Beach State Reservation, situated at the west end of Buzzards Bay, is also a popular destination for birdwatching and surf fishing.

earnings bought loads of burgers and ice cream at Betty Ann's Dairy Freeze, one of the thoroughfare's few surviving businesses from the fifties. Buzzards Bay, with its distinctive 1935 vertical lift railroad bridge, "was a great place to grow up," Luce says. "You had the beaches; you had fishing; you had boating. We were free to roam about." Retail and residential development is key to Main Street's renewed vitality, he believes.

Situated at the acute angle of the V-shaped, thirty-mile-long body of water that shares its name, and disconnected from some of its sister villages in the town of Bourne by the Cape Cod Canal, Buzzards Bay isn't the only southeastern Massachusetts place that's seen its fortunes shift. English colonists from Plymouth settled the South Coast in the mid-1600s. The coastal lands surrounding broad, sheltered Buzzards Bay, bounded by Cape Cod to the east and the Elizabeth Islands to the south, proved fertile for farming.

The Buzzards Bay watershed remains home to the majority of Massachusetts's cranberry bogs, but after a run-up in prices for the "red pearls"—the state's top agricultural product—during the 1990s, declining crop values have left some independent growers struggling.

New Bedford, the largest and most notable city on Buzzards Bay, saw the region's most dramatic rise to prominence and its most cataclysmic economic change. By 1841, when twenty-one-year-old Herman Melville embarked from Fairhaven, sailing past New Bedford's deep harbor on a voyage that would inspire an American literary masterpiece, the city was one of the nation's wealthiest, thanks to its domination of the whaling industry. "Nowhere in America," Melville penned in *Moby Dick*, "will you find more patrician-like houses, parks and gardens more opulent, than in New Bedford . . . ; all these brave houses and flowery gardens came from the Atlantic, Pacific, and Indian

oceans. One and all, they were harpooned and dragged up hither from the bottom of the sea."

Quaker whaling merchants' tolerance and abolitionist stance made this boomtown a haven for fugitive slaves, freed African-Americans, and West Indian and Portuguese immigrants. The diverse and cosmopolitan city was forced, however, to turn to alternate enterprises, including glass-making and textiles, as the world's whale population became depleted and cheaper petroleum rendered whale oil obsolete. By 1925, the "city that lit the world," once home port for five hundred whaling ships, sent its final vessel forth on this risky, but lucrative, big game chase.

And yet, the working waterfront remains at the heart of the city's economy. A much smaller catch—

The remnants of the ramparts at Fort Phoenix State Reservation in Fairhaven overlook the entrance to New Bedford Harbor.

scallops—has made New Bedford the nation's highest-revenue-producing fishing port in the first decade of the twenty-first century. Efforts to dredge up tourism business have been successful, too. The warped brick streets that Melville once strode and landmarks he visited—such as the Seamen's Bethel—are encompassed within the thirteen-block New Bedford Whaling National Historical Park, created by Congress in 1996. The New Bedford Whaling Museum, the largest institution devoted to America's whaling industry, depicts the city's heyday vividly through extensive collections and interactive exhibits. Dozens of Portuguese restaurants ladle up kale soup, and Old World bakeries entice epicures with handcrafted sweet breads. Just fifteen miles from the city, the two-mile spread of sand at Horseneck Beach State Reservation in Westport rivals any Cape Cod beach, although it is known mostly to locals.

The Cape's well-honed reputation casts a formidable shadow over the South Coast; most motorists speed Cape-ward on interstates. But anyone who has given the seven hundred or so pages of *Moby Dick* even a cursory read knows the dangers inherent in a single-minded quest. And *Cars* taught even young movie viewers the value of drifting off course and forgetting about making great time.

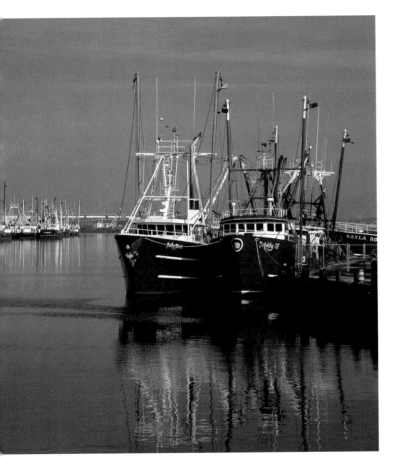

New Bedford's harbor is crowded with fishing boats and scallop draggers, evidence of the old whaling city's resurgence as a commercial fishery. According to the National Oceanic and Atmospheric Administration (NOAA), New Bedford's 2006 catch was worth $281.2 million, the highest value of any fishing port in the nation.

Cape Cod

An Artist's Dream Come True

Above: These Falmouth homeowners aren't the only Cape Codders who feel as if they own a piece of Shangri-La, the fabled land of perpetual happiness.

Left: Cape Cod's forty-mile Outer Beach, including this secluded expanse in Truro, is encompassed within the National Seashore and forever protected from development. "A man can stand there," wrote Henry David Thoreau in Cape Cod, published in 1865, "and put all America behind him."

Cape Cod's earliest European settlers made their living from the land. "They were pretty much afraid of the sea for most of the seventeenth century," says Mark Wilkins, director/curator of the Cape Cod Maritime Museum. "Who doesn't look to the sea with a bit of trepidation and fear?"

Rick Gurnon, president of the Massachusetts Maritime Academy, might actually have a response for Wilkins's rhetorical question. For the Academy's young men and women, the sea represents opportunity unfathomable to most undergrads—let alone eighteenth-century sailors and fishermen. The nation's oldest maritime college transforms wet-behind-the-ears adolescents into seaworthy and seasoned leaders whose skills in marine trades like engineering, environmental safety, international maritime commerce, and emergency management garner most graduates starting-salary offers in excess of seventy-five thousand dollars.

From his office overlooking the Cape Cod Canal, "the Admiral," as Gurnon is known around Buzzards Bay, explains that cadets learn from their required Sea Term aboard the *Enterprise* that "operating a ship at sea is dangerous, difficult work" that requires

Functional and Beautiful: The Cape Cod Canal

PILGRIM MILITARY commander Myles Standish suggested as early as 1623 that a canal across the one-mile isthmus connecting Cape Cod to mainland Massachusetts would be a boon to commerce. Plymouth's colonists had to settle, however, for establishing a trading post along this Native portage route. At George Washington's behest, Continental Army Engineer Thomas Machin surveyed the site in 1776 and confirmed its suitability for a canal, but throughout the 1800s, the complexity of the project proved daunting, even as ships smashed as frequently as every other week on the Outer Cape's treacherous, fog-shrouded shoals.

Financier August Belmont Jr.'s wealth and political clout, coupled with William Barclay Parsons's engineering prowess and the labor of hundreds, finally accomplished the inevitable: The Cape Cod Canal opened on July 29, 1914, winning a race with the Panama Canal by seventeen days. The new waterway cut the trip from Boston to New York by 135 miles on average, but the slender channel, with its swift currents and sharp turns, was still dangerous to navigate. When the federal government acquired the canal in 1928, it charged the Army Corps of Engineers with deepening, widening, and perfecting its course.

Improvements dramatically increased vessel traffic; as many as twenty thousand commercial and pleasure boats transit the two-way, toll-free canal each year. Cargos range from gypsum and petroleum to fish and cars. Surprisingly, nearly 3.5 million people are drawn to the Cape Cod Canal's banks annually to picnic, camp, fish, and run, walk, bike, or skate along miles of Corps-maintained service roads.

Park Ranger Samantha Mirabella, who oversees the Cape Cod Canal Visitor Center in Sandwich, explains that while the Corps' "main mission is to ensure safe navigation," its secondary goal is to provide free recreational access to its 1,100 waterside acres. The canal, she says, is not only a "beautifully engineered project" that provides insight into global commerce, "its natural beauty is fantastic." Although container ships are more commonly sighted along this shortcut between Cape Cod and Buzzards Bays, Mirabella has watched Atlantic white-sided dolphins and even a whale travel the canal. "Anything that's out there can come in," she says. "As long as it can fit, it's coming in."

planning, cooperation, and trust. "They realize how dependent you are on others in the team," he says.

It's a lesson the sea has been teaching Cape Codders since residents of the sixty-five-mile-long peninsula first ventured beyond their safe harbors. The Cape is composed of fifteen towns, each with unique beauty and rich history, but in times of need, "the whole Cape rallies," says Chatham selectman Dougie Bohman. When a baby in Dennis was diagnosed with a rare leukemia, for example, "people from all over the Cape went in to see if they were a match for a bone marrow transplant; they ended up with two thousand potential donors," she says.

For seasonal homeowners and vacationers—who inch their way across the Bourne and Sagamore Bridges on summer Fridays—the Cape is a tonic for their hectic, high-tech lives. There's no denying that their presence affects the Cape's character, but most newcomers quickly embrace the historically hard-working haven's unpretentious and laidback ways. "The Cape's gotten very sophisticated . . . in a very Cape Cod way," comments hotel and restaurant owner Deb Catania.

Even at the height of the season, "there are still a lot of places for a quiet walk in the woods or along the beach," assures kayaking guide Bob Wilds. And by November, you can meander along the shore for miles and not see a soul. The Outer Cape, forever shielded within the boundaries of the Cape Cod National Seashore, has pristine qualities that are remarkable considering its suburban location. The Cape has "become a little city," says Wilds, "but it is still one of the prettiest places on the planet."

The Cape's First Town

The "Ten Men from Saugus" who settled Cape Cod's oldest town in 1637 made no bones about their dual ambitions: "to worship God and to make money." Without a deepwater harbor, however, Sandwich remained a sleepy, agrarian community through the eighteenth century. The restored Dexter Grist Mill on Shawme Pond—a town center fixture since the mid-seventeenth century—still operates

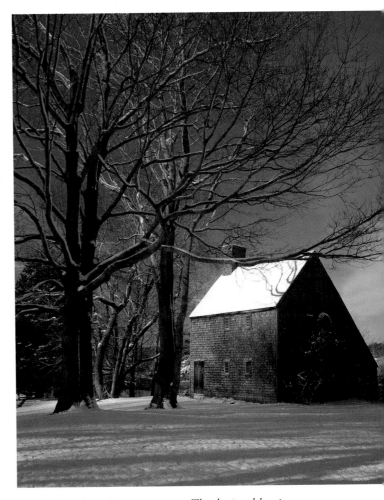

Hoxie House has seen many winters. The classic saltbox in Sandwich, built circa 1675, is one of the Cape's oldest houses. Restored and open seasonally for tours, it was originally the home of Sandwich's minister, his wife, and their thirteen children.

seasonally, grinding corn into meal that is sold by the bag. Across Main Street, the Sandwich Glass Museum, with its collection of five thousand sparkling, color-infused pieces, commemorates the town's transformation into an industrial center in 1825, when Deming Jarves founded the Boston and Sandwich Glass Company. Jarves's factory employed five hundred artisans, whose free-blown, intricately hand-cut, and lacey pressed-glass creations are coveted by collectors.

As quickly as it achieved global renown, Sandwich became a ghost town when the glassworks closed in 1888. Even sand—a key glass-making ingredient—had to be imported by the Cape company because

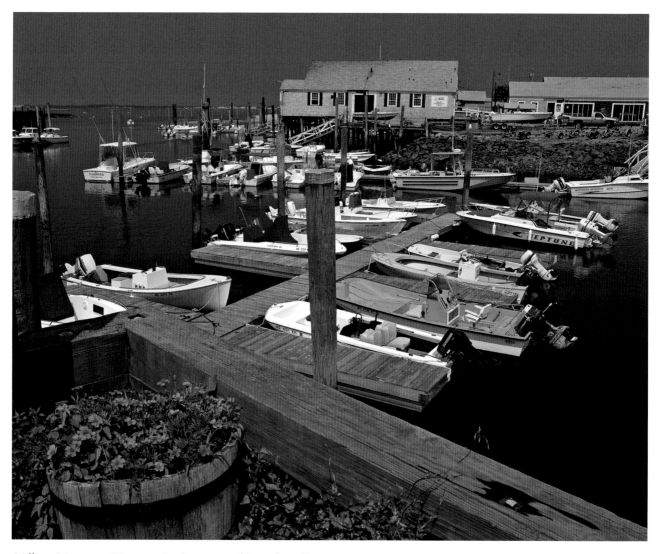

Millway Marina on Maraspin Creek in Barnstable Harbor sells, services, and stores recreational vessels. It is one of about three dozen marina businesses on Cape Cod.

local granules were too coarse. As railroad shipping gave Midwestern companies with access to cheaper raw materials entree to eastern markets, the competition proved lethal. Within a few decades, however, vessel traffic on the Cape Cod Canal and automobile traffic on the Old King's Highway would allow Sandwich to incarnate anew as a tourism destination.

The Dan'l Webster Inn occupies a Main Street site where lodgers have stayed since colonial days. The Fessenden Tavern, which served as a Revolutionary War–era patriot headquarters, was renamed in 1915 for the Boston lawyer, orator, and statesman who had a standing reservation from 1815 to 1851. Rebuilt

following a 1971 fire, the property was acquired by the Catania family at a 1980 foreclosure sale. "My father fell in love with the Dan'l Webster Inn," says Deb Catania; the restaurateur and history buff "was the only one who bid for it." She and her five brothers were immediately pressed into service. "We were kids running this place," she says. Catania Hospitality Group, which she co-owns and manages with two brothers, has since expanded to include lodging properties in Hyannis and Plymouth and seven Hearth 'n Kettle restaurants.

Initially attracted to its "small town feeling," Catania still makes Sandwich her home. Although

the year-round population has grown, primarily because of Sandwich's proximity to Boston, "it still has a nice community feel," she says. When 1991's Hurricane Bob destroyed the Sandwich Boardwalk, which slopes gracefully over Mill Creek and lush marshlands as it stretches toward Town Neck Beach on Cape Cod Bay, the town had no trouble finding sponsors for the walkway's 1,700 wooden planks, which are individually engraved with an enchanting succession of donors' sentiments.

Catania says, "I like the hotel business," but she admits the seasonality of tourism on Cape Cod presents challenges. "If we were in Boston, we'd be rich," she tells her brothers, but perhaps Sandwich's founders erred in their stated priorities. Cape business owners are more friendly than cutthroat. And in spite of development, the Cape has retained "its beautiful naturalness; it still takes my breath away," Catania says. Each spring, after being "locked up all winter in big sweaters," she'll call a girlfriend and they'll cruise historic Route 6A, stopping "where we feel like it." In the fall, she'll repeat the trip as cranberries surface atop flooded bogs. "How many highways can you drive down and see the ocean?" she reflects. "We are so lucky to be here; I would never give up my home on the Cape."

The Bay Side

The outstretched, curved arm of the Cape holds within its protective embrace a 604-square-mile embayment of clockwise-spinning currents that is as ecologically significant as it is historic, as potentially tricky to navigate at low tide as it is captivating to observe. Designated a State Ocean Sanctuary in 1970, Cape Cod Bay is remarkable in the diversity of its plant and animal life; these sheltered waters even serve as feeding grounds for North Atlantic right whales, one of the world's most critically endangered species. The Cape's three hundred miles of bayside coast are lined with soft sand. The bay's waves—warmer and gentler than those of the outer ocean—beckon to families. Many a toddler has tentatively touched toes to saltwater for the first time along these shores, but

Eastham's First Encounter Beach is named for a more hostile initial meeting between the Pilgrims and the native Nauset.

With the *Mayflower* anchored in Provincetown Harbor at the northeastern edge of Cape Cod Bay, its male passengers signed the Mayflower Compact, history's first document establishing a democratic government. Although the Pilgrims spent their first five weeks in the New World considering Cape Cod as their settling spot, lack of fresh water—not to mention the skirmish with the Indians—persuaded them to sail westward to Plymouth. Had they chosen a home on the Cape's north shore, they would soon have discovered the navigation obstacles presented by the bay's dramatically fluctuating tides. As waters recede, they expose sand flats—in Brewster, they're as wide as two miles—and boats face a real danger of running aground. In Barnstable, "you literally see the harbor cleaned right out," says Bob Wilds, explaining that water levels vary by nine to eleven feet—thirteen feet on full-moon nights.

Wilds leads groups of two to thirty-two paddlers on trips out of Barnstable Harbor timed to take advantage of the visual splendor that is revealed as the tides subside. A naturalist who spent twenty-four years on whale-watch boats, Wilds "missed the ocean" after five years "on terra firma," so he founded Great Marsh Kayak Tours in 2000 to provide vacationers with an intimate experience of the bay's delicate wetland ecosystem. Paddling out at high tide, the kayaks glide over submerged seagrass fields. Returning as the tide ebbs, "you can see every critter that is trying to survive until the next tide," Wilds says. The Great Marsh—sandwiched between Barnstable and slender Sandy Neck Barrier Beach—is habitat for an ever-changing contingent of migratory birds. Peer down through the water, and "suddenly you're looking at snails, crabs, fish," he says. Heading back toward the widening beach, "the visuals are absolutely mind-boggling, the colors in the sands and the reflections on the water. It's an artist's dream come true," Wilds says.

Add a sunset, and there are few New England sights more breathtaking. "I have traveled a great

deal of this planet, and I have never seen more beautiful sunsets than on the north side of Cape Cod, especially if you catch that low tide," Wilds asserts. "People who live on the Cape will tell you they flock to the north side for sunsets."

Travelers intimidated by the prospect of paddling can take nearly any northbound turn off Route 6A, the winding and historic Old King's Highway, which parallels Cape Cod Bay for thirty-four miles between Bourne and Orleans, for a view of the fiery skies that harbinger day's end. But time on the water—away from the Cape's summer crowds—can be a revelation. On his tours, Wilds says, "people see that there is a lot more beneath the water and alongside the water than they ever imagined. They see that there is a lot to learn, and there is a lot to save. It really affects

people." Even kids, who'd balk if they suspected they were learning something on vacation, delight in exploring the Great Marsh. "They're the ones keeping up in the kayaks and asking all of the questions," Wilds says. The vast majority of his kayaking clients are beginners, and Wilds laments only slightly his lack of repeat customers. "Once they've done it, they all seem to buy their own kayaks," he says.

Provincetown

Each Thanksgiving Eve, the 252-foot granite monument that lords over Provincetown becomes an even more impressive sight when white lights strung from the tower are illuminated. Dedicated in 1910, this singular landmark does not honor the

Sunsets on the bay side of Cape Cod are incomparable.

Charismatic Megafauna

"PROVINCETOWN IS WHERE whale watching originated on the East Coast," says Joanne Jarzobski, whose career aspirations were sparked when her family took a whale-watch tour while vacationing on Cape Cod. "I was seven years old, and I got hooked," she recalls. Now, as marine education director for the Provincetown Center for Coastal Studies (PCCS), Jarzobski oversees the nonprofit's collaboration with commercially owned Portuguese Princess Excursions. Provincetown is "the closest port to Stellwagen Bank," making it an ideal whale-watching departure point, Jarzobski explains. The nutrient-rich waters that surround this submerged plateau are feeding grounds for large baleen whales: minkes, finbacks, and humpbacks.

As boats set out on three- to four-hour tours, PCCS's on-board educators discuss history, ocean geology, and, of course, whales. The excitement becomes palpable as the first spouts and splashes are spotted. "The views of whales are often remarkable," Jarzobski says. "It's very rare that we don't find a whale out there"; she's had only one trip without a sighting in over 1,100 whale watches she's logged. "Endangered humpback whales are the favorite of the whale watcher; people call them charismatic megafauna," she says. These forty- to forty-five-ton mammals that measure upwards of fifty-five feet "jump out of the water and hit their tails or flippers," Jarzobski describes, "and they're here in large numbers."

PCCS maintains a catalog of 2,100 humpbacks identified in the Gulf of Maine since 1976; 400 to 700 of them migrate to Stellwagen Bank from breeding and calving grounds in the Caribbean each April through October. Salt—the first whale named—has been back every year except one; Crystal, the first of Salt's eleven calves, returns regularly, too. Sharing whales'

Patterns of pigment on tail flukes help researchers to identify and track the movements, behaviors, and well-being of individual whales.

names and family connections resonates with the public, but identification is also crucial to research efforts. Naturalists have learned, for example, that humpbacks return to the same feeding grounds from data collected on whale-watch trips. Whales can be distinguished, Jarzobski says, from natural markings—such as Salt's white-encrusted dorsal fin—and from scars.

"More than 60 percent have entanglement scars," says Jarzobski, and although PCCS has a team that responds to entanglements, 300,000 whales, dolphins, and porpoises perish each year in fishing gear. The ultimate goal of Portuguese Princess tours isn't showing whales to curious tourists, it's saving these majestic, threatened creatures. Jarzobski remembers one amazing trip when a humpback named Nile breeched repeatedly, as observers—including a school group—wildly chanted her name. "It was our first sighting of her after a disentanglement," she says. "Those kids are never going to forget that whale. When you see a whale breeching out of the water, you certainly want to make sure the oceans are safe for them."

Commercial Street in Provincetown is lined with eclectic shops hawking everything from taffy and fudge to starfish and seashells, maritime antiques to fine, locally painted works of art.

fishermen and sailors, nor the painters, poets, and playwrights who have shaped Provincetown's character for generations. It commemorates the town's original transient tourists. The Pilgrims may have passed over Provincetown, but by the mid-1800s, seafaring settlers, including many Portuguese immigrants, had established a thriving community around the snug harbor at the tip of Cape Cod. The tight-knit fishing village's isolation waned by the nineteenth century's close, as writers, artists, and vacationers discovered this welcoming, inspiring haven at the Cape's outer extreme.

"The fishermen used to let the artists stay in their fishing shacks," says Hilda Neily; their descendants still toss samples of the day's catch to artists painting on the pier. Neily has her own gallery on Commercial Street now, but when she arrived in Provincetown in the 1960s, she was thankful for the turnips and potatoes her teacher, Henry Hensche, shared from his garden. Hensche, a disciple of American Impressionist and Cape Cod School of Art founder Charles Hawthorne, once told her: "If it wasn't for poor people, poor people would starve to death." As Neily's mentor for fifteen years, he also imparted the lesson that's allowed her to realize her dream of making a living as a painter: how to see color.

Young artists scrutinize Neily's vivid works, trying to ascertain her "trick," and casual browsers experience déjà vu as they ponder her seascapes, street scenes, and still lifes. "It's familiar because it's real," she says. "It's a visual truth." People who encounter her painting outdoors, employing the techniques

High-reaching dahlias thrive in Provincetown's sandy, fast-draining soil, and the vibrant hues of these abundant blooms are a perennial inspiration to artists.

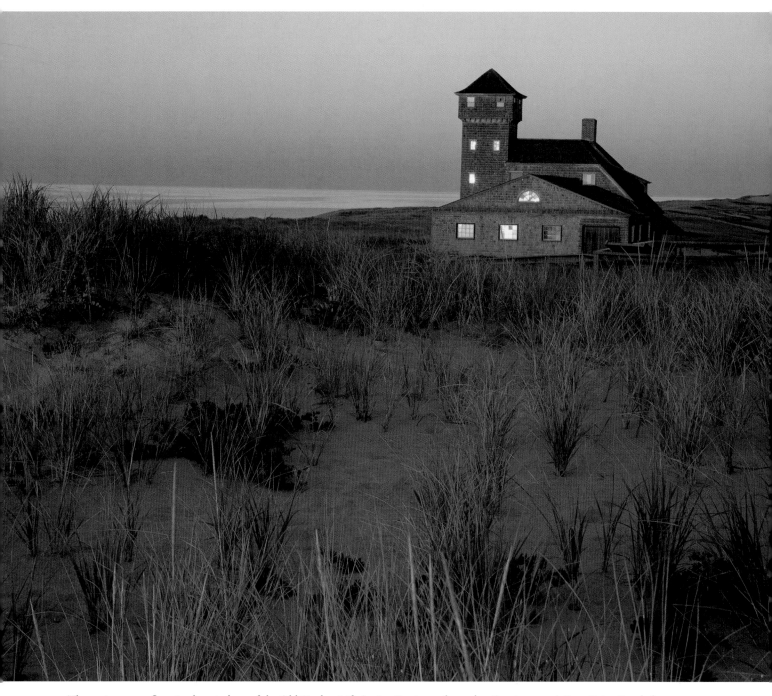

The setting sun reflects in the windows of the Old Harbor Life-Saving Station, relocated to Provincetown's Race Point Beach from Chatham's Nauset Beach in 1977. On Thursday evenings in the summertime, National Park Service rangers reenact a breeches buoy rescue at the station, which is now a museum. U.S. Lifesaving Service crewmen used this rescue apparatus to retrieve shipwreck survivors without endangering their own lives.

she's mastered for capturing the color of the air between her easel and a scene—what artists call "light"—often try to observe and question. "You just want to swat them," says Neily, who finds interruptions distracting. "It's only the tourists" who gawk,

she says, but in the summertime, that's nearly everyone. Provincetown has fewer than 3,500 year-round residents, but at peak times, this eclectic, spirited, gay-friendly resort is crammed with as many as 60,000 seasonal homeowners and visitors. Neily's

reluctance to chitchat with passersby is solely a survival instinct. Like fellow Provincetown business owners, her window of opportunity is limited. "Everybody's making their whole year's income in four short months," she explains. "Everybody—in every business—works really hard."

Artists also face tough competition. "The galleries come and go," Neily says; there are more than fifty currently. "For a small town, that's a lot," but she assures "there's room for everybody," and voices respect for her peers. "I've never seen the consistent, good quality that I see in Provincetown," she says. Soaring real-estate prices, however, and the lack of year-round employment for those who can't pursue their art full-time, have forced many to leave. "It's been a big loss to the community," Neily says.

When P-town shutters, some artists hunker down to work, while others depart for warmer climes. Neily's winter home in arty, funky Gulfport, Florida, reminds her of Provincetown decades ago, but the Cape calls her back each spring. "There's no limit to how much there is to paint," she says, and while eking out an existence is no longer easy, artists still gravitate to the magnificent, reflective light that bathes this peninsula encircled by sea. Once you've lived in Provincetown, every other place "never matches up," Neily says. "You make such a bond with that town—the beauty of the place never lets you down."

The National Seashore

Few seacoasts have official historians, but the Cape Cod National Seashore, which stretches the entire forty-mile length of the Outer Cape, from the dunelands of Provincetown to Chatham, is an unparalleled coastal expanse. "It's definitely a unique job," admits Bill Burke, whose desk at the national park's Salt Pond Visitor Center overlooks its namesake tidal pond, Nauset Marsh, and the always dynamic Atlantic. The National Park Service first studied the feasibility of protecting America's shores in the 1930s, and when research resumed after World War II, a report titled *Our Vanishing Shoreline* contained a "startling revelation," Burke says:

Storied Shacks on Shifting Sands

CREWMEN BASED at the Peaked Hill Bars Life-Saving Station built the first primitive shacks on the desolate and delicate dunes that shield Provincetown from the Atlantic. In the 1920s and 1930s, as the town's popularity grew, more of these diminutive homesteads, some cobbled together from flotsam, sprouted up along the shore east of Race Point. The natural splendor and isolation of the wind-sculpted sands that swaddle nearly two-thirds of Provincetown appealed to both eccentric loners and luminary writers. It is the latter squatters—Eugene O'Neill, Jack Kerouac, Norman Mailer, e.e. cummings, and others—whose association with the "dune shacks" led to their designation as a National Register Historic District in 1989.

Without clear titles and improvements, such as electricity and running water, eighteen of the nineteen shacks—rustic by their very nature—failed to meet the criteria for private property and became federal possessions in 1961 when the Cape Cod National Seashore was created. Nearly a half-century later, angst still surrounds their eventual fate as life tenancies granted to the last of the long-time dune dwellers expire. Several shacks are operated by nonprofit organizations, which dole out affordable stays to artists and other applicants by lottery. The only thing certain is that these storied shacks' unconventional and defiant place in the Cape landscape is secure.

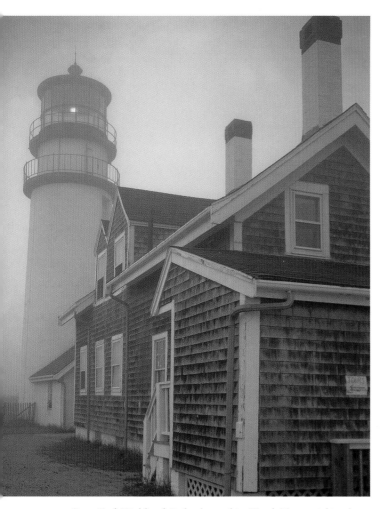

Cape Cod Highland Light, located in North Truro within the Cape Cod National Seashore, is the oldest and tallest lighthouse on Cape Cod. The current tower and its shingled keeper's house date to 1857. The beacon, lifted and moved away from its precarious position on an eroded cliff in 1996, still serves as an active navigational aid, and its role is critical on such a foggy day as this.

"Private property was being bought up along the seashores; there was really only a small amount of coastline open to the public."

The Cape, many feared, would soon resemble the overdeveloped New Jersey shore, but preserving a populated, six-town region required the Park Service to devise a new paradigm. "Traditionally,

Right: Artists are so much a part of the fabric of the Outer Cape that they often blend comfortably into the landscapes they're painting, such as this scene of Truro's Pamet River Harbor.

National Parks are established in wilderness areas," explains the Seashore's Historian. "The tricky part about putting a National Seashore here," Burke says, "was that there was already a lot of private land; people had been living here for thousands of years." Creation of the Cape Cod National Seashore, which opened to the public in 1961, necessitated a series of compromises. The boundaries of the 43,000-acre park, which is small compared with other federally protected tracts, were drawn to exclude the town centers of Chatham, Orleans, Eastham, Wellfleet, Truro, and Provincetown. More than six hundred private homeowners retained their residences within the park, and traditional activities, such as hunting and shellfishing, were allowed to continue. "It was a new breed of park," Burke says. "There was a very obvious attempt made to shoehorn the park in so that the outer beach could be preserved for recreation for everyone."

The Seashore records five million visits annually, and while diverse recreational opportunities await year-round, the "whole story" of the park's allure "starts and ends at the beach," says Burke. At two visitor centers, travelers and locals can learn about

hiking and bicycling trails, scenic drives and over-looks, birdwatching opportunities, ranger-led pro-grams, and tours of some of the seventy historic structures within the park, including a whaling cap-tain's home atop Fort Hill in Eastham, the Old Harbor Life-Saving Station in Provincetown, and several lighthouses. Inevitably, "a visit will include the beach," says Burke. More than a dozen town- and park service–managed beaches connect to form the "largest unbroken stretch of sandy beach in New England," he says.

Each year, about three feet of shore is consumed by the pummeling sea, but coastal erosion is not the park's worst enemy, says Burke; this threat is pre-dictable and, thus, manageable. More worrisome, he believes, is the potential for the six hundred pri-vate homes—mostly little cottages—within the park to be redeveloped on a grander scale, irrevocably altering the park's character. "The people buying them have a lot of money," he says. And while the Park Service has provided towns with guidelines, it ultimately has no zoning authority.

Park Superintendent George Price is also keenly focused on the issue of "relevance," since a new

A curtain of fog slowly parts, revealing a classic Truro scene of grass- and rose-anchored dunes. Henry David Thoreau, who devoted a chapter of his book Cape Cod *to his stay at Highland Light, wrote: "in summer dense imprisoning fogs frequently last till midday, turning one's beard into a wet napkin about his throat, and the oldest inhabitant may lose his way within a stone's throw of his house or be obliged to follow the beach for a guide."*

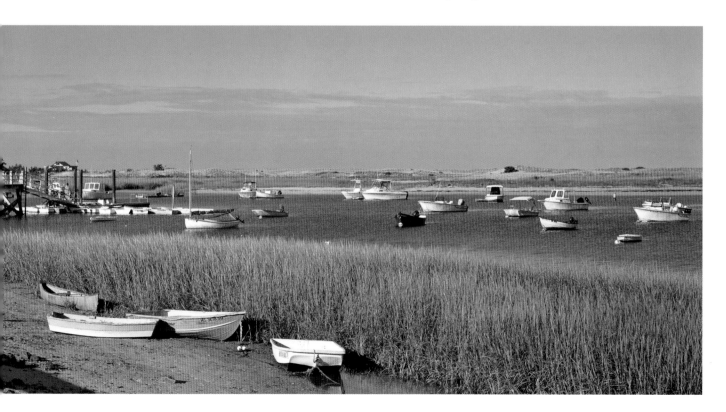

generation raised on video games and the Internet feels less affinity for nature, says Burke, whose oldest daughter, like every fifth grader in Harwich, Dennis, Yarmouth, and Falmouth, spent a week at the Seashore's Truro Lifesaving Station. This long-standing rite of passage for Cape kids allows them to discover the seaside wonderland in their backyard. "They hike all the trails and walk the beaches and are fully immersed in the natural environment," says Burke. The week without television and other electronic diversions "was tough" for some of her peers, says Burke, who was heartened that his daughter truly enjoyed the experience.

In a constantly connected, fast-paced world, the compromises that won the Seashore its protected status may also ensure its enduring appeal. The six still-active maritime communities enveloped by the park retain their historic charm and distinct flavor, while offering a full complement of services and amenities. Yet, only minutes away, the unspoiled beauty of a national park beckons. The curvature of the Outer Cape conjures the illusion that the wide band of sand is endless; dune grass–tufted cliffs foster a sense of isolation. "Even in August, you can feel like you're alone on the beach," Burke says. "It's almost a wilderness experience." Many areas remain

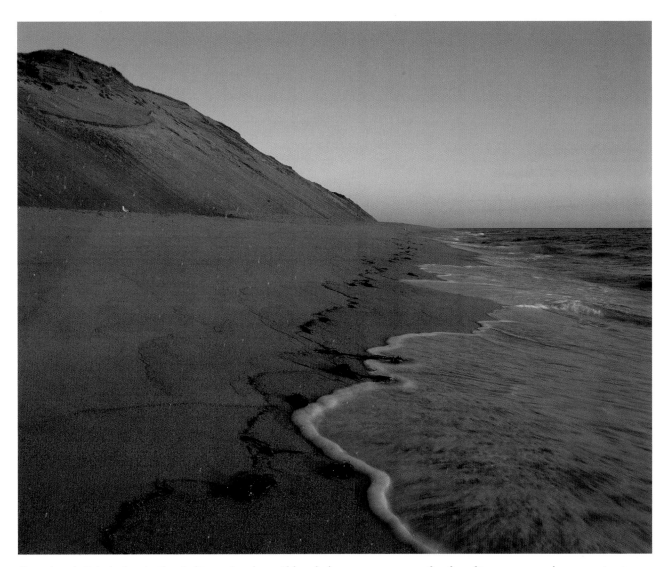

Dawn's early light bathes the Cape's shimmering shore. Although the ocean repossesses a few feet of its outer arc each year, erosion is not the peninsula's worst enemy.

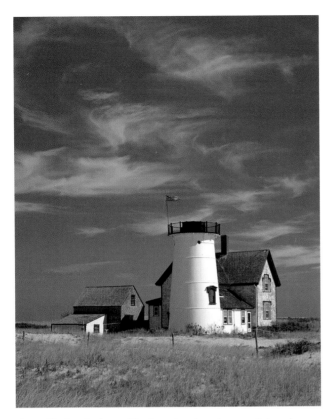

Stage Harbor Light in Chatham is privately owned, but the deactivated 1880 beacon and its keeper's quarters are visible to those who undertake a mile-long hike along Hardings Beach.

Street exudes quaintness; its Lighthouse and South Beaches afford mesmerizing ocean views, punctuated at times by playful pods of seals, although riptides make swimming risky for humans. On Shore Road, the white cast-iron beacon that replaced Chatham's original 1808 lighthouse in 1877 broadcasts its beam, even through fierce nor'easters. And at Nickerson's Fish Market at the Chatham Fish Pier, locals and out-of-towners line up to purchase fish and shellfish plucked from deep waters by one of only two surviving commercial fishing fleets on Cape Cod.

There's a refrain sometimes heard around town: "Keep Chatham, Chatham," says Dougie Bohman, a part-time physical therapist who has served on the Board of Selectmen for fifteen years. Some residents yearn for yesteryear—not, perhaps, the town's eighteenth-century seafaring heyday, but at least a time before McMansions loomed along Shore Road. The town's housing boom has been the most noticeable change Bohman has observed since relocating to the Cape with her husband, Ray, and three sons in 1966. "You're seeing more and more huge, multi-million-dollar houses; that doesn't sit well with a lot of people," she says.

As a member of the town finance committee for a dozen years before being elected selectman, Bohman is sensitive to the fact that owners of grand seasonal homes pay "more than half of the real estate taxes in town." Her nostalgic neighbors' sentiment is understandable: "It's like when your kids are little and you'd like to put a brick on their heads to keep them from growing," she says. "But," she quickly adds, "it's just not realistic." Like Chatham's outlying barrier beach, a fragile spit of sand that is regularly reshaped at the whims of the tides, the town's appearance cannot remain unaltered forever.

Still, on summer Friday evenings, as red-jacket-clad musicians take their places on the gazebo bandstand in Main Street's blanket-strewn Kate Gould Park, just as they have since the 1930s, it's entirely believable that this seaside village can defy time. "It's a great tradition," Bohman says of these free concerts, where vacationers' children dance alongside Chatham

blissfully undisturbed. "There are miles and miles of walking trails and sand roads that some people know about, but they're not really marked on any maps," he says. While there was initial opposition from some residents concerned about the park's impact on traffic, local services, and property values, Burke reveals that "99.9 percent of the people you talk to now say: it is great that the National Park is here because it stopped development and created a beautiful place to experience the beach. It's the best thing that ever happened to the Cape."

Charming Chatham

Almost every buildable lot has been built; almost every inn lacks a vacancy on summer eves. Yet Chatham, located at the Cape's "elbow" and surrounded by water on three sides, still has the soul of a small fishing village. Its strollable, shoppable Main

children. Little do most interlopers know: Chatham residents also know how to party come winter.

The quiet season has contracted since the Bohmans moved to Chatham, when Ray used to remark: "You could fire a cannon down Main Street and not hit a thing." Dougie quips that "now, you have to wait until January or February to do that." A sea delicacy, harvested in November and December, is one reason to visit during shoulder season: bay scallops "melt in your mouth; you've never tasted anything better in your life," Bohman says. And on First Night, Chathamites ring in the New Year in their own inimitable way with an arts celebration featuring concerts, a noise parade, a bonfire, and fireworks. As midnight approaches, the Countdown Cod,

a colorfully illuminated, nine-foot aluminum fish sculpture, is lowered from a crane.

Hyannis : The Hub

"You can't even talk about Cape Cod without also talking about the sea; it's had such a long, rich tradition of making its living from the sea," says Mark Wilkins. Until 2004, however, there was no museum devoted to the lighthouses and lifesaving stations, the ships lost and the lives transformed by the Cape's seagoing pursuits. It wasn't Wilkins's experience at the Smithsonian American Art Museum that initially landed him a role at the Cape Cod Maritime Museum. It was his hobby: wooden

Cleome, or "spider flowers," can't camouflage the allure of the beach at Kalmus Park, located a short walk from the Ocean Street Dock in Hyannis.

Woods Hole Oceanographic Institution

At the Ocean Science Exhibit Center in the Falmouth village of Woods Hole, visitors glimpse a mere sampling of the accomplishments of the Woods Hole Oceanographic Institution (WHOI), from understanding toxic algae to deciphering marine mammal communication, from counteracting coastal erosion to locating the deeply submerged remains of the world's most famous shipwreck. While WHOI's studies of hydrothermal vents on the ocean floor, Gulf Stream currents, and plate tectonics are perhaps more weighty contributions to science, WHOI science writer and editor Mike Carlowicz admits that the 1985 *Titanic* discovery was "the landmark event" in raising public awareness of the wide-reaching efforts of this Cape Cod–based research organization.

Even before WHOI was formally established in 1930, the former whaling and shipping port of Woods Hole was an active academic community. "It was a summering spot for scientists," says Carlowicz. Within this compact village, WHOI's one thousand employees are far from alone in their oceanology interests. The National Marine Fisheries Service, Marine Biological Laboratory, U.S. Geological Survey, Woods Hole Research Center, Sea Education Association, and U.S. Coast Guard all have Woods Hole facilities. "It's really an interesting scientific community within the larger context of Cape Cod," Carlowicz says.

WHOI is unique among ocean research institutions because its scientists are complemented by engineering and construction teams. In addition to operating three research vessels for the oceanographic community, "we design and build robotic vehicles and instruments to go into the ocean," Carlowicz says. "We have the ships, we have the research staff, and we have the engineers and the sailors; it's a nice blend." WHOI has been tapped for its expertise to play a key role in the National Science Foundation's Ocean Observatories Initiative. Carlowicz describes it as an effort to "wire the ocean" to gain a "longer-term view" of trends.

Carlowicz, a former NASA writer and the author of *The Sun* and *The Moon*, believes the seas still hold incredible mysteries. "We have better maps of the surface of the moon and of Mars than we do of our own Earth," he says, explaining that two-thirds of the planet is shrouded in water too deep to be penetrated by satellites. WHOI is committed not only to understanding this environment, but to communicating its findings. Funded primarily through federal grants, the institution feels a "responsibility to share results with the public," Carlowicz says. WHOI may be headquartered in New England, but its explorations are global. "The New England waters" are "our test bed," Carlowicz says, but "we're working all over the world."

boat building. The facility opened with a catboat replica project underway but no permanent collections of its own. Since then, "programs have really taken off," the director/curator says.

The maritime museum is ideally situated on the Inner Harbor in Hyannis. The largest of Barnstable's

seven villages, Hyannis is the hub of transportation and commerce on the Cape, home to its only major airport and to a harbor crowded with sport and commercial fishing boats, Nantucket- and Vineyard-bound ferries, and tour boats that grant gawking passengers a peek at the Kennedys' Hyannis Port

"Village greens have meaning; this one continues to have meaning," says Falmouth Historical Society Executive Director Carolyn Powers. This lush expanse where sheep once grazed and Revolutionary War militiamen trained is now the site of everything from community events to peace vigils to historic walking tours.

compound. While some may impugn Hyannis for its strip-malled, suburban feel, this centrally located village is rapidly reinventing itself as it reemerges as a year-round residential community.

"There seems to be a vitality about Hyannis," says Wilkins. Members of the Main Street Business Improvement District are striving, he says, to transform Hyannis into a community "where people live and work," rather than a place they drive through "to buy an ice cream cone or get a T-shirt." A performing arts center is planned for the site of the armory behind town hall, where expectant father and president-elect John F. Kennedy accepted Richard Nixon's concession in 1960. It will complement the seasonal Cape Cod Melody Tent, with its revolving, circular stage. The John F. Kennedy Hyannis Museum on Main Street is one of Cape Cod's few year-round attractions, a place to understand how these shores shaped the president's

character. Eclectic restaurants and shops line Main Street, and a landscaped brick "Walkway to the Sea" links the thoroughfare with waterfront Aselton Park—and the Cape Cod Maritime Museum.

"There really is a renaissance of culture in Hyannis, and we're happy to be a part of it," says Wilkins. *Sarah*, the replica catboat crafted using traditional techniques and materials, was launched with much fanfare in 2007; Senator Edward M. Kennedy was among the hundreds in attendance. "She's now afloat on the Inner Harbor and will serve as a floating classroom," explains Wilkins, who dreams that a taller ship will join her one day. "The Cape should have a schooner or packet: two boats that were predominant here in the nineteenth century," he says.

While he likes to "focus on human dramas from the seventeenth century to the present" in designing the museum's changing exhibits, the opportunity to

view boat restoration work in progress is key to the museum's allure. "There is a very great love of wooden boats" on the Cape, says Wilkins, who admits: "I have five wooden boats on my property in varying states of seaworthiness. People will bend over backward to find them a home. Wooden boats today are expensive; they are labor-intensive. But they have a soul," he says. "They have the mark of the human hand."

Falmouth : Proud Traditions

Nobska Light stands on a rise of land overlooking the convergence of Vineyard Sound and Buzzards Bay. One night each year, its flashing strobe is accompanied by the joyful strains of huddled, bundled-up carolers. It's the kickoff to Falmouth Holidays-by-the-Sea Weekend, which greets December with events ranging from the lighting of the village green to the Cape's largest holiday parade. Summer folks who flock to Falmouth to sunbathe, swim, sail, kitesurf, and fish along nearly seventy miles of shore miss this wintertime ritual. Many more hurried vacationers, en route to the Steamship Authority's Woods Hole ferry dock, see this tucked-away town in the Cape's southwest corner as nothing more than the final speed bump on their journey to Martha's Vineyard or Nantucket.

Those who call its eight villages "home" year-round, however, quickly become immersed in Falmouth's seasonal rhythms and beloved traditions. "I have learned so much about this town and the things that people cherish," says Carolyn Powers, who relocated when she accepted the Falmouth Historical Society's executive director position in 2002. Falmouth's character is particularly on display at biannual town meetings. "It's grassroots politics at its best," Powers says of this distinctively New England form of local government. "There are divisions of opinion, but once a decision is made, people embrace it and move forward," she notes. "It's a community of can-do people."

The spirit of Falmouth is embodied, too, in its impressive annual 4th of July Fireworks Spectacle, funded entirely by donations from residents, visitors, and businesses. A major fireworks supporter once told Powers: "The community that gave birth to Katharine Lee Bates has to have one of the most fantastic fireworks displays in the U.S."

Bates spent the formative first twelve years of her life in Falmouth. The youngest of four children, she was just a month old when her father died in 1859. The minister's family "relied on the community to help them," Powers says. In her writings, the Wellesley English professor would later refer to Falmouth as "a friendly little village that practiced a neighborly socialism without having heard the term." Although Bates's name might not ring a bell, surely a refrain she penned does:

"And crown thy good with brotherhood, from sea to shining sea."

Although she was atop Colorado's Pikes Peak when she scribbled the first version of "America the Beautiful," surely the shores of Cape Cod were not far from Bates's mind. "There are folks here who think her understanding of brotherhood came from her experiences as a child," says Powers. "We're terribly proud of that poem."

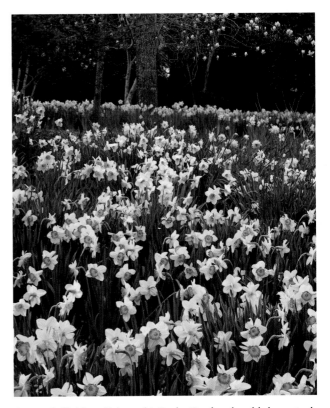

Sunny daffodils in Falmouth's Spohr Gardens herald the arrival of spring on Cape Cod. Along much of New England's coast, spring is a late-arriving, brief season.

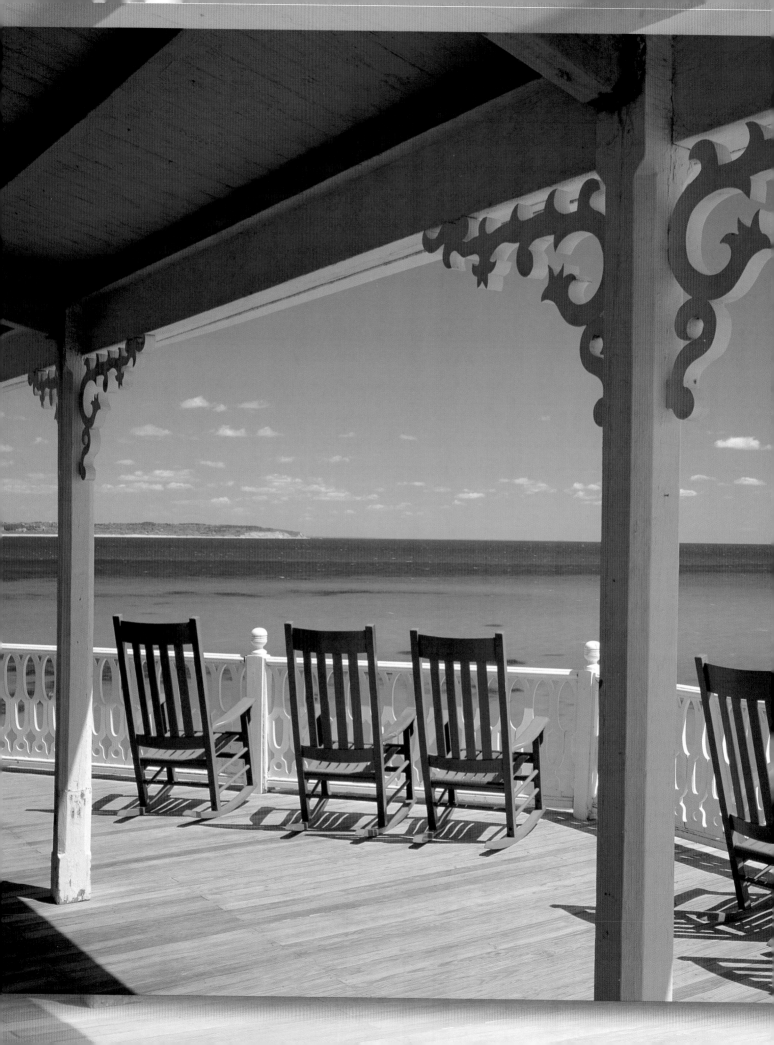

The Islands
Nantucket, Martha's Vineyard & Block Island

Heavenly Isles
Suspended in Time

Above: From spring through autumn, the colors of nature really pop against Nantucket's subdued architectural backdrop.

Left: With its turquoise waters, seventeen miles of beach, open-air restaurants and taverns, and laid-back vibe, Block Island is New England's closest thing to a Caribbean escape.

In New England, time travel may be largely seasonal, but it is far from impossible. While physicists contemplate speed-of-light motion and warps in the time-space continuum, thousands of vacationers simply hop on planes or board ferry boats bound for offshore isles where time seemingly disregards nature's laws.

The southeastern Massachusetts islands of Nantucket and Martha's Vineyard and Rhode Island's Block Island are piles of glacial rubble marking the fringe of the last ice sheet's southern advance some twenty thousand years ago. Just as the receding freeze gave birth to these irregularly shaped outer lands, each winter's departure reveals anew the enduring appeal and distinctive traditions of these historic havens. Nantucket is lively and chic. Martha's Vineyard exclusive and liberal. Block Island eccentric and pristine.

The intrepid folks who hunker down on these fragile, weather-buffeted islands year-round are gracious hosts to both high-profile summer homesteaders and day-trippers, who crowd beaches and wobble along narrow, unfamiliar roads on rented bicycles and mopeds. It is, after all, easier to snare tourist dollars than it is to harpoon a great whale. And while seasonal guests and transient visitors may tax infrastructure, they also make remarkable contributions to the preservation of island ways and landscapes. There are Left Coasters and Europeans on the member rolls of the Block Island Conservancy. Nantucket Soundkeeper's Dean Bragonier says it's easy to elicit support for environmental protection efforts. "There is an inherent desire to keep things the way they are," he says. The generation of philanthropists enchanted with these islands feels no need to erect institutions bearing their names; they prefer to quietly sustain places where they feel charmed and safe.

Reaching these storied ocean outposts may not require a time machine, but it does involve a level of complexity and expense that deters those who don't feel the islands' strong pull. That's part of their appeal to the paparazzi-shy, who hope to go unrecognized. Nantucket tour guide Gail Johnson says Anne Meara and Jerry Stiller are "here all the time. They ride around on their bikes with their hats pulled over their faces so nobody knows who they are . . . but they're the only people who do that."

Nantucket's Nurturing Nature

Named Nantucket, or "far away island," by the native Wampanoags, the isle that lies thirty miles off Cape Cod is near not only to the hearts of its twelve thousand full-time residents but to scores of others who visit for a day, a week, or the summer season, when Nantucket's population soars to nearly sixty thousand. It's not just corporate honchos, politicos, and celebrities with breathtaking waterview homes who cherish this offshore retreat. Curious visitors also flock to Nantucket by air and by sea to stroll its cobblestone streets, marvel at its well-preserved architecture, dine in its top-notch restaurants, and test their credit limits in its upscale shops—even if they don't realize that the "Nantucket Reds" they purchase at Murray's Toggery won't help them to blend in with true islanders.

"The more pink, the more status; heaven help you if they look new," says Gail Nickerson Johnson

Flowering Scotch broom provides a golden frame for Nantucket's Old Mill, which operates seasonally. Built in 1746 by a Nantucket sailor who had spent time in Holland, it is the oldest functioning mill in America.

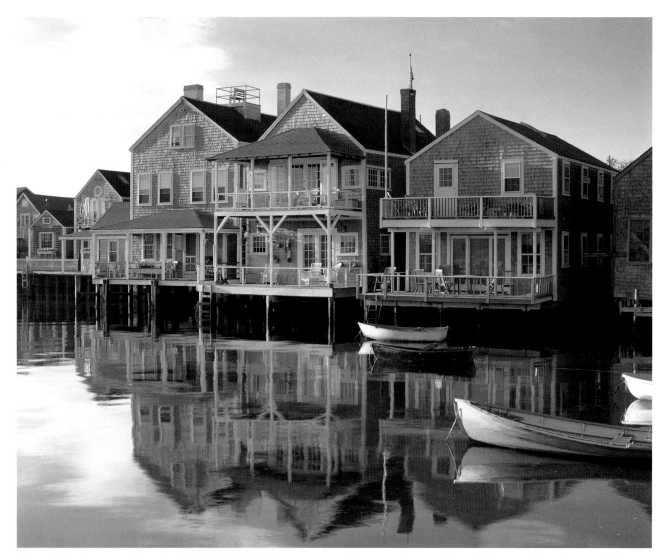

Restored boathouses on Nantucket's Old North Wharf are now magnificent waterfront residences. The scene of these homes and their owners' colorful skiffs mirrored in the water is one of the last many island visitors see as they reluctantly return to the ferry.

of the island's signature scarletwear, which fades with years of washings. Like her mother, who began offering island tours in a Ford Woodie before Gail was born, this sixth-generation Nantucket native takes tourists out of crowded Nantucket town on van tours that showcase the island's diverse terrain: pristine beaches, storm-battered bluffs, indigenous cranberry bogs, marshlands, ponds, heathered moors, and the scrub oak and pitch pine barrens of the "Nantucket Serengeti."

The changing landscape is a foil for the island's monochromatic dwellings. "You can paint your house any color you want as long as it's gray or white," Johnson cracks. Before she sets out for Siasconset, or "'Sconset," as islanders say, Johnson rumbles her Ford van over streets paved with rounded stones that once served as ships' ballast, pointing out the mix of Colonial, Federal, Greek Revival, and Victorian architecture on Main Street. Nantucket has eight hundred pre–Civil War buildings; the oldest house dates to 1686 and belonged to the grandson of one of the nine original settlers, who acquired the island from patentee Thomas Mayhew for thirty pounds and a pair of beaver hats.

Most of the grand abodes, however, were built with the whaling profits that came the island's way

A sport-fishing boat docked at Straight Wharf is well equipped to pursue the bountiful bass, blues, and bonito that inhabit Nantucket's waters.

Nantucket's cobbled Main Street is a shopper's nirvana and the place to see and be seen on a summer evening stroll. Warning to women: High heels and cobblestones are a potentially perilous combination.

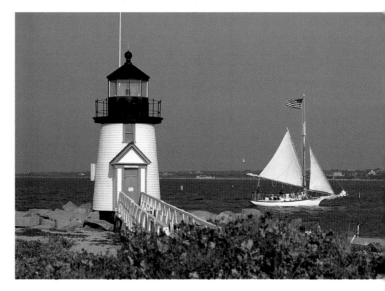

Nine different beacons have graced the entrance to Nantucket's inner harbor since the original Brant Point Light—the second lighthouse in America—was erected in 1746. The current structure, a diminutive, twenty-six-foot tower that dates to 1901, is always a welcome sight for travelers arriving on Nantucket-bound ferries.

from 1750 to 1850. By the early nineteenth century, Nantucket was the third-largest city in Massachusetts, behind Boston and Salem, and from 1800 to 1840, the island was the whaling capital of the world, with as many as eighty-eight vessels at sea hunting the ocean mammals. On Centre Street, once known as Petticoat Row, women owned and operated businesses and shops while their husbands were away, sometimes for years at a stretch.

"The women pretty much ran the town; this became a large feminist paradise," Johnson says, adding, "We like to think nothing has changed; we just don't go whaling anymore."

The seven-hundred-plus pages of Herman Melville's *Moby Dick*, based on the true story of the *Essex*, a Nantucket whaleship, are a time-consuming read, but one glance at the eighteen-foot lower jawbone of an eighty-five-foot sperm whale displayed at Nantucket's Whaling Museum tells the same story: Whaling was a risky profession. By the mid-nineteenth century, the demand for whale oil waned, and gold in California replaced blubber as the object of pursuit for men seeking lucrative adventure. Nantucket's economy stalled, and the island remained isolated until travelers discovered its charms.

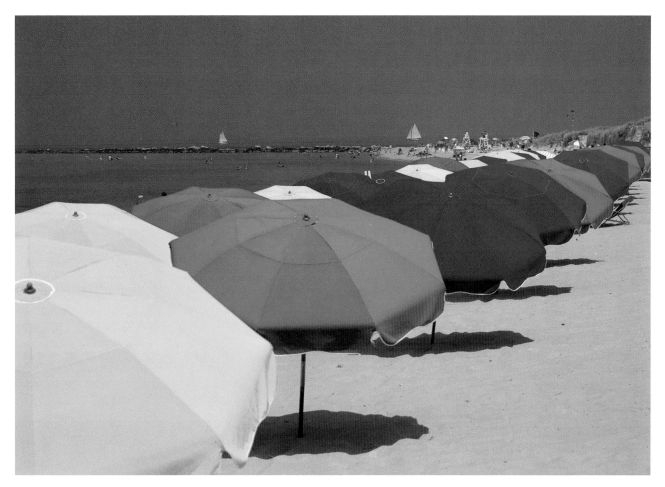

Colorful umbrellas at Cliffside Beach Club's private beach are ready to shield hotel guests who are fair-skinned or paparazzi-shy, but visitors to Nantucket's family-friendly Jetties Beach, the public beach visible just to the east, must provide their own sun protection and disguises.

Visitors infuse Nantucket with lively energy in the summertime, but islanders prefer quiet, colorful autumn and even the desolate months after Christmas, when they attend fundraisers and other social events and work on their properties. "I love winter," Johnson says, insisting: "People who say they are bored here in the winter are just boring people."

Even in the off-season, a transient visitor might not glimpse the true spirit of Nantucket, which emerges at times of adversity. "Everybody really knows everybody, still," says Johnson, and islanders realize they are never far away from a friendly face and a comforting shoulder. "When my parents were sick, the support of the town was just wonderful; it was overwhelming," she says. "That's when you realize how lucky you are."

Still, there is something about this elegant island that replenishes the soul of even the casual day-tripper, and it only costs a wish and a penny, tossed from the ferry as it rounds Brant Point, to ensure a return trip to Nantucket.

Martha's Vineyard: On the Way to Heaven

"In spite of the fact that I've been staying in a hospice, I'm not going to heaven immediately. My doctor informs me that I can stop over on Martha's Vineyard on the way there," wrote humor columnist and forty-five-year island summer resident Art Buchwald in his 2006 swan-song book, *Too Soon to Say Goodbye*. After declining dialysis in February of

A Coveted Souvenir

IN 1854, CONGRESS authorized America's first lightship, an illuminated vessel moored near hazardous shoals thirty-five miles south of Nantucket. Even for retired whalers and seasoned sailors, life aboard this floating lighthouse was fraught with seasickness and monotony. No one knows who wove the first basket with cane from the rattan plant, an import from Malaysia and Thailand that was the Styrofoam peanut of its day, used to cushion ships' cargo. But the men stationed aboard the Nantucket South Shoal Lightship were soon impressing wives and girlfriends with their creations perfected during months afloat.

Government orders required the lightship's crew to cease making the baskets, which had become a lucrative cottage industry, in 1902. Still, this uniquely Nantucket art form was preserved by a few craftsmen. After World War II, as island tourism began to pick up, Jose Reyes popularized a modified basket style with a woven, embellished lid, and Nantucket Lightship Basket handbags became a fashion sensation.

Kathleen Myers, one of about three dozen full- and part-time basket makers on island, explains that Nantucket Lightship Baskets are still made using the same materials and techniques employed in the 1850s. The bottoms are slotted wooden plates; the cane is tightly woven over a mold; and the rim is nailed in place. As Reyes did, many artists decorate their works with ivory or wood carvings, scrimshaw, and leather handles. "It's really the detail of the baskets that makes them very special," says Myers. Many of the island's top basket artists have a two- or three-year order backlog for custom, commissioned pieces.

Almost every woman who sets foot on Nantucket instantly covets a handcrafted bag, but the prices give most a case of sticker shock. Myers explains, though, that a plain,

Nantucket Lightship Baskets are handcrafted works of art that have become status symbols. Peering at these woven creations through shop windows is a favorite pastime, but one look at their price tags reveals they are an investment, not a souvenir.

average-sized handbag requires sixty to eighty hours of intensive handwork. Each is truly a tote-able piece of art. Antique baskets, including works by lightship artisans, which are sometimes exhibited at the Nantucket Lightship Basket Museum, are highly collectible and fetch thousands of dollars.

Myers, who serves on the museum's board of directors, realizes her work may also appreciate after she's gone, but there is more than monetary value to each lovingly crafted piece. "It's hard to part with any of them; they become like your children," she says. Still, her customers' reactions when they see their finished baskets are the richest reward. "They're thrilled; it's something they treasure," Myers reflects. "They appreciate your work. It's a marvelous feeling."

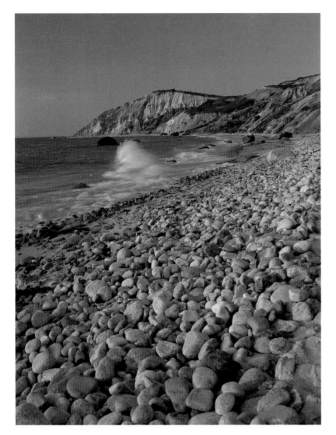

The varicolored Aquinnah Cliffs—composed of layers of red and white clay, green sand, white quartz, black organic soil, and lignite—were a tourist destination on Martha's Vineyard even before a paved road reached this magical spot.

With its white-steepled Congregational church, fairgrounds, farmers' market, and Alley's General Store—"dealers in almost everything"—the Martha's Vineyard town of West Tisbury retains its rural New England charm.

that year, Buchwald entered a Washington, D.C., hospice to await the inevitable, but after five unexpectedly productive and socially vibrant months, he returned to his beloved Vineyard Haven home for a final summer chapter. "I doubt that people will be that interested in me there," he told readers of his column.

Martha's Vineyard is New England's largest island, and though it lies just seven miles off the Cape Cod coast, its mystique is tightly entwined with its reputation as an exclusive, isolated hideaway. Here, Hollywood celebrities and literary luminaries, corporate leaders and media legends, musicians and politicians trade their public personas for an unpretentious and unhurried existence that approaches normalcy. "They can be ordinary people here to a large degree; they get to operate in a world where they're not noticed, and if they are

noticed, they're not bothered," explains entrepreneur Caleb Caldwell, who owned a Vineyard limousine company for seven years and now operates two inns and two restaurants on Kennebec Avenue in Oak Bluffs. "There is an element of detachment here that appeals to them," he says.

With six distinct towns, a collection of five lighthouses considered one of America's most diverse within a compact area, diametrically different seasons, and even two sets of tides from the Atlantic Ocean and Nantucket and Vineyard Sounds, Martha's Vineyard itself has multiple and ever-morphing personas.

The Down-Island or eastern towns of Tisbury, Oak Bluffs, and Edgartown are best known to visitors, who must vie for a restricted number of passenger and even more limited number of vehicle spots aboard Vineyard-bound ferries departing from Rhode

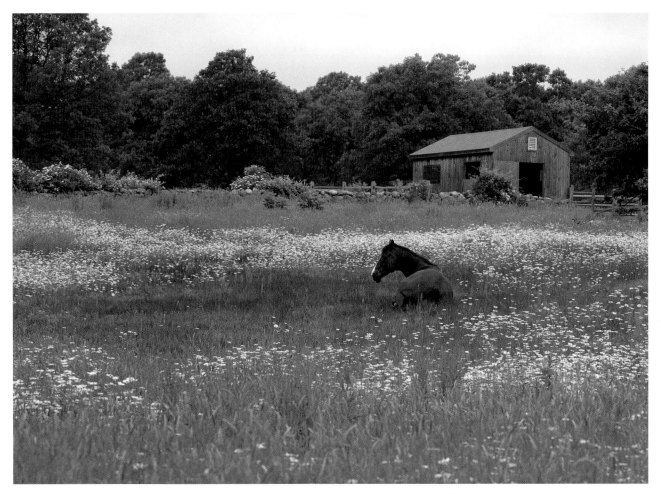

Martha's Vineyard is surprisingly bucolic. The island is home to a number of horse farms and horseback riding trails: A private, gated equestrian community is even being developed on the Vineyard.

Island and Massachusetts. Tisbury, or Vineyard Haven, is a congested commercial hub; its harbor is the port of arrival for most mainlanders. Culturally diverse and architecturally eclectic, Oak Bluffs is the Vineyard's original resort area and, as one of only two "wet" towns (alcohol is also served in Edgartown), a destination for dining and nightlife. Edgartown, settled by the English in 1642, exudes New England charm. Like neighboring

Right: The Martha's Vineyard town of Oak Bluffs, originally incorporated as "Cottage City" in 1880, is home to the most notable collection of Carpenter Gothic–style houses in the world. The grounds of the Martha's Vineyard Campmeeting Association are home to hundreds of these elaborately filigreed "gingerbread cottages," which truly resemble delicate confections.

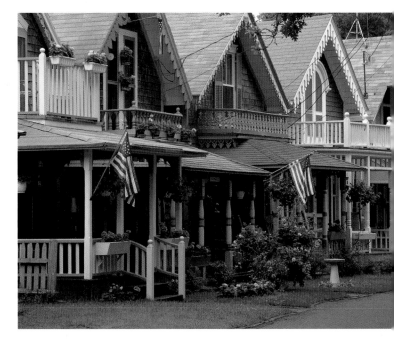

Vineyard Wonderland

STEPPING INSIDE THE thirty-four-acre grounds of the Martha's Vineyard Campmeeting Association in Oak Bluffs is akin to falling through a rabbit hole. Fancifully detailed gingerbread cottages painted petal pink, sea coral, lemon-drop yellow, and every other shade of the pastel rainbow crowd so close along narrow, circular streets that their peaked roofs almost touch. You'd half expect fairies or elves to inhabit these petite residences, but they're the homes of ordinary people with an extraordinary devotion to caring for their life-sized dollhouses—and for each other.

Most of the more than three hundred cottages that occupy tiny, Association-owned lots were built between 1859 and 1880. Their architectural style mimics the tents they replaced. The faithful and the curious have flocked to these picturesque grounds since 1835, when Edgartown resident Jeremiah Pease selected an old oak grove as the site for a religious campmeeting. Although founded by Methodists, the Martha's Vineyard Campmeeting Association was never formally connected with the Methodist church, and it remains a Christian organization that welcomes all faiths.

Most cottages are seasonal, and while some have remained in one family, a handful go on the market each year. All a prospective buyer needs is a letter from a clergyman, two letters attesting to his character, approval of the Residential Lease Committee, and $400,000 to $500,000. Newcomers, particularly those who volunteer, are quickly immersed in the rhythms of the community.

"We have a plethora of activities," says Sally Dagnall, who has been coming to the campground for more than sixty summers and met and married her husband here. Renters and even day visitors can also attend everything from Sunday services to concerts, movies, plays, and weekly Community Sings. "There are activities almost every night" in July and August, says Craig Lowe, the Association's Publicity Chairman and a seventh-generation resident. The 1879 wrought-iron Tabernacle, the only structure of its kind in the country, is the hub of activity. The height of the season arrives on an August evening, when ten thousand visitors turn out to see the cottages' glowing lanterns during the Grand Illumination, a tradition that is more than a century old.

Dagnall, author of the first published history of the Association, admits that there are potential drawbacks to living in a place where a sneeze can elicit a "God bless you" from three doors down. Residents must follow "good neighbor" rules. "We have to be quiet by eleven," she says. And some of her neighbors have had strangers enter their homes, unaware that while these adorable abodes have National Landmark status, they are not museums.

Still, the benefits far outweigh any negatives. "This is such a special place," Dagnall says. "It's like living in America one hundred years ago." Neighbors drop by to visit. Kids bang pots in the Fourth of July parade. "People look out for each other's children and they look out for each other," she says. When friends meet after months away, "it's like you saw them yesterday," Dagnall adds. "It's a world unto its own, a comfortable world."

The community not only fosters lifelong friendships, it may engender long life. Lowe says, "I don't know whether it's the water or the atmosphere, but we have a lot of elderly people here."

The season's end is bittersweet, but email newsletters keep members connected until they meet again on island shores. "You just pray that everybody comes back next year," Lowe says.

Nantucket, its boutique-lined brick sidewalks, land-mark churches, and stately sea captains' homes reflect nineteenth-century whaling wealth.

The towns that lie at higher longitudes, or Up-Island, are surprisingly bucolic. Fishing and farming were the island's primary occupations for a century and a half after settlement. In West Tisbury, the farmers' market attracts frenzied crowds, and in Chilmark, sheep still graze in stone-wall-enclosed pastures. The salty fishing village of Menemsha in Chilmark is the Vineyard's best place to eat fresh-caught lobster and savor a sunset. And in the south-western town of Aquinnah, where members of the Wampanoag tribe inhabit ancestral lands, the red-streaked clay Aquinnah Cliffs they hold sacred are the island's most mesmerizing sight.

Martha's Vineyard is equally well known for the things it lacks: traffic lights, chain stores, fast food

outlets. It's not just the fifteen thousand year-round Vineyarders, including some who haven't been off-island for decades, who care deeply about protecting the natural beauty and small-town feel of their island home. When the population swells fivefold and the dollar value of the private jets parked at Martha's Vineyard Airport is nothing short of astounding, the island benefits from the energy and generosity of equally devoted summer residents. "When they are here, they become important mem-bers of the community," Caldwell says.

For a quarter-century, Art Buchwald was at the podium for the Possible Dreams Auction, a major annual fundraiser for Martha's Vineyard Community Services, banging the gavel on such fantasy items as a private concert at Carly Simon's Vineyard home and revelation of her secret inspiration for "You're So Vain." Buchwald died in January of 2007, and

Stunning vistas, such as this scene of boat-dotted Quitsa Pond from the Nashaquitsa Lookout, unfold on a drive Up-Island.

although the auction was planned as usual that summer, for the first time in the event's twenty-nine-year history, the heavens sent rain.

The Water's Keeper

The Type-A people who vacation on Martha's Vineyard are "not very good at recreating, so they get involved with something," says Dean Starbuck Bragonier, Martha's Vineyard program director for Nantucket Soundkeeper. "We have a massive influx of very powerful and successful individuals," he says. "They pour a lot of their time and effort and money into preserving this area."

Bragonier's job is to educate Vineyarders and to focus philanthropic efforts on an ecologically unique, historically significant, and recreationally superb interior sea—Nantucket Sound—situated at the junction of the cold Labrador Current and the warm Gulf Stream. "The draw is the body of water that encompasses these three land masses: Nantucket, Martha's Vineyard, and Cape Cod," he says of the region's appeal. "You take out the water, and all of a sudden you've just got three bumps on a map."

Descended from the Starbuck family of Nantucket whaling fame on his father's side and with a strong naval lineage on his mother's side, Bragonier would have been genetically inclined to embrace life on the water even if his parents had not brought their three-day-old infant home from the hospital to their idea of affordable Manhattan housing—a trawler moored at the Seventy-Ninth Street Boat Basin. He spent childhood summers on Nantucket, met his wife, musician Sally Taylor, while working as a lifeguard on a Martha's Vineyard nude beach, owned an Oak Bluffs café for five years after college, and lobbied hard for a return to the coast from Colorado, where he and Taylor founded the Tranquility Project to assist Southeast Asian land-mine victims. Philanthropy resonated with him; the mountains did not.

When Taylor, her brother, Ben, and their mother, Carly Simon, played a Riverkeeper benefit concert in New York during the summer of 2006, Bragonier

approached Robert F. Kennedy Jr. about getting involved with the Waterkeeper Alliance, a nonprofit that supports more than 150 local "Keeper" organizations. After a month of volunteer work, he was on the payroll at Nantucket Soundkeeper, a program of the Alliance to Protect Nantucket Sound, which was formed to oppose Cape Wind's plans to locate an offshore renewable-energy project on Horseshoe Shoal, "right in the middle of the Sound."

This "opportunity to be actively working to preserve a body of water that my family has enjoyed for centuries" was "definitely meant to be," Bragonier says. The essence of the Keeper concept is "making your presence known by regular and reliable patrolling" of a waterway. He's as likely to be found on the Sound chatting with commercial fishermen and recreational boaters as he is to be meeting with bureaucrats or speaking about the environmental advantages of organic fertilizers.

Nantucket Sound is "a relatively pristine body of water; we are in an opportune position to simply maintain and preserve," Bragonier says. Regardless of the Cape Wind outcome, Nantucket Soundkeeper will continue its efforts to mitigate threats posed by development and protect sensitive finfish and shellfish habitats.

Water Street's landmark National Hotel comes into view as the Block Island Ferry approaches Old Harbor. Before they even set foot on land, newcomers realize they're bound for an enchanting, time-forgotten place.

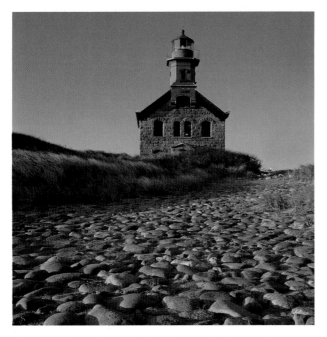

The 1867 Block Island North Light, the third to stand on the unsteady shore at Sandy Point, was unceremoniously abandoned in 1973, rendered obsolete by a much less fetching steel tower offshore. The town of New Shoreham acquired the aging and badly vandalized lighthouse in 1984 for one dollar, and volunteers have worked tirelessly to raise the funds to restore the granite beacon and its iron tower to their former glory.

Bragonier, like many others from all walks of life who cherish the beaches, seafood, and island way of life, says he can only feel deserving of the luxury to work, play, and raise a family in this environment "by pitching in to preserve it."

Block Island

Bitter saline winds signal that winter isn't going away more reliably than any furry forecaster. So, while the people of Punxsutawny, Pennsylvania, are hoisting Phil and making proclamations about spring's ETA, the residents of Block Island spend Groundhog Day taking a headcount. The results of the semiofficial annual census are announced and toasted at the Albion Pub that evening. Residents who are off-island on February 2 miss their chance to be enumerated, but curious tourists count. "If you come out for a beer, you get counted," says Block Island Historical Society administrator Ben Hruska.

Situated twelve miles south of Rhode Island and fourteen miles east of New York's Montauk, this three-by-seven-mile, pork chop–shaped isle's winter population is usually shy of a thousand souls. New Shoreham, the island's lone municipality, is the smallest town in America's smallest state. Hruska recalls feeling intimidated the first time he substituted at Block Island School and was told he'd teach the entire senior class: "Four people walked in."

While residents of other seasonal New England spots eagerly anticipate autumn, when visitor numbers subside, Block Islanders are inclined to greet spring with open arms, even though it means ferries will soon deposit hordes of beachgoers on the shores of this quirky Victorian throwback island. "I don't like all of the empty houses in the winter," says *Block Island Times* columnist Martha Ball. Come May, "the days are long, the light is golden," and "everything is new and full of promise," she says.

The gracious architectural lines of nineteenth-century hotels with wraparound porches and rooftop cupolas ease into view long before ferries inbound from Rhode Island, Connecticut, and New York dock at Old Harbor. Block Island was settled in 1661 by sixteen families, whose names are inscribed on Settlers' Rock near the North Light. They were fishermen and farmers, as hundreds of miles of stone walls crisscrossing the island attest. Unlike Nantucket and Martha's Vineyard, though, Block Island "had no natural harbor," says Hruska, explaining the island's delayed heyday. After 1874, when Old Harbor was constructed, and especially after 1895, when the Great Salt Pond was opened to the sea, a thriving tourist business became a possibility.

More than 150 years after the first hotel—the still-elegant Spring House—opened its doors, tourism remains the island's lifeblood, in spite of the high costs of maintaining and operating old hotels on an island where all goods must be shipped via ferry and electric rates are the highest in the continental United States. Businessman and island tour guide Jim Murphy, who built the mahogany Block Island Sittin' Machines—Adirondack-style chairs—that grace the Spring House's front lawn, explains

that while rooms don't come cheap in-season and the ambiance is grand, Block Island is a casual place. He tells people who want to wear a jacket and tie to dinner to "go to Newport. Out here, we don't care for that," he says.

What islanders do care about is preserving their piece of paradise so that visitors will always find Victorian grandeur and wild beauty here. Doug Hoyt, president of the Block Island Conservancy, a grassroots organization formed in 1972 to acquire 230-acre Rodman's Hollow, says the goal is to "preserve the cultural heritage and the character of the community." Islanders' early conservation efforts attracted the attention of the Nature Conservancy, a national organization, and also led to the formation of the Block Island Land Trust, a municipal agency with the power to tax real-estate transactions and float bonds to raise funds. "Open space is easy if you have a lot of money. Everyone's in favor of open space; it's like motherhood," says Hoyt, an attorney who finally tired of commuting to New York City. When the Nature Conservancy named Block Island one of Earth's "last great places" in the early 1990s, citing its diverse habitat and more than

forty state and federal rare or endangered species, it fueled fundraising efforts, and the trio of organizations has been instrumental in preserving 40 percent of the island's 6,200 acres.

Standing atop the 150-foot clay cliffs on the south side of Block Island, the glorious sea scene seems majestic and serene, but the Mohegan Bluffs are named for the carnage that occurred when an invading band of forty Mohegan Indians was rebuffed by the island's native Manisseans in 1590. With erosion occurring at a rate of seven-and-a-half feet or so per year, Southeast Light seemed likewise doomed to tumble over the sheer bluffs, but in 1993, after a decade of fundraising and planning by passionate islanders, the lighthouse was safely moved from its precarious perch.

Visitors who spend a day bicycling, hiking, sunbathing, shopping, or touring the island with an opinionated cab driver sometimes miss the fact that Block Island is "a community where people live; it's not just this pretty little vacation town," says Ball. Whether it is the forces of nature or the designs of man that threaten to alter this great place, islanders take a stand, and that's what really counts.

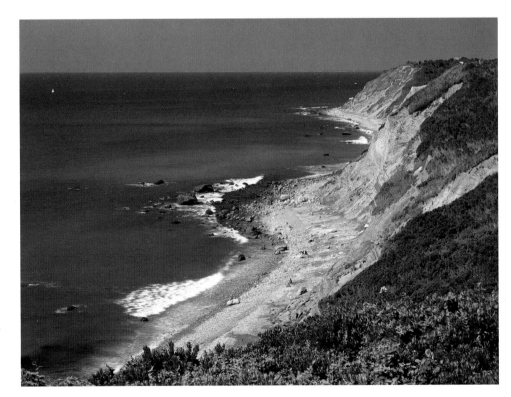

Reaching the secluded beach at the base of Block Island's inimitable Mohegan Bluffs requires a ferry trip from the mainland; a cab, moped, or bicycle ride clear across the island; and a somewhat treacherous descent along a steep, narrow wooden staircase—but the experience of standing on this remote curve of sand is simply unforgettable.

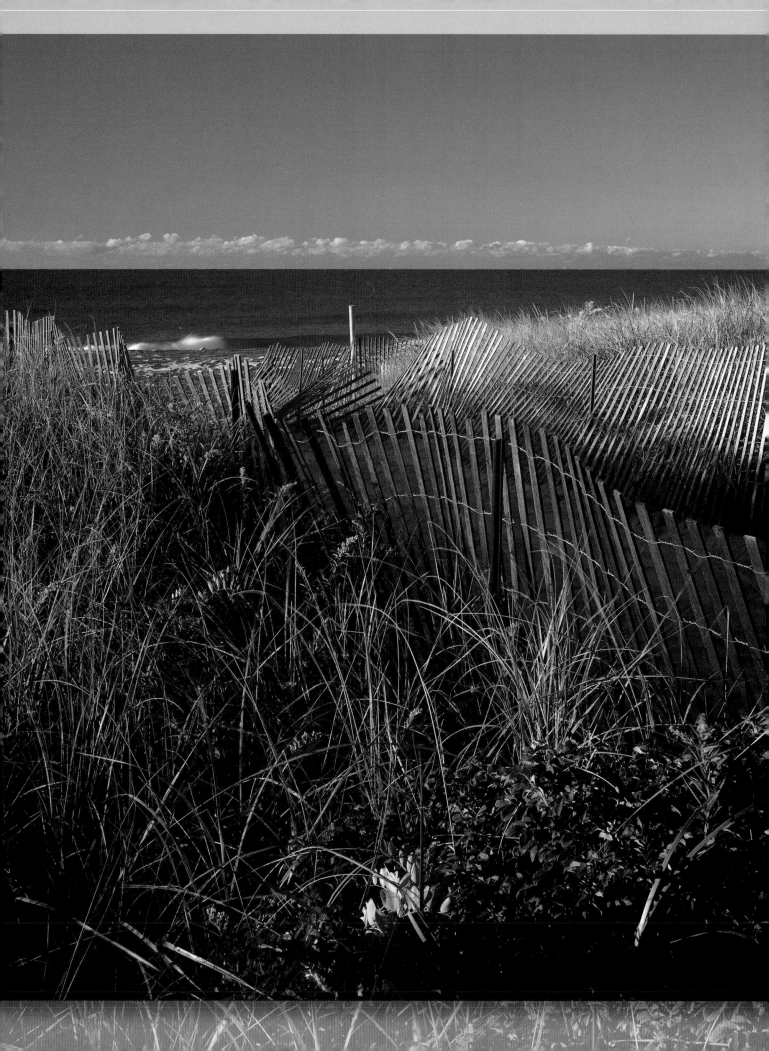

CHAPTER 7

Rhode Island

Ubiquitous Beaches

Above: At the Avondale Boat Yard on the Pawcatuck River in Westerly, boat jack stands that hold stored boats off the ground through the winter are cast aside once fair winds return.

Left: A walking path across the grassy dunes leads to the Atlantic waves and wide band of sand at Watch Hill's East Beach.

The tiniest state in America measures just forty-eight miles long and thirty-seven miles wide. So how can Rhode Island's coastline run for four hundred miles? Put down the calculator and number-two pencil, and turn instead to a map or aerial photograph of Little Rhody, and the answer to this riddle becomes instantly clear. Narragansett Bay cuts a jagged crater deep into the state, adding 256 miles of mainland and island shoreline to the equation. The upshot is: If you're within Rhode Island's borders, it's impossible to be more than thirty minutes' drive from the coast.

Of course, it is the allure of being directly on this historic and dramatically varied seafront that prompts tourists to spend $5 billion in Rhode Island annually. The aptly nicknamed "Ocean State" has more than one hundred public and private beaches, some natural and unspoiled, others replete with concessions and amusements. In another twist of logic, everything tastes better near the shore, whether it's fritter-like clam cakes or the state's own chowder, a clear-broth variety teeming with native quahogs. Even the chief attraction in Rhode Island's most popular destination benefits from its proximity to the sea. Situated on the southern end of Aquidneck Island—the largest of more than thirty isles in Narragansett Bay—Newport was once the summer playground of America's wealthiest families. The magnificent oceanfront homes they left behind are the city's finest treasure. If you were to transplant them to the Berkshires or the Catskills, "Would people go see them? Sure," says Evan Smith, who heads the Newport County Convention and Visitors Bureau. "Would the same number of people go see them?" he speculates. "I don't think so."

Little Compton : A Rural Bastion

Little Compton occupies the southern portion of a peninsula bounded by the Sakonnet River and the Massachusetts state line. This Newport County town is just a twenty-five-mile, circuitous drive from the city of Newport, yet this rural bastion remains something of a secret. If you do find your way to Little Compton, good luck finding your way around. "There are no signs"; the locals "don't want you to know where you are," says Susan Samson, who began escaping to Little Compton from New York City with her husband thirty-five summers ago.

"Keep Little Compton little" is many residents' motto, says Samson, a native Midwesterner who initially elicited odd looks when she'd greet people with a "Hi, how are you?" Many Little Compton families have held their lands for generations, and those who hope to infiltrate this community must exercise patience. Some newcomers depart hastily when they learn they can't buy their way into the local yacht or golf clubs. "People get in," says Samson: "It just takes four or five years." The residents of Rhode Island's second-least-populated town are "not

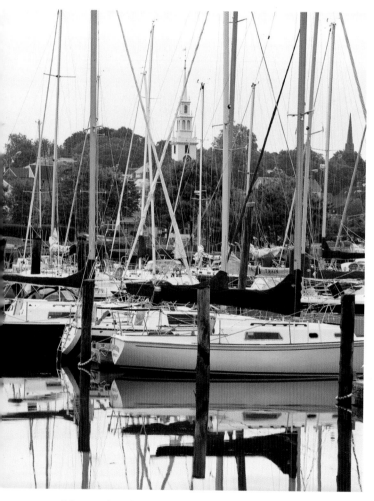

Newport has always been defined by its waterfront, and sailing remains one of the city's most popular leisure pursuits.

Little Comptoners are loathe to ask for assistance. "People are so proud," says longtime resident and vineyard owner Susan Samson. Volunteer-supported organizations, such as the Little Compton Community Center, ensure, however, that the needs of residents are met. "It's just neighbors sharing with neighbors," Samson says.

snobby as much as they are reserved," Samson observes. "They wait and see what you're going to do. It's very New England."

Resistance to change has its merits. The waters off Sakonnet Point still sustain a small fishing fleet. Little Comptoners care deeply about land conservation and agricultural preservation. In 2007, after more than thirteen years of negotiations, conservancy groups and state and federal agencies successfully ensured Little Compton's Treaty Rock Farm will remain forever agricultural. Named for the alliance forged there between the colonists and the Sakonnet Indians during King Philip's War, the

120-acre riverside farm has remained in the Richmond family for more than 350 years. The three sisters who own the property will continue to produce wool and beef on the protected plot.

Although Little Compton's fruit and vegetable growers haven't embraced agritourism, Samson says that "chefs come from as far away as Boston to buy from our stands." And most tourists who do wander over from Newport or Cape Cod are lured by the opportunity to sample the fruit of the land. In 1987, the original owners of New England's oldest winery—Sakonnet Vineyards—decided to sell. "My husband and I are a little bit crazy, so we bought it,"

By the advent of the twentieth century, Newport's rocky shoreline had become the province of America's elite families. The Cliff Walk—New England's most splendid coastal pathway—ensures that the ocean views they treasured will always be accessible to the public free of charge. (Photograph by Kim Knox Beckius)

Samson divulges. Little Compton's cool weather climate resembles that of France's Burgundy region, and the Samsons have grown and experimented with a variety of grapes: Pinot Noir, Gewürztraminer, Chardonnay, Vidal. "We're making very good wines at this point," says Samson. Unlike their neighbors, "we love people to come, and we encourage them to walk through the fields."

The winery is on Little Compton's outskirts, near the Tiverton line, and there isn't much reason to venture farther. Visitors may head east to the village of Adamsville, where a monument commemorates the famous red chicken first bred in Little Compton—the Rhode Island Red—and Gray's general store has operated continuously since 1788. You can also drive to Sakonnet Point "and just look, but there's nothing to do out there," says Samson. The 2009 debut of the Stone House Club, an upscale destination resort, may alter the Point's character.

Change *does* occur in Little Compton, but "it's amazing how slow it is," Samson remarks. Just as every wine reflects its place of origin, Little

Compton has rubbed off on the Samsons, who have transferred some of their acreage to the Little Compton Land Trust. And, in spite of the potential cost savings, they're sticking with corks. "The whole romance of opening a bottle of wine is not screwing off a cap," she insists.

Newport: Seaside Splendor

In the context of its nearly four centuries of history, Newport's heyday was a relatively brief, forty-year chapter. But oh, what a glorious epoch unfolded when real estate heir William Backhouse Astor Jr. purchased and refurbished an oceanfront "cottage" in 1881. "*The* Mrs. Astor," as his wife, Caroline, the reigning queen of New York society, preferred to be called, "unleashed the tidal gates" when she took up summer residence in Newport, says Pieter Roos, executive director of the Newport Restoration Foundation (NRF). "If you wanted to be part of New York's high society, you had to have a house here," he explains. The NRF owns Rough Point, commissioned by Frederick W. Vanderbilt in 1887 at the start of the "building wars" along Bellevue Avenue. By 1905, palatial seasonal homes lorded over Newport's intriguing coastline.

As the country slid into Depression in the 1930s, the lavish balls, dinner parties, musicales, and polo matches became a memory. "By the 1950s, many of these houses were in a state of permanent disuse"; they "were seen as white elephants," Roos says. The Preservation Society of Newport County, founded in 1945 to save the city's architectural legacy, paid less than $100,000 apiece for many of the mansions now open to the public. Cornelius Vanderbilt II's The Breakers, the largest and most opulent of all, was acquired for $365,000. Thanks to preservationists' foresight, Newport remains "emblematic of the Gilded Age in a way that few other places are," says Roos. The opportunity to glimpse the lifestyle of the late nineteenth century's rich and famous attracts many of the city's three million annual visitors. The Cliff Walk, a 3.5-mile pathway that affords views of Bellevue Avenue's spectacular estates and

the thrashing surf they overlook, is Newport's most popular attraction.

The mansions tell only a small part of Newport's story, however. "The Gilded Age is fascinating, but the colonial period is Newport's golden age. Gilding is very thin; gold is deeper," Roos remarks. Settled by farmers in 1639, the city achieved prominence as activity shifted to its easily navigable, strategically situated bay. By the outbreak of the American Revolution, Newport was the colonies' fifth largest city. It was also "the first great laboratory for religious tolerance," says Roos, explaining that Rhode Island's 1663 Royal Charter was the first English document to grant freedom in "matters of religious concernment." The thriving seaport proved: "Not only can people of different religions live together, they can prosper," he says. The 1699 Quaker Meetinghouse and Touro Synagogue, the first

synagogue established in America in 1763, remain important landmarks. They're among 430 structures in Newport built before 1799. "Newport has as many or more eighteenth-century structures extant as any other city in America; you can come to Newport and see what a wooden city looked like," says Roos. The longevity of the city's early architecture is part luck— Newport never experienced a major fire—and part misfortune. British occupation turned Newport into an impoverished backwater; it never regained its prewar status as a merchant trading center.

Newport's position on the ocean has allowed it to continually reinvent itself, though, from the 1840s, when Fall River Line steamboats delivered the first vacationers, to the 1880s, when America's wealthiest coveted Newport views, to the half-century from 1930 to 1983, when the America's Cup came to

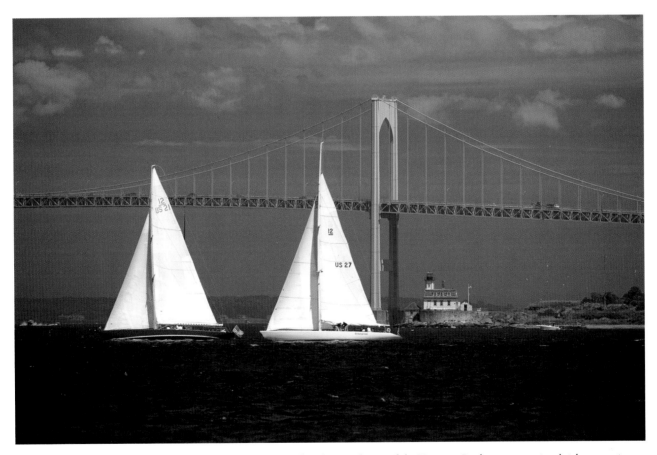

Rose Island Lighthouse was deactivated in 1971, two years after the completion of the Newport Bridge, a suspension bridge spanning Narragansett Bay's East Passage. Restored and relit in 1993 by the nonprofit Rose Island Lighthouse Foundation, it is maintained by an eclectic parade of vacationers who pay to serve as "Keeper for a Week." Two rooms in the lighthouse museum are also rented overnight to visitors seeking a shorter-term experience of lighthouse life.

Doris Duke's Most Priceless Collection

JAMES BUCHANAN DUKE was a southern tycoon who turned his father's tobacco company into a monopolistic enterprise. As his business interests diversified, "he decided he needed to be in New York," says Pieter Roos, and being a member of the city's high society still meant summering in Newport in the 1920s. After renting for a few summers, Duke purchased Frederick W. Vanderbilt's Bellevue Avenue mansion in 1922 and moved into the renovated and expanded home two years later. He died the following year.

Rough Point was one of several properties twelve-year-old only child Doris Duke inherited, along with $100 million of her father's fortune. Christened the

Billionaire heiress and philanthropist Doris Duke bestowed many gifts upon Newport, not the least of which was her own estate—Rough Point—with its vast collection of fine and decorative arts intact. (Photograph by Kim Knox Beckius)

"Million Dollar Baby" by the press, Doris had summered in Newport since the age of three, but the world beckoned to the jet-setting heiress. By the 1950s, she attempted to donate Rough Point to Newport Hospital; the offer was declined. As the decade waned, however, she nostalgically reembraced Newport, and until just a year before her death in 1993, she spent three months annually at her forty-room seaside estate. An avid swimmer, she was known for plunging into the ocean daily until she was well into her seventies, "which was no mean feat; the water's not always warm," Roos says. When swimming off the rocks at Rough Point finally became impractical, she installed a saltwater lap pool in the basement.

town, branding Newport the "Sailing Capital of the World." The waterfront remains a bustling shopping and dining district, the backdrop for a diverse lineup of concerts and festivals, and home to Newport County's largest employer—the U.S. Navy. Evan Smith, president and CEO of the Newport County Convention and Visitors Bureau, says: "No trip to Newport from May to October is complete unless you get out on the water." This was, after all, America's original recreational hotspot, a place where not only sailing but golf, tennis, and polo "made their American debut," he says. For tennis fans, there's no greater thrill than playing on the Tennis Hall of Fame's hallowed, yet public, grass courts. Newport, Smith notes, is "a place where history and sport and culture all come to life."

The hospitality community is intent on expanding Newport's "season," and wherever he goes, Smith eagerly extols the year-round virtues of this seaside destination, not the least of which is its unrivaled assortment of three hundred unique bed-and-breakfast inns. There's one time of year, however, when he tries not to travel. "Summer in Newport is extraordinary," he says. "When you're here in the summer, and you smell the ocean breeze and see Newport in all of her glory . . . it is an impressive show. I am just euphoric for 120 days. Why would I go anywhere else?"

Surfin' RI

It's not Malibu or Maui, but Narragansett is the hub of surfing in New England. That's right—surfing in

Doris willed Rough Point to the Newport Restoration Foundation (NRF), an organization she founded in 1968, with the express intention that it be opened to the public. "Handing over Rough Point with its great collections intact was a wonderful gesture on her part," says Roos, the organization's executive director, but it was hardly her greatest gift to Newport. Known for her eccentricities and for amassing incredible troves of everything from couture jewelry and wine to exquisite furnishings and Islamic art, the heiress also snatched up almost eighty colonial structures in Newport starting in the late 1960s. Unlike some people of her stature, "she had a lot of intelligence and pursued interests in great detail," Roos remarks. Preserving eighteenth-century architecture was not a lark, but a passion. "She went to desperate measures to save these houses; they were houses no normal preservationist would collect," he says, explaining: "These old buildings were about as bad as they could be without being torn down or saved." Once she'd

stabilized them, however, "she wasn't entirely sure what to do with them," says Roos. Some advised her to create "a Williamsburg of the North," but she knew intuitively that "eighty separate house museums scattered around Newport wouldn't work," he says.

"I like the fact that they're not museums because a house museum is an artificial change," says Roos. By maintaining these colonial structures as residences, shown to the public only from the exterior on walking tours, the Foundation sustains Newport's character without disrupting its existence as "a living, breathing community." Still, ensuring these structures' survival is one of NRF's main aims. "Nobody else owns seventy-six eighteenth-century houses in Newport; I take that very seriously," Roos says. He's also devoted to enhancing awareness of "what Doris Duke did for Newport. If it hadn't been for her," he says, "three-quarters of the houses we own wouldn't be standing today. She had a remarkable effect on Newport. I think it's underappreciated."

New England. It sounds even more far-fetched considering that the region's biggest, gnarliest waves curl up in the dead of winter, but stroll along Narragansett Town Beach on a frigid day, and you might see diehards clad head to toe in neoprene, icicles dripping from their goggles, brazenly paddling into the swells. They could be warming up for the New England Mid-Winter Surfing Championships, held each February in Rhode Island since 1968. In summer, the waves are less vigorous, yet still fairly reliable and *much* warmer, making Narragansett's half-mile, sliver-of-moon-shaped beach a popular destination for both shredders and beginners. Two nearby surf shops offer rentals and lessons, and a section of the town beach is reserved solely for wave riders.

There are separate fees for parking and admission, but that doesn't keep crowds away from 'Gansett's Town Beach on warm weather days. Energetic Narragansett Bay waters and the entertaining exploits of surfers aren't the only things that make this swath of firm, gray sand a standout. There's no beach in New England with a more glorious architectural backdrop. As daylight fades, spotlights illuminate the resilient and graceful stone structure that spans Ocean Road. "The Towers" was designed by famed New York architects McKim, Mead & White as the gateway to their Narragansett Pier Casino, which was completed in 1886 and immediately became the elite resort community's center of recreation and entertainment. "The Pier," with its ballroom, bandstand, theater, shops,

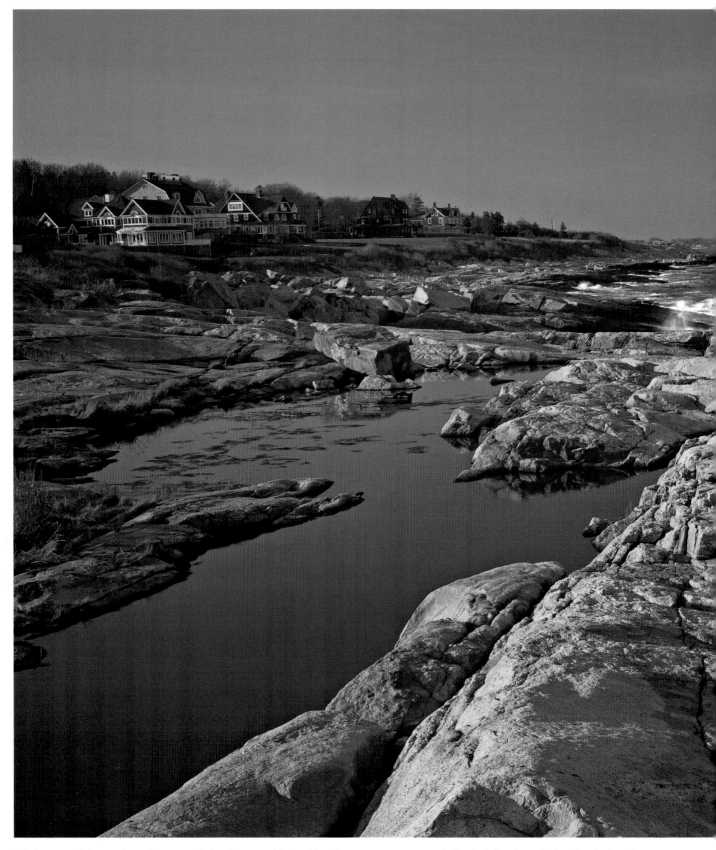

With views of glassy tide pools, trapped behind immovable boulders that carry on an around-the-clock battle with the relentlessly roiling sea, the owners of grand cottages along Narrangansett's shore must have little need for TV.

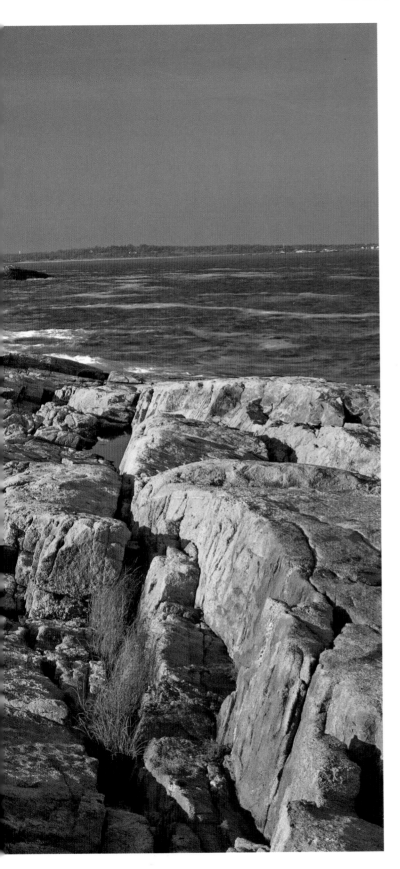

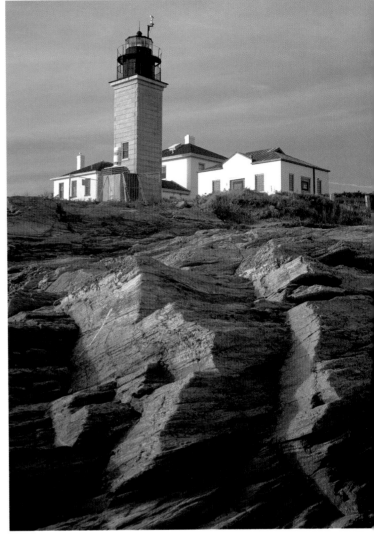

Beavertail Light is located at the southern tip of Conanicut Island in Jamestown's Beavertail State Park. In 1749, this dramatic tip of land was selected as the site for the nation's third lighthouse. The current stone tower dates to 1856.

restaurants, tennis courts, bowling alley, rifle range, and billiard room, was destroyed by fire in 1900: "The Towers" survived. The epic Hurricane of 1938 also failed to dislodge the granite landmark, as did a 1965 fire that doomed the rebuilt casino. Beautifully restored and used as a venue for public and private events, "The Towers" reminds beach-goers of a simpler time, when music was played by a band, not a boom box; friendly badminton games made *New York Times* headlines; and vacations at the beach lasted all summer long.

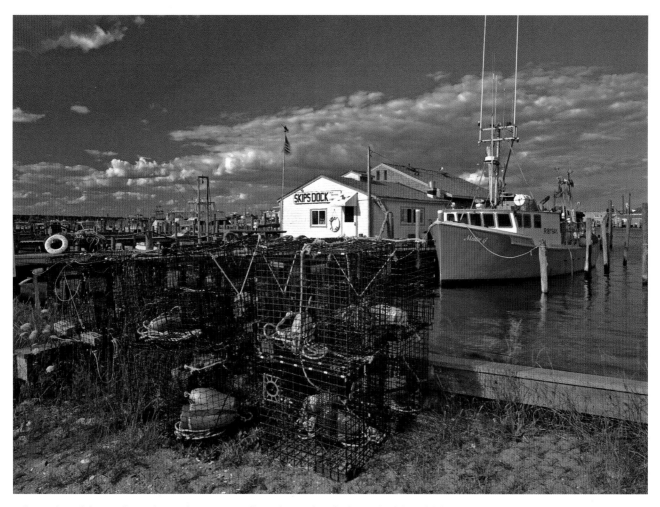

The working fishing village of Jerusalem is an excellent place to buy fresh-caught fish and lobsters right off the docks.

Shipwrecks and Seafood

In the eighteenth and nineteenth centuries, ships navigating the busy water route between New York and Boston often did not fare well along Rhode Island's coast. More than two thousand wrecked ships still litter Rhode Island's sea floor: the largest number per square mile of any state in the nation. No place was more treacherous in a storm than Point Judith, Narragansett's mile-long shoreline protrusion at the western entrance to Narragansett Bay. Even after the first lighthouse was installed in 1810 on the tip of land that delineates Block Island and Rhode Island Sounds, ships continued to run aground: Some years, the Point's rocky shoals claimed more than one vessel per month. The octagonal, brown and white Point Judith Lighthouse, built in 1857, is the third beacon

to stand on the site. From the scenic public grounds of this active Coast Guard Station, visitors can watch skilled surfers catching waves that surge and break like those that once prodded colonial trade ships and luxury passenger steamers perilously close to the Point.

Starting in 1890, the Army Corps of Engineers undertook a Harbor of Refuge federal navigation project at the entrance to Point Judith Pond, a four-mile-long, north–south-oriented salt pond three miles west of Point Judith. Designed to provide safe haven for ships caught in storms, the construction and ongoing maintenance of a permanent breachway was also a boon to the twin villages of Galilee and Jerusalem, which flank the pond's outlet to the sea. Fishing had been a mere sideline for area farmers, but fishermen from Nova Scotia quickly realized this

Salt Ponds: Critical to the Coastal Ecosystem

SALT PONDS ARE a distinctive feature of Rhode Island's coastal terrain. These estuarine embayments, trapped behind the barrier beaches that built up between glacier-chiseled points of land from Watch Hill to Point Judith after the last Ice Age, are periodically breached—by shifting sands and by human plans. The tidal exchange that keeps salinity levels in flux makes the ponds' ecosystems dynamic. Sustaining the health of these placid pools is important, not only because they serve as major destinations for water contact recreation, but because the creatures that breed and incubate below the surface are a critical link in the region's food chain.

Rhode Island's nine coastal salt ponds provide inviting habitat for quahogs, steamers, oysters, and blue crabs; their eelgrass-blanketed floors are a nursery for juvenile fish. The ponds provide not only an abundant food source for fledgling marine life but "protection from the big open waves and from predators," explains Mark Bullinger, executive director of the Salt Ponds Coalition. By summer's end, the ponds teem with tiny baitfish that "form the basis of the food chain," he says. "You can see huge schools—millions of them—big dark clouds of them." As pond water temperatures cool, they head for the ocean, where hungry schools of blues and bass await. With sport fishermen descending on the region each fall from as far away as North Carolina, the state's tourist economy is also dependent upon these little fishes.

From Charlestown's Ninigret Pond—the largest in the chain, with three marinas and a state boat launch—to South Kingstown's pristine and protected Trustom Pond, the salt ponds support a variety of commercial and recreational pursuits: aquaculture, fishing, kayaking, sailing, windsurfing, hiking, clamming, birdwatching, beachgoing. Some, like Quonochontaug Pond, are quite healthy, but "they're all under stress," Bullinger says. Threats include nutrient loading, a byproduct of shoreline development; sedimentation, which can inhibit the inflow of refreshing tides; and warming temperatures, which retard eelgrass growth and foster algal blooms. Stagnant waters and dense development have made Green Hill Pond, connected via a channel to Ninigret Pond, "the most contaminated of the major salt ponds," but "our data indicates that things are becoming slightly better," Bullinger reports. The Salt Ponds Coalition, a watchdog group, is the "longest continuously operating volunteer marine water quality testing organization in the country," he notes. Volunteer Salt Pond Watchers have gathered critical information about the ponds' conditions since 1985.

The Coalition also encourages recreational use of the ponds. "The more we get people involved with the salt ponds, the more they'll be concerned about protecting the water quality," Bullinger believes. The organization's guided kayak trips and kid-friendly Salt Pond Safaris are "75 percent fun with this 25 percent message mixed in—just enough," Bullinger says, to "get people engaged with the ponds, help them understand them, and plant that seed of stewardship."

Recreational fishing boats moored in Galilee reflect in the sheltered waters of Point Judith Pond, the most developed of Rhode Island's salt ponds.

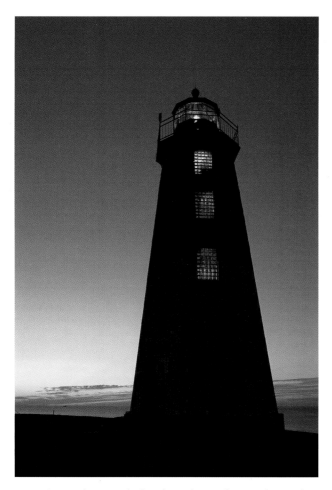

Dawn's rosy glow signals that the night watch is nearly over for Point Judith Lighthouse.

South County's Beach Extremes

Sediment deposited by receding glaciers was churned by the sea into the first massive ridges of sand that snake along Rhode Island's outer rim. These south-facing barrier beaches are reshaped daily by wind and waves; their inherent vulnerability makes them unsuitable for development: a lesson Rhode Islanders learned the hard way when these fragile sands bore the brunt of hurricanes' wrath in 1938 and 1954. By the 1970s, the state's Coastal Resources Management Council officially banned new construction on barrier beaches, which are highly susceptible to erosion. Governmental regulations and conservation efforts have served the public well, ensuring that wondrously diverse coastal expanses are accessible for recreation.

Daisies—symbols of innocence and perennial prognosticators of love—carpet a spruce-sheltered field at the Ninigret National Wildlife Refuge.

location's potential. Generations later, more than forty million pounds of fish and shellfish are unloaded at the Galilee State Pier each year, making Point Judith one of New England's most successful commercial fisheries. Recreational boaters and sportfishing charters also utilize this vital channel.

Galilee's fishing community has always had an uneasy relationship with tourists, who they fear threaten the character of this gritty working waterfront. The lure of watching lobster boats and trawlers at work and dining waterside on Rhode Island's freshest seafood is too much for many to resist, however, even though the sweet scent of greasy, deep-fried clam cakes only partially masks the overwhelming odor of salt air infused with diesel fumes, today's catch, and tomorrow's bait.

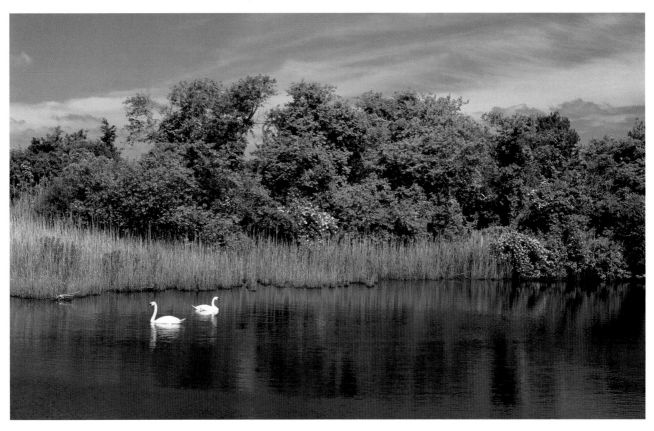

More than 250 bird species visit Charlestown's Ninigret National Wildlife Refuge annually, and seventy make its diverse terrain their nesting grounds. Habitat restoration is an ongoing objective at this former Naval auxiliary landing field, reclaimed as a nine-hundred-acre refuge on the banks of Rhode Island's largest salt pond.

South County isn't technically a county, but Rhode Islanders and savvy travelers know this region as an ocean lover's Eden. Encompassing one hundred miles of coastline between Wickford—North Kingstown's quaint waterfront shopping village—and Watch Hill, South County delivers a full spectrum of beach experiences. At one extreme is Misquamicut, a seven-mile chain of state and privately owned public beaches in Westerly. Families are drawn to this coastal community's dense assortment of motels and vacation cottages; its water slides, miniature golf courses, and other amusements; the fried seafood served at snack stands; and the moderate surf, ideal for boogie boarding and bodysurfing. Charlestown's pristine, three-mile-long East Beach is Misquamicut's antithesis. With facilities limited to a few portable toilets, this wild and peaceful beach haven, protected within the Ninigret

Conservation Area, has the aura of a tropical isle, complete with pale sand, gem-blue waters, and salt-spray rose–scented breezes.

Eternally Elegant Watch Hill

The fashionable and exclusive community of Watch Hill in the town of Westerly exists in a state of suspended animation. Its chief attractions are unaltered in a century's time. Its seaside homes with commanding views fetch modern, multi-million-dollar sums, but many of these lovingly kept Victorian cottages and shingled mansions have graced the landscape for generations. The last of Watch Hill's turn-of-the-century grand hotels—the Ocean House—will reopen in 2010, rescued from seemingly certain extinction. It wouldn't be at all unsettling to encounter parasol-toting women

The Great New England Hurricane of 1938

NAPATREE POINT, the slender barrier beach that defines Rhode Island's southwestern edge, has always been a fragile curl of land. The Great Gale of 1815 stripped this spit of its namesake forest. When the fiercest of all New England storms—the Great Hurricane of 1938—bore down on the Watch Hill appendage with little warning, the storm surge swept away the Point's cottage community, yacht club and all, leaving only a debris-littered sand swath in its wake.

Four Category 3 hurricanes made landfall in New England in the twentieth century, including back-to-back storms Carol and Edna in 1954, but none could match the massive, fast-moving '38 hurricane for its intensity. Its arrival at high tide amplified the tidal-wave-like surge, which rose eighteen to twenty-five feet along the shore from eastern Connecticut to Cape Cod. The storm, still the region's record holder for a wind gust of 186 miles per hour, stalled only briefly over southern New England, but by the time it subsided, 2,600 boats and 8,900 buildings had been destroyed, and there were 564 people dead, more than 1,700 injured, and 63,000 homeless. Rhode Island accounted for more than half of the casualties. Of the forty-two Napatree Point residents swept out to sea with their homes, fifteen perished.

"People have this false sense of security because it hasn't happened in so long," says Glenn Field, warning coordination meteorologist at the National Weather Service's Southern New England Forecast Office, of the more than fifty-year gap without a major hurricane in the region. "Southeastern New England gets hit by a Category 1 hurricane roughly every fifteen to twenty years; it's not that rare," Field says, but he explains that "it takes a special set of circumstances to *really* get hit." Although he says, "that doesn't happen often," many meteorologists and coastal residents can't help thinking: "We're due."

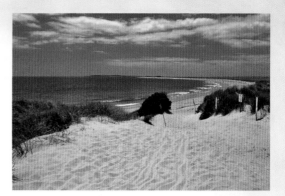

Napatree Point has been a New England ghost town since 1938, when the fiercest hurricane ever to make landfall in the region knocked the gracious cottages that lined this strip of sand into the sea. The fragile dunes now serve as habitat for migratory birds and a place of quiet relaxation for beachgoers.

While hurricane forecasting has improved immensely, Field cautions that New England storms—which accelerate faster and pack a stronger initial wallop than Florida hurricanes—can be both sneaky and potent. Computer models show that a storm in the "wrong" spot could create a storm surge "that's twice what anybody who's alive today has seen," he says. And while early warnings would hopefully minimize loss of life, the evacuation window could be as brief as twelve hours. The 1938 storm leveled 238 million trees in Connecticut alone: Many have been replaced by businesses and homes. "We'd be looking at a lot more property damage," if a storm of similar magnitude struck the highly developed coast, Field believes.

Napatree Point was never rebuilt; the conservation area's grassy dunes now shelter migratory birds and other wildlife. Its rippled sands, just a short walk from the center of Watch Hill, are a serene and scenic retreat for sunbathers, fishers, birdwatchers, and picnickers. Still, the Point's desolation is a reminder of nature's ferocity and unpredictability.

in long, fluted skirts during a stroll along boutique- and café-lined Bay Street, the eternally elegant village's central thoroughfare.

Instead, visitors chance upon Ninigret, chief of the Niantics; his bronze likeness guards the yacht-dotted harbor. Like their Native American predecessors, the colonists who named Watch Hill found this high peninsula an ideal lookout point during the French and Indian and American Revolutionary Wars. For twenty-seven years following the establishment of Watch Hill Light Station in 1808, its first keeper, Jonathan Nash, kept watch over boats navigating the eastern entrance to Fishers Island Sound. Later, Nash and his son, George, would open and operate the Hill's first hotel—famed for its twenty-five-cent lobster dinners. Guests arrived via steamboat, then later by electric trolley, as more seaside hotels sprouted up. By the twentieth century's dawn, the secluded coastal village was a well-established summer resort.

The Watch Hill Yacht Club was founded in 1913 for the purpose of sponsoring races and providing a gathering place for kindred souls with a passion for sailing. Today, the club's members still enjoy social events on and off the water.

Watch Hill's population still swells on summer days, as seasonal residents and visitors crowd Watch Hill Beach, with its brown-sugar sand and child-friendly surf. From this diminutive public sandbox at the foot of Bay Street, sunbathers enjoy excellent views of Watch Hill Lighthouse, rebuilt of granite in 1856 and automated in 1986. Just steps from the beach, America's oldest surviving Flying Horse Carousel takes youngsters under age twelve for a memorable spin. Its antique horses, each carved from a single piece of wood and adorned with a leather saddle and genuine horsehair tail and mane, don't just go-round; they're suspended from chains, so they lift off the ground and fly-round as the carousel's speed mounts. Built by the Charles W. F. Dare Company of New York in the mid-1860s and left behind by a traveling gypsy carnival in 1879, the carousel is one of only fifteen in the nation with a ring dispenser: The child who grasps the brass ring wins another ride. Day-trippers who arrive early to secure parking may find they've exhausted Watch Hill's entertainment possibilities by late afternoon, but if they leave too soon, they miss its most timeless sight. Views to the west over Little Narragansett Bay provide a rare East Coast opportunity to watch the golden tangerine sun settle into the sea.

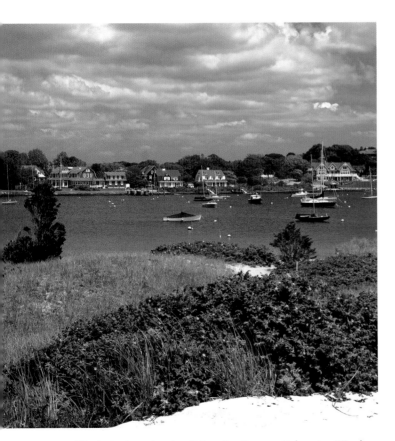

The lovingly maintained Victorian "cottages" that ring Watch Hill Harbor give this exclusive seaside resort unmatched charm.

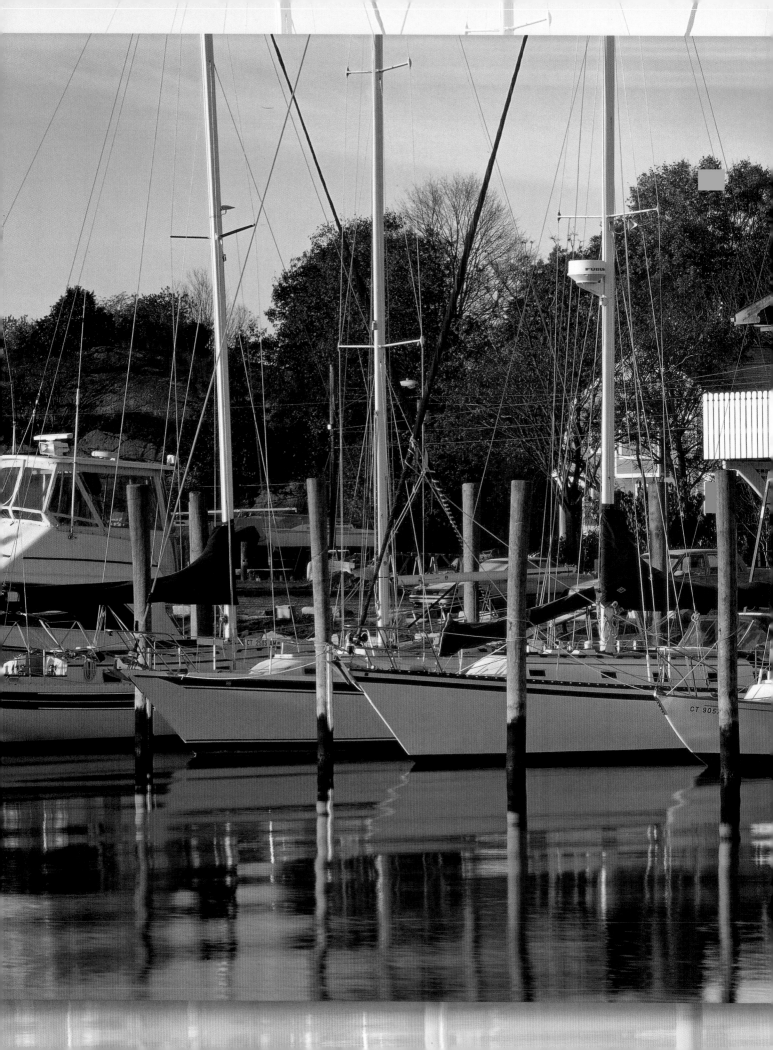

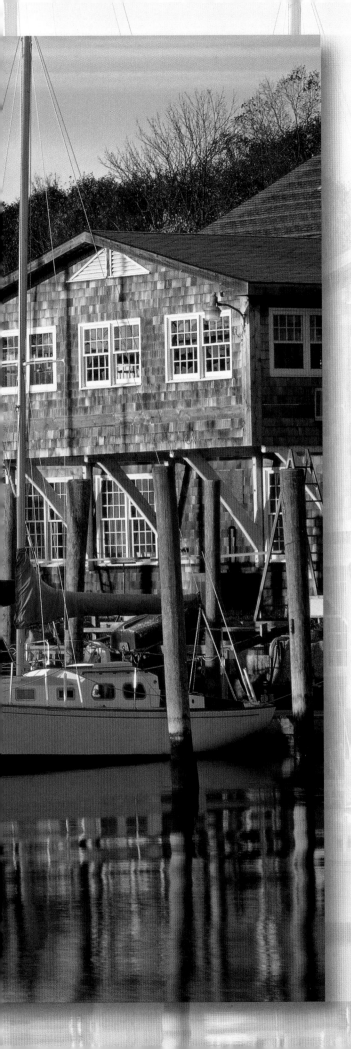

CHAPTER 8

Connecticut

*Proud Maritime
Traditions*

*Above: Children and even adults can hide inside this cavernous
Japanese maple tree at Harkness Memorial State Park in Waterford.
Edward and Mary Harkness, notable philanthropists, deeded their
230-acre estate on Long Island Sound to the State of Connecticut
in 1950.*

*Left: Even as fall's crisp air and warm colors signal the approaching
end of boating season, Mystic's recreational mariners keep their
sailboats at the ready, reluctant to miss any lingering opportunities
for golden moments on the water.*

Connecticut's history is as wedded to the sea as any New England state's. Veined with rivers that flow toward the sheltered harbors of Long Island Sound, *Quinnehtukqut*, as the Mohegans christened this "place of the long tidal river," was geographically predestined to play a vital role in the development of America's maritime economy. Its naval tradition is as old as the nation. Its pirate legends are older still.

At Mystic Seaport, America's seafaring heyday is vividly portrayed, and the artifacts of ocean-bound trade—including the last wooden whale ship afloat—are preserved. What visitors seldom realize is that the museum's expansive collections include twentieth-century outboard engines, marine radios, and other electronic nautical gear, too. "We're still collecting," says Mystic Seaport senior curator Bill Peterson.

Residential and industrial development has altered the coastal landscape, but Connecticut's maritime history is far from a closed chapter. In pockets along the shore, glorious natural expanses are preserved and centuries-old maritime pursuits survive. Groton's largest employer—Electric Boat—is still in the business of shipbuilding, albeit high-tech submarines. The U.S. Coast Guard Academy in New London trains cadets to sail the last square-rigged tall ship in active service, the Barque *Eagle*. New Haven is home port for the Freedom Schooner

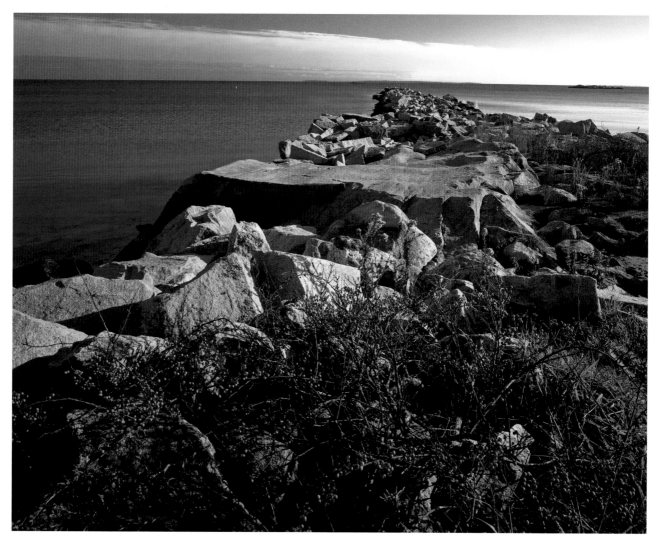

After Labor Day, when the summer crowds that flock to Rocky Neck State Park's white-sand beach have gone, this rock jetty—a favorite spot for fishing and strolling—becomes a solitary place.

Amistad, a replica of the storied slave ship, which makes educational visits to ports on both sides of the Atlantic. From his home base at the Institute for Exploration in Mystic, *Titanic* discoverer Dr. Robert Ballard continues his deep-water archaeological research. Collaboration among groups devoted to maritime studies is on the rise. "I see a critical mass of organizations with diverse maritime interests that are beginning to come together to form working relationships with one another," Peterson observes.

Long before Europeans arrived, Connecticut's native population relied on Long Island Sound's abundant fish and shellfish for sustenance. Even Indian currency—strung shell beads known as wampum—came from the sea. Cash and innovative ideas are the currency that now make Connecticut one of the wealthiest states. The southwestern shore is even dubbed the "Gold Coast" for its extraordinary affluence. The challenge for those devoted to preserving Connecticut's coastland is to convince those of means to cast their wampum back to the sea.

Brave Stonington Borough

"A Fishing Fleet Fights for Survival," blared a 1994 *New York Times* headline. "An Old Fleet Under a Dark Cloud" was the banner atop a similar *Times* story about Stonington Borough published in 2002. These doom-filled prophesies weren't without merit. In 1999, a sudden, catastrophic decline in Long Island Sound's lobster population garnered $13.9 million in federal disaster relief. Foreign competition and increasingly stringent government regulations designed to prohibit overfishing make it tough to eke a living out of the Sound. Still, this tiny village in the town of Stonington, located on a tapered, mile-long peninsula near the Rhode Island line, retains its proud distinction as home to the state's sole surviving commercial fishing fleet. As it has since 1954, the community gathers at the town dock each summer to feast on lobsters, clam fritters, and Portuguese chili; to celebrate the centuries-old fishing industry with a parade and the traditional Blessing of the Fleet; and to remember

those lost at sea, as a broken-anchor-shaped wreath is set adrift.

Perhaps there is something in the salt-tinged air that instills resiliency in the residents of this coastal enclave. What else could explain the bravado of the Borough's citizens when threatened with destruction and encouraged to evacuate by Commodore Thomas

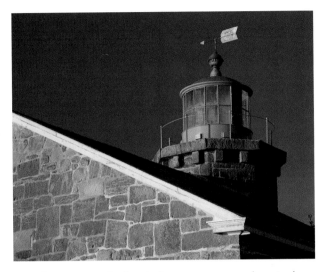

Circular iron stairs lead to the lantern room atop the retired Stonington Lighthouse's thirty-five-foot, octagonal tower—and to spectacular, 360-degree coastal views.

This cannon is one of a pair proudly displayed in Stonington Borough's Cannon Square. It represents one third of the entire artillery feisty citizens relied on to repel the British in 1812.

Hardy during the War of 1812? Although the British ships anchored offshore were armed with at least 120 cannons—and the village's entire artillery consisted of three—town leaders sent word to Hardy: "We shall defend the place to the last extremity; should it be destroyed, we will perish in its ruins." On August 12, 1814, after a three-day exchange of fire, Hardy's fleet sailed away in shame, and as the Battle of Stonington story spread, it bolstered the spirits of war-weary Americans.

Two of the cannons that saved Stonington stand in Cannon Square, at the junction of Water and Main Streets, surrounded by the stately homes of captains and merchants who prospered during the nineteenth century, when Stonington Borough was a busy whaling, sealing, fishing, and trade port. The sophisticated galleries, antique shops, and eateries that line Water Street; the staggering price tags on waterfront homes; and the luxury yachts that glide before the admiring eyes of sun seekers at petite, yet public, duBois Beach seemingly mock these symbols of resistance.

Although some urban transplants object to the noise—and smell—associated with the working waterfront, and recruiting a new generation to fish these waters may prove challenging, lobsters, scallops, flounder, and other groundfish sustain the fishing families, many of Portuguese descent, who persevere.

Near Stonington Point, at the peninsula's tip, the 1840 Stonington Harbor Light, inactive since 1889, is now the Old Lighthouse Museum, a repository for town artifacts including a twenty-four-pound British cannonball. The lantern room in the tower affords far-reaching views. From this spectacular vantage point, what's difficult to detect is any hint of gloom ahead for stalwart Stonington Borough.

Mystic : More than a Slice of Heaven

Even before a family-owned pizzeria on Main Street sparked a Hollywood screenwriter's imagination, Mystic was Connecticut's best-known coastal destination. Mystic is conspicuously absent, however,

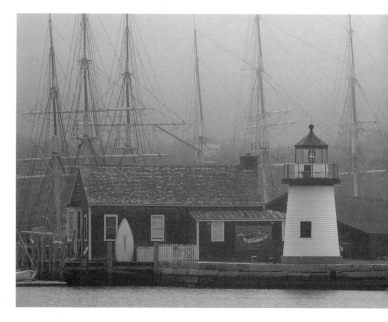

Murky fog is nature's authentic touch at Mystic Seaport, where America's seafaring heritage is honored, analyzed, and preserved.

from the official list of Connecticut cities and towns. Although the community that lies on the Mystic River's shores is linked by a single zip code, a centuries-old history, and a 1922 bascule drawbridge that is an engineering wonder, the east bank is actually part of the town of Stonington; the west bank is in Groton.

This technicality matters little to visitors, who flock to Mystic to savor much more than a "slice of heaven" at the restaurant made famous by the 1988 film, *Mystic Pizza*. With its quintet of shipyards on the sheltered Mystic River estuary and small fleet of whalers, Mystic Harbor was a busy port in the mid-1800s. Now, this non-municipality bustles with vacationers. Whether they embark on a day sail, mingle with marine animals and delve into underwater archaeology at Mystic Aquarium & Institute for Exploration, or clamber aboard antique vessels and immerse themselves in the activities of Mystic Seaport's re-created nineteenth-century seafaring village, few leave Mystic without acquiring a deeper appreciation for the sea.

Wooden shipbuilding was a commercial endeavor in Mystic as early as the 1600s, and even though competition, economic depression, and obsolescence

contributed to the industry's post–Civil War decline, the creation in 1929 of the Marine Historical Association, precursor to Mystic Seaport, "put Mystic on the map again as a maritime community," says Bill Peterson, who has overseen the living history museum's extensive collections for more than thirty years. New England's early economy was inextricably linked to maritime pursuits, Mystic Seaport's senior curator stresses. "You can't separate the New England economy and New England's history from its ship-building and shipping roots," he says.

Mystic Seaport strives to tell the story not only of Mystic's heyday, but of the nation's maritime heritage. "We're about America and the sea and all of its facets," says Peterson, who describes the always-expanding collections as "a maritime soup." It's "an academic as well as a popular institution," he says, where the rich repository of logbooks, manuscripts, rare volumes, photographs, paintings, and artifacts attracts scholars from around the world. Casual visitors, meanwhile, are fascinated by National Historic Landmark ships, such as the *Charles W. Morgan*, a whaling vessel that is the "crown jewel" of the collection; exhibits of ship models, figureheads, and scrimshaw; and the Preservation Shipyard, where craftsmen use traditional techniques to restore and build wooden boats, such as the *Amistad* replica launched as an educational vessel in 2000.

"Curators and professors are all typecast as stodgy; museums are all typecast as dusty. Mystic Seaport is anything but," assures Peterson. His star turn wasn't as career-altering as Julia Roberts's waitress role in *Mystic Pizza*. But when Steven Spielberg shot scenes for the 1997 movie *Amistad* on-board the *Morgan*, the curator, who is also a member of the local fire department, was positioned just feet from Morgan Freeman during a sequence where a burning lamp dropped on deck. That, he says, "was really cool."

Weathered lobster buoys dress up a wood-shingled shack at the Noank Village Boatyard, a public marina near the Mystic River's entrance.

Bluff Point State Park

Built with wealth amassed by the tribe since the 1992 debut of its Foxwoods Resort Casino, the Mashantucket Pequot Museum is one of the finest Native American research and education facilities in the nation. When the designers who created the museum's centerpiece—a full-scale re-creation of a sixteenth-century Indian village—needed inspiration for the twenty-two-foot-high, six-hundred-foot-long mural that would encircle the installation, they took a 360-degree camera to a coastal woodland just ten miles away. With its oak-hickory forest, tidal marshes, grass-tufted sand dunes, and curvy sandspit beach, Groton's Bluff Point State Park appears largely as it did four centuries ago, when Connecticut's southeastern shore was the Pequots' domain. Situated on an eight-hundred-acre peninsula jutting into Long Island Sound, this coastal reserve is the largest undeveloped tract on Connecticut's shoreline and a destination for mountain bikers, hikers, birdwatchers, paddlers, and sunbathers seeking seclusion.

The Right Place for a Fourth-Generation Shipwright

"MY GRANDFATHER told me: Never go to work in the shipyard and never be a ship caulker—that's the man who makes the ship watertight. He figured it was hard work; he wanted something better for his grandson," says Howard Davis. His great-grandfather had been a caulker; his other grandfather a sailmaker. But even at seventeen, when he met the "wonderful woman" who's been his wife for fifty-nine years, he had the boat bug.

"I first met her back in 1939," he says. "She came visiting next door to where I was living. I was working on a restoration of a boat that had been damaged in the hurricane. I wasn't too much interested in girls; I was working on a boat."

At eighteen, he took a job building wooden boats at the Noank shipyard. But in September of 1958, with fiberglass boat manufacturing on the rise, there were "no more to build," Davis remembers. "I was suddenly out of a job."

He visited Mystic Seaport's offices. "They weren't hiring." So, on his wife's advice, he decided to try the back door, and when he met the shipyard manager, he received encouraging news: there was enough money in the budget to pay him through the end of the year.

"January of '59 came, and I was happily working," he says. When his boss told him he could stay—and that he'd be getting a raise to two dollars per hour—Davis thought: "I've got it made now."

And stay he did, even when he was asked in 1982 to take on the job of ship caulker. His recaulking work on the *Charles W. Morgan* landed him on the cover of *WoodenBoat* magazine. One day in 1988, he wasn't feeling well at work, so he sat down to light his pipe and relax. In intensive care, they told him he'd had a heart attack. "I didn't feel that bad," he says. Nevertheless, a year later he decided, "It was time to retire from the shipyard and join the education department."

In 2008, at eighty-six, he marks fifty years of Seaport service. "I get paid to stand and talk all day," he says of his current role answering visitors' questions and spinning yarns about the attraction's remarkable vessels. "People who come for two or three hours wind up staying all day," he says, adding, "I hope to stay here as long as I can—as long as I keep my bypasses working."

Davis's grandfather wasn't the only one who counseled him to pursue an alternate profession. "My mother wanted me to be a bookkeeper," he recalls. "I did what I wanted to. I haven't gotten rich, but I've been happy." His home is still in Noank; the sea is his yard. Ask him if wooden boat building is a dying art, and he answers without hesitation: "At the Seaport, it isn't."

The Submarine Capital of the World

The coastal cities of Groton and New London straddle the mouth of the Thames River, a fifteen-mile tidal estuary critical to Connecticut's defenses since colonial days. Fort Griswold on the Groton side and Fort Trumbull on the New London side, now state parks, were established to protect New London Harbor, one of the finest natural ports on Long Island Sound and a retreat for privateers that routinely harassed British ships. This provocation would make the Thames's banks the site of Connecticut's only major Revolutionary War engagement. In 1781, Connecticut native and notorious turncoat Benedict

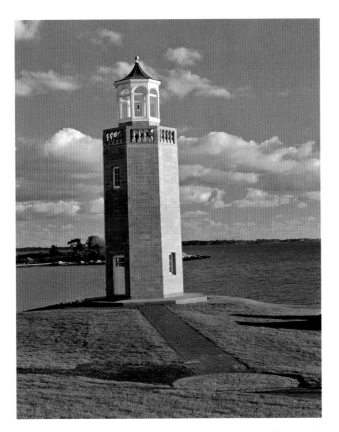

The Avery Point Lighthouse in Groton was deactivated in 1967 after just twenty-three years of service. It remained dark for thirty-nine years until the Avery Point Lighthouse Society and the University of Connecticut, which has a campus at Avery Point, teamed to raise half a million dollars to restore and relight the deteriorating beacon.

manufacturing subs, and the U.S. Navy was buying. The naval base in Groton, established on state-donated land in 1872, became the nation's first submarine base.

At the U.S. Navy Submarine Force Museum, open free to the public on the grounds of the base, visitors learn about the evolution of these fascinating craft. They can also board the USS *Nautilus*, the world's first nuclear-powered submarine, for a self-guided tour. Built by Electric Boat in 1954, the *Nautilus* was the first submarine to journey twenty thousand leagues under the sea. Electric Boat continues to supply the Navy with world-class subs, although the General Dynamics subsidiary no longer turns out a submarine every two weeks, as it did during World War II. A memorial on Bridge Street in Groton remembers fifty-two submarines and their crews that never returned from that conflict and remain "on eternal patrol."

Arnold led the British in a devastating raid. The Battle of Groton Heights left eighty-eight dead at Fort Griswold and New London in flames.

New London rebounded to become a vital nineteenth-century whaling port, third only to New Bedford and Nantucket. In 1932, the west bank of the Thames became home to the United States Coast Guard Academy. By then, however, the river's status as a military-industrial corridor was already secured. Connecticut inventor David Bushnell devised the first submarine in 1775, and although his one-man *Turtle* was largely unsuccessful in its covert Revolutionary War operations, others would continue his quest for a manned submersible capable of military maneuvers. By the advent of World War I, Groton-based Electric Boat Corporation was

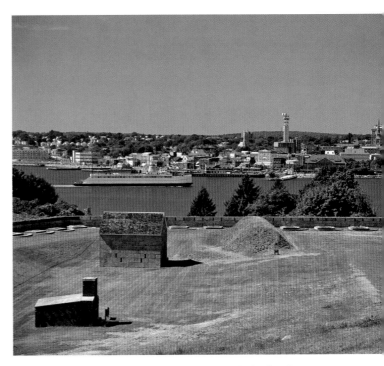

The water battery at Fort Griswold, which overlooks the Thames River and the city of New London, was rebuilt several times during the bastion's long history. Although the fort was in use through World War II, the Battle of Groton Heights—one of the ten bloodiest engagements of the American Revolution—was its most defining moment.

The shoreline city of New Haven has been home to Yale University since 1716. The historic campus is an overlooked tourist attraction, home to fine museums of art and natural history; Yale Rep, a professional theater that has incubated Broadway plays; and the elite Yale School of Music, which presents nearly three hundred public concerts annually, most of them free.

Old Saybrook: Where the River Meets the Sound

New England's longest river, the Connecticut, flows 407 miles from its origins in northernmost New Hampshire to its ultimate outlet: Long Island Sound. Although it was Dutchman Adriaen Block who first explored this vital inland waterway in 1614, it was the English who secured the first permanent settlement at the river's mouth in 1635. Situated at this coastal crossroad, Old Saybrook flourished as a commercial center. In 1701, America's third-oldest institution for higher education was established here; the Collegiate School relocated to New Haven in 1716 and was renamed for benefactor Elihu Yale in 1718.

Connecticut's oldest shoreline town claims more than one hundred homes of historic significance. Old Saybrook's Main Street could serve as an architectural classroom: building styles evident include Colonial, Georgian, Federal, Greek Revival, Stick Style, Gothic Revival; there's even an octagonal Sears and Roebuck kit house from the late nineteenth century. While most remain private residences, the 1767 General William Hart House is home to the Old Saybrook Historical Society and open seasonally for tours, and the Deacon Timothy Pratt House, built circa 1746, welcomes overnight guests.

Stage and screen legend Katharine Hepburn, who died at her seaside Old Saybrook cottage in 2003 at the age of ninety-six, once remarked: "If you survive long enough, you're revered—rather like an old building." Fittingly, Main Street's gem is destined to be the Katharine Hepburn Cultural Arts Center & Theatre. A multi-million-dollar refurbishment will transform a 1911 building, originally a theater and for a spell the town hall, into this performance venue with exhibits highlighting the career of the four-time Academy award winner.

Although Hepburn was known to shop at Main Street establishments, her family estate, nestled within the exclusive borough of Fenwick, afforded cherished privacy. Fenwick homeowners enjoy some of Old Saybrook's best views, especially of the inner and outer lighthouses that mark the entrance to the Connecticut River, but the scenes visible from Saybrook Point—accessible to all—are also exceptional. Visitors can walk through history at Fort Saybrook Monument Park, site of Connecticut's first military fortification; admire the yachts moored at the beautifully maintained marina; dine at waterside restaurants; or birdwatch from the mile-long causeway over South Cove. And for anyone whose miniature golf game isn't up to par, the distractingly lovely backdrop of the waterfront course at Saybrook Point Park provides a convenient excuse.

Connecticut's Sandbox

When traffic along I-95 stalls for miles on sweltry summer weekends, it's a sure bet the warm, white sands and softly undulating surf at Connecticut's largest beach are many drivers' destination. Hammonasset Beach State Park at exit 62 attracts more than one million visitors each year; the 919-

Farming the Sea

THE EASTERN OYSTER, named Connecticut's state shellfish in 1989, was so abundant in coastal bays and river estuaries that it was a staple food for native peoples and early colonists. From the mid- to late nineteenth century, millions of mollusks were plucked from Connecticut's coastal waters as improvements in cultivation allowed the commercial oyster industry to thrive in places like New Haven and Norwalk. But as water quality in Long Island Sound deteriorated in the twentieth century, few oystering operations survived.

Federal regulations introduced in the 1970s have mitigated water pollution, and although a modern revival in oyster farming suffered a hiccup in 1997, when two parasitic diseases decimated the population, "the good news is, after that outbreak, we found pockets that had survived," says David Carey, director of Connecticut's Bureau of Aquaculture. By breeding these disease-resistant strains at the state oyster hatchery in Noank, a new generation of seed oysters was produced, and a decade after the decline, harvests are improving exponentially, supporting more than forty commercial shellfishing outfits, ranging from large companies to family-owned premium producers.

Connecticut oysters have always been prized, and this new crop of hearty, fast-growing bivalves is every bit as delectable. Like wine, an oyster's taste reflects its cultivation location, and Carey says the deep, cold, nutrient-rich waters of Long Island Sound—part saltwater, part fresh—yield "a nice, firm oyster with a long shelf life" and "unique flavor." Locally harvested specimens show up on menus all along the shore, but Carey laments that some travel miles—to Boston and New York wholesalers—before making their way to Connecticut tables. As interest in the eat-local movement accelerates, his bureau hopes to promote in-state shellfish consumption; oysters are even popping up at farmers' markets in coastal towns.

Challenges remain. The health of the Sound and its shellfish must be monitored continually; some areas remain too polluted to sustain a safe harvest. Deep-water cultivation is expensive, creating an entry barrier for entrepreneurs. Acres of underwater shell beds—the hard surface larvae prefer to set upon—are buried in silt, and funding for reclamation of these growing grounds is difficult to obtain.

That's a shame because although oysters may not be cute and cuddly as marine creatures go, they're awfully admirable. As these filter feeders make a comeback, they also give back by improving their environment. "A mature oyster will pump anywhere from fifty to one hundred gallons of water a day; they pull a lot of nutrients out of the water," Carey says. "They can definitely make a positive contribution" to the quality of water in the Sound.

acre seashore's two-mile beach can seem crowded with colorfully festive umbrellas and towels, but there's always a vacant patch of sand waiting to be claimed. The littlest beachgoers sculpt sandcastles while older siblings bob on the Sound's buoyant waters. Couples stroll the boardwalk hand-in-hand past cushiony dunes blooming with purple beach roses. And after hours of seaside play—punctuated, perhaps, by a hike or bike ride along the park's trails, a picnic under a tree canopy, or a visit to the Meigs Point Nature Center's touch tank and other exhibits—overtired tots wail the dismay internalized by older ocean lovers when a day at the beach has come to a close.

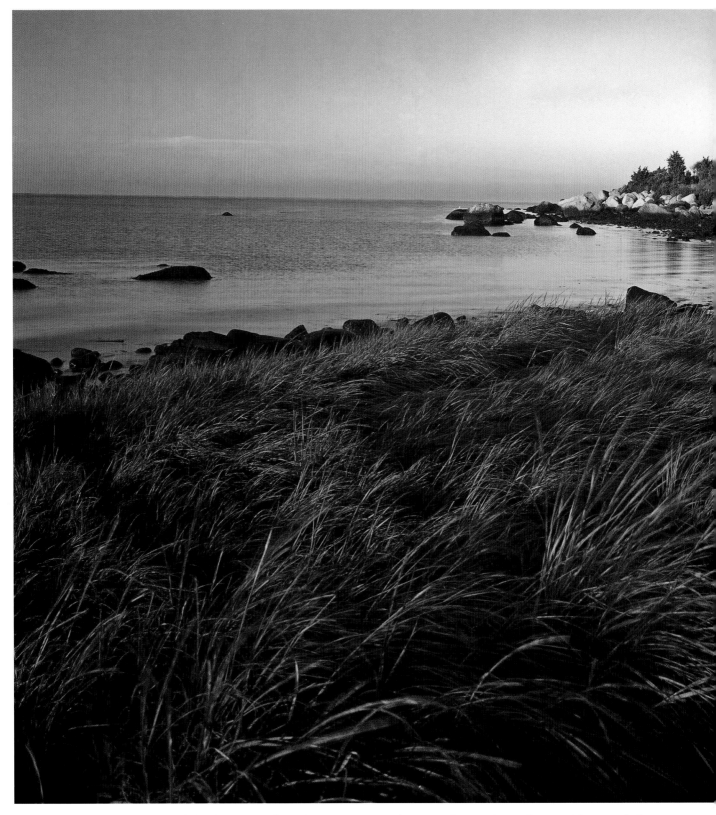

The family-friendly, three-mile sandy beach is just one facet of Hammonasset Beach State Park in Madison. There are 460 acres of salt marsh within the park's boundaries. These tidal wetlands provide essential habitat for plants, fish, birds, and animals, including several species that are regionally or even globally rare or important.

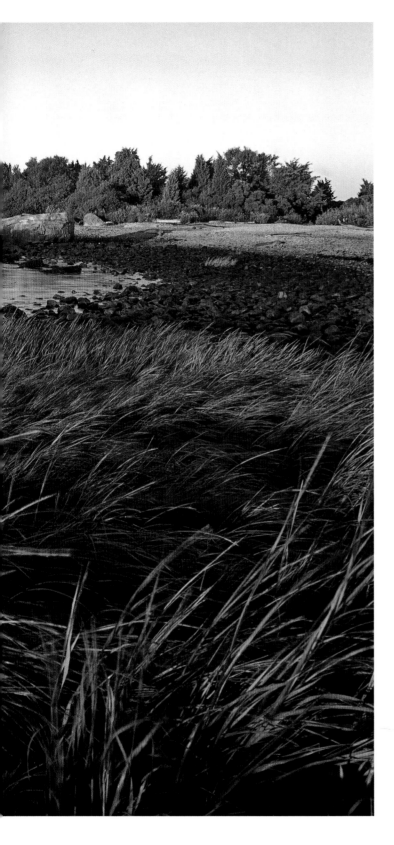

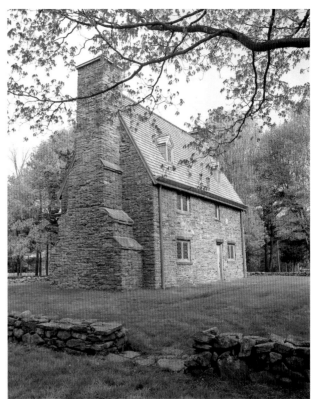

Guilford claims dozens of pre–Revolutionary War homes including the Henry Whitfield House, the oldest stone home in New England.

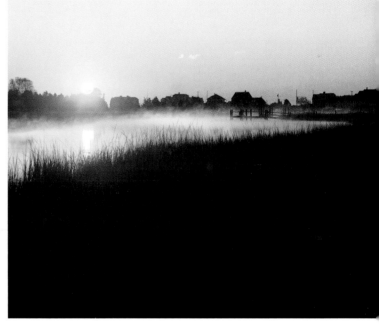

The sun makes its daily debut over the narrow Neck River, which gently winds its way through salt marshes before spilling into Guilford Harbor. Upriver in Madison, an oyster restoration project is being undertaken along the tidal river bottom.

The Thimble Islands

AT LOW TIDE, more than one hundred islands can be counted off the coast of the sleepy, Sound-side village of Stony Creek. These tiny, pink-granite isles, known as Kuttomquosh or "beautiful sea rocks" to the Mattabesec Indians, are collectively called the Thimble Islands for the wild thimbleberries that once sprouted on their shores. Most are mere boulders, Ice Age remnants protruding from the sea, but the twenty-three habitable islands have names of their own—sometimes two or three—and enough stories to enthrall passengers aboard three seasonally operating tour boats that ply the shallow and treacherous bay, easing passengers close enough to these exclusive hideouts to wave to sunbathers or eavesdrop on the lively but indistinct chatter that accompanies summer fetes.

Legendary pirate Captain Kidd, who found High Island's secret harbor an ideal hiding spot, had much more to fear than ogling eyes. The British Navy finally caught up with the rogue in 1699, after he left the Thimbles for Boston. "He should have stayed here," says Captain Bob Milne, a Stony Creek native with more than two decades of tour-guide experience and a book on the Thimbles to his credit, of Kidd's fatal mistake.

As he expertly maneuvers the *Volsunga IV* around dangerous rocks and submerged reefs, Milne recounts fascinating tales. Kidd's much-sought treasure has never been found. A midget who lived on Cut-in-Two Island found love when Tom Thumb came courting, but the diminutive celebrity left the heartsick Miss Emily for another little woman at P. T. Barnum's urging. William Howard Taft used a mansion on Davis Island as his summer White House. Mother-in-Law Island is named for the woman who dared to check up on her honeymooning daughter, only to find herself stranded on the island for days when the newlyweds took off with her boat.

Only a handful of the islands have electricity. "Most of the islanders prefer not to have it; they want to enjoy the peaceful way of life," Milne explains. One holds only a gazebo; its owner lives aboard a houseboat. The largest, seventeen-acre Horse Island, is an undeveloped Yale University research facility where one hundred species of

For those who have reserved one of Hammonasset's 558 campsites, a day at the beach doesn't have to end at dusk. In Connecticut, where sleeping beside the sea is almost exclusively the province of millionaires, it's quite a bargain for families to pay less than twenty-five dollars per night to drift off to the Sound's soothing lullaby. Many cut vacation costs further by cooking out, but it's tough to resist the twin temptations of fried whole bellies and free WiFi at the Clam Castle, just outside the park on Route 1 in Madison.

After Labor Day, the beach quiets, but the number of overnight guests actually increases as migrating birds find Hammonasset's marshes and meadows, grass-fringed dunes, and coastal forests a hospitable stopover. The Meigs Point Butterfly Garden also attracts winged travelers; hundreds of monarchs rest and nectar-up as they pass through each September on their long-haul flight to Mexico.

Ninety Miles Off Broadway

With its colonial-era houses, jagged stone walls that once outlined farmlands and orchards, and a sprawling, centuries-old town green that remains a cherished community hub, Guilford has more rural New England character than you'd expect to find on the Connecticut coastline a mere ninety miles from midtown Manhattan. Settled in 1639 by Reverend Henry Whitfield and his Puritan followers on land purchased from the native Menuncatucks, Connecticut's seventh

birds have been recorded. Money Island, with its thirty cottages, is the most densely populated, and Milne says, "It's always been the center of activity."

By the turn of the twentieth century, Money Island had its own post office, general store, hotel, and bowling alley, and Stony Creek, with its five Victorian hotels and trolley connection to Manhattan, was "a bustling summer resort town nicknamed the Newport of Connecticut," says Milne. But the hurricane of 1938 was devastating to the community; seven islanders died.

"After that big storm, everyone got in their new automobiles and drove up to Cape Cod, where they're all still stuck in traffic," Milne cracks. Now, there is only one way for tourists to set foot on these private islands. "You have to make a friend," Milne says. The best person to know is Christine Svenningsen, widow of party-goods entrepreneur John Svenningsen, who has collected ten of these storied isles, including the crown jewel. Svenningsen paid $23.5 million for Rogers Island and its twenty-seven-room Tudor-style mansion.

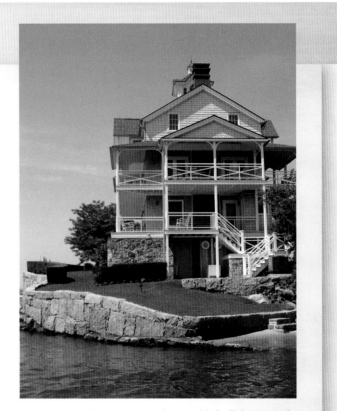

Like many of the miniature isles sprinkled off the coast of Stony Creek, Wheeler's Island, one of ten Thimble Islands owned by Christine Svenningsen, is only large enough to hold a single house. The island's retaining wall is made of locally quarried Stony Creek pink granite. (Photograph by Kim Knox Beckius)

town evolved from an agrarian outpost to a maritime center to a Victorian vacationland; its green morphed from cattle grazing grounds to marketplace to public square to recreational park, always remaining vitally important to the town's activity and identity.

The stone abode Whitfield built upon arrival—Connecticut's oldest surviving dwelling—became the state's first museum in 1900. Recent preservation efforts, such as the creation of the Guilford Town Center Historic District and the restoration of the lighthouse on Faulkner's Island, have helped to guard Guilford's heritage, even as urban escapees have snatched up homes on Sachem's Head, a rocky promontory jutting into the Sound on the south side of town. Named for the gory story of an

Indian conflict that did not end well for one Pequot leader, this headland's gorgeous water views command a ransom.

The Gold Coast

When State Park Commission field secretary Albert Turner walked the coast from New York to Rhode Island in 1914, he deemed a once-agricultural section of Westport one of the most suitable sites for a shoreline park. It would take twenty-three years, however, for the state to wrangle lands from homeowners' hands to create Sherwood Island State Park, a waterside playground open to all in the heart of Connecticut's wealthiest and most densely populated

Although it is flanked by two busy beaches, Connecticut's 9/11 Living Memorial in Sherwood Island State Park is a quiet and reflective place to remember a tragedy that shattered the lives of many Connecticut families.

by salty air lay out their spreads beneath the shady pavilion, away from the covetous eyes of scavenging seagulls. There are some visitors, though, who are drawn to Fairfield County's only state-owned beach for more reflective and reverent reasons.

Between the park's East and West Beaches, a granite memorial faces lower Manhattan. On September 11, 2001, shocked and anxious onlookers watched from this spot as smoke clouds rose from the World Trade Center Twin Towers. Stone tiles flanking the memorial are inscribed with seventy-two names of Connecticut residents who perished that day. Connecticut's 9/11 Living Memorial, an intimate, landscaped space designed to offer solace to terrorist victims' loved ones, is a poignant reminder of how physically and emotionally close southwestern Connecticut is to New York City.

But the "Gold Coast," as Lower Fairfield is nicknamed, can't be completely written off as a metropolitan appendage. Sure—Greenwich, Darien, and Westport are bastions of wealth and influence, where Wall Street's elite and celebrities from the arts and entertainment world escape to palatial and secluded

county. On summer days, carefree children gather seashells; swimmers wade into the Sound's mild surf; sun-seekers glance up as sailboats are puffed about by warm breezes; and picnickers with appetites enlivened

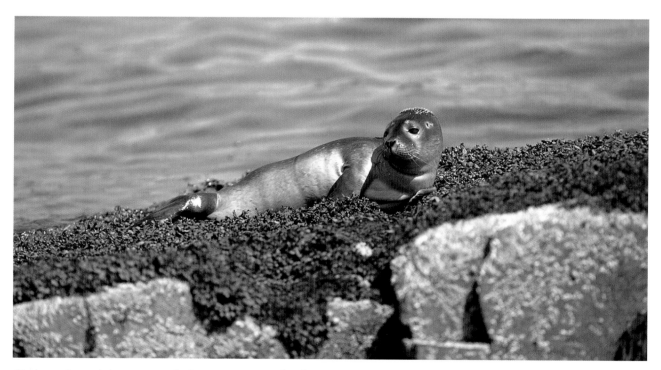

Harbor seals spend their summers basking on sun-warmed rocks in Maine, but come winter, they migrate south to the warmer waters of Long Island Sound.

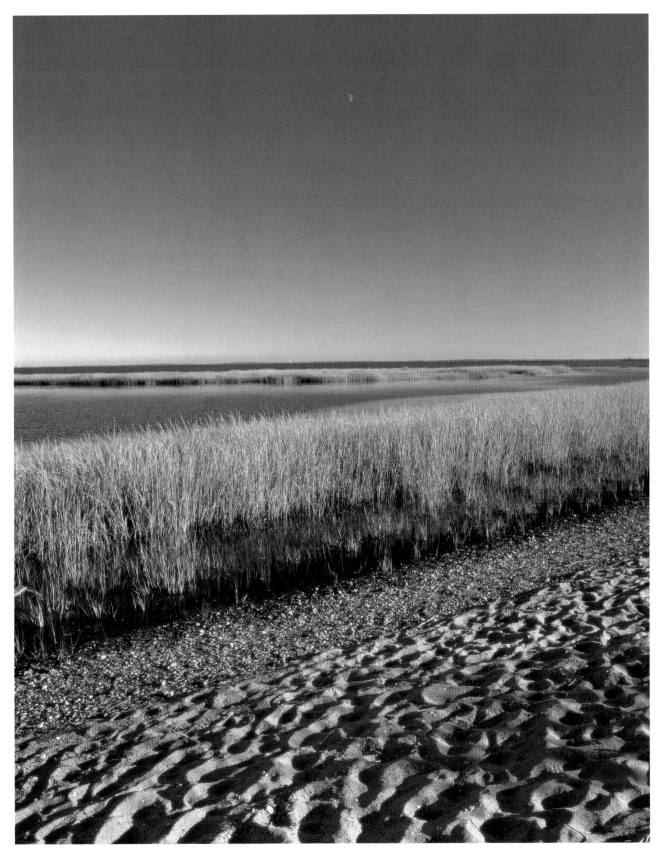

Situated at the mouth of the Housatonic River overlooking an 840-acre salt marsh protected within the Wheeler Wildlife Management Area, the Connecticut Audubon Society Coastal Center at Milford is a birdwatcher's paradise.

A Sound Future

LIKE REALITY TELEVISION contestants, the mated osprey pair that has returned annually since 1997 to the spindly nesting platform within Milford's 840-acre Charles E. Wheeler Salt Marsh seems blissfully immune to the fact that its actions are under continual surveillance. It's not just the binocular-clutching birdwatchers lining the rails of the tiered observation tower at the neighboring Connecticut Audubon Society Coastal Center at Milford Point who have their voyeuristic eyes trained on the raptor couple. A webcam poised over the platform beams "live from the nest" footage to observers around the world, who might spy the female protecting her eggs or a chick embarking on its first solo flight. Osprey were abundant in Connecticut in the 1940s and 1950s, but the population declined precipitously as development and pesticide use surged in the 1960s, landing these fish-eating hawks on the state's Species of Special Concern list from 1989 until 1998. Milford's osprey enjoy the greatest celebrity, but widespread education and platform construction efforts contributed to the return of these sharp-eyed, soaring birds to Connecticut's coastal skies.

A webcam focused on grass growing on Long Island Sound's murky bottom wouldn't command nearly the audience, but photographic mapping of eelgrass beds in 2002 and again in 2006 by the U.S. Fish & Wildlife Service Coastal Program uncovered a similarly optimistic tale of habitat restoration. Submerged eelgrass serves as an incubator and nursery for fish and shellfish, but water quality issues contributed to the plant species' severe decline starting in 1931. The 2006 survey showed a promising 298-acre expansion of eelgrass terrain.

The Sound's turnaround was sparked in the 1970s by federal legislation aimed at combating water pollution, conserving fish stocks, and protecting marine mammals. Kathy Howard, chief instructor at Groton-based Project Oceanology, says the expanding population of harbor seals that winter in Long Island Sound "is evidence that those efforts are having positive impacts." First

homes. Greenwich's posh Greenwich Avenue rivals Rodeo Drive. Burgers at Paul Newman's Dressing Room restaurant in Westport set diners back twenty-five dollars. Even Martha Stewart, who abandoned her Turkey Hill estate for new digs in Bedford, New York, found Westport too snooty and un-neighborly for her tastes.

New England ambiance and community camaraderie are alive and well, however, in more down-to-earth Fairfield County places like the city of Norwalk. "It's only one hour from Grand Central Station, and yet it's a completely different world," says Susan Snider, who traded her corporate job and commute for the role of executive director of the nonprofit Norwalk Seaport Association in 2006. The organization is the driving force behind September's annual Oyster Festival, which attracts upwards of sixty thousand visitors. This food- and entertainment-filled, three-day celebration of Norwalk's enduring oyster industry requires the support of two thousand volunteers, and it's a major fundraiser not only for the Seaport Association, but for dozens of local groups.

The festival is "part of the fabric of the community," Snider says, but its true purpose is to support her organization's education and environmental preservation efforts. On ferry outings to the lighthouse and nature trail on Sheffield Island, travelers learn about the Association's partnership with the U.S. Fish & Wildlife Service to preserve four of the sixteen islands just a mile from Norwalk Harbor.

spotted in the Sound in the late 1980s, these migrants from Maine and southern Canada sought new winter hunting and scavenging territory as their numbers rebounded. Project O offers public Seal Watch Cruises in February and March, and while Howard says most participants are simply "out there to see the cute, fuzzy animals," they're also encouraged to assist scientists with the serious work of collecting census data. By the late 1990s, the seal population had plateaued in southeastern Connecticut. The result: further seal sprawl in the west end of the Sound.

While public awareness of the value of Long Island Sound has been heightened, the coast is far from clear for this shallow basin. "Wherever humans interact with nature, there are going to be impacts," says Howard, who first learned to appreciate Connecticut's coastal waters while vacationing at the shore in Old Lyme with extended family. "Great-Grandma taught me to fish; I got my feet wet early," she recalls. Now, she says, as she gazes out toward Groton Long Point from her Avery

Point office, "It breaks my heart to see every available space get a house." Coastal development, sewage discharge, and temperature fluctuations—which are particularly noticeable in this semi-enclosed body of water—are continuing threats to the Sound's health.

For the young people who set out aboard Project Oceanology's research vessels, the Sound is a place where dry science concepts suddenly become exciting, where the imperiled ocean environment unfolds as a living thing worthy of respect. Established in 1972 by a consortium of school districts, Project O employs trained marine scientists who are also certified teachers to provide students with hands-on learning opportunities. Howard believes these memorable experiences with the marine environment not only sustain kids' interest in science, they foster emotions that may resurface when they're in a voting position. "It's easier to remember being wet and slimy from fish," she says, "than to remember the book you read about it."

Part of the Stuart B. McKinney National Wildlife Refuge, these isles are frequented by migratory shorebirds. Snider supervises volunteer efforts to combat overgrowth and restore fragile habitat.

Norwalk may not have the financial advantages of the towns it's nestled between, but it offers golden opportunities for both recreational and cultural experiences. Snider recalls spending a May morning on Sheffield Island with a friend, painting and fixing windows, "getting all dirty and sweaty," then attending the symphony that evening at Norwalk's acoustically superb Concert Hall. "It was just a magical day," she says. "How lucky we are that we can go out to an island during the day and then come back, get dressed up, and go to a first-class concert and never leave town."

Albert Turner, the state official who spearheaded coastland preservation, wrote that as he ambled Connecticut's shore: "I tried to imagine the changes of the next thirty years, and still future thirties, and very gradually I began to perceive that natural scenic beauty and the unrestricted private ownership of land are things apart, and quite incompatible." His foresight, and the efforts of modern preservationists, ensures the southernmost stretch of New England's shore won't vanish into the vortex of the metropolis. After all, as Turner realized, "So long as man is born with eyes and ears and arms and legs, he will continue to use them in various ways, and it turns out that some of those ways are impossible to him in the city."

Acknowledgments

Kim Knox Beckius

I am so grateful to my father, not only for his thoughtful editing of this manuscript, but for all he has taught me about what matters in life. His unwavering devotion to our family, and especially to my mother during her long battle with cancer, has been inspirational. Dad—I love you.

I am incredibly thankful we were able to fulfill Mom's wish to see the ocean one last time. A special thank you to my brother, Michael, and to Rebekah, Jim, and Brooke Habinowski for sharing that memorable day at Sherwood Island State Park.

My husband, Bruce, and daughter, Lara, are game fish whenever I plan a travel adventure, and they also cope admirably with a sometimes "absentee mommy." I am fortunate to have their love and support for my creative endeavors. I owe my mother-in-law, Barbara Raymond, tremendous gratitude, as well, for feeding and entertaining my family on so many weekends.

Thanks, too, to my daughter's kindergarten teachers: Traci Cavanaugh, Diane Clerkin, and Libby Marek. Your energy, kindness, and loving care allowed me to focus on this project, knowing that Lara was in excellent hands.

My sincere appreciation goes to Voyageur senior editor Josh Leventhal for presenting me with the opportunity to write this book and for his amazing understanding and support during a tumultuous year. Thanks, as well, to Voyageur acquisitions editor Margret Aldrich for her attention to detail and enthusiasm for this project, and to my literary agent, Barb Doyen, who has done so much to propel my writing career.

So many tourism and public relations professionals provided travel assistance and connected me with wonderful coastal people to interview. I am especially grateful to Julie Cook (North of Boston Convention and Visitors Bureau), Bill DeSousa-Mauk (Michael Patrick Destinations & Communications), Jessica Dugan (Block Island Tourism Council), MaryEllen Fitzpatrick (Newport County Convention & Visitors Bureau), Marti Mayne (Maynely Marketing), Michael O'Farrell (Mystic Seaport), Moe Smith (Cape Cod Canal Region Chamber of Commerce), and Carol Thistle (Boston Harbor Island Alliance).

Special thanks to Jay Hyland, president of the Lighthouse Preservation Society, for a lunch I'll never forget and to my wonderful friend, Jessica Mand, for traveling to Nantucket with me and sharing her knowledge of the island.

This book would not have been possible without the generosity of so many people who shared their stories and their passion for New England's coast. Thank you all for allowing me to portray this magnificent region through your observations and experiences.

William H. Johnson

First, I have to thank my folks, for it is partly the way I was raised that gave me my creativity and desire to see what's around the next corner. Next would be my late wife, Marilyn, who had the biggest impact on my life. Without her help and understanding, my photography career would not have been possible.

I'd also like to mention a couple of fellow photographers, Fred Sieb and Bob Raiche, who showed me it was possible to make a living in photography when I was starting out and not sure about taking that leap to switch careers and pursue my passion. Finally, to Ansel Adams, whose work inspired me to get into photography in the first place.

Suggested Readings

Allen, Everett S. *A Wind to Shake the World: The Story of the 1938 Hurricane.* Beverly, MA: Commonwealth Editions, 2006.

Ball, Martha, and Malcolm Greenaway (photographer). *Block Island: Rhode Island's Jewel.* Beverly, MA: Commonwealth Editions, 2007.

Beckius, Kim Knox, and William H. Johnson (photographer). *Backroads of New England: Your Guide to New England's Most Scenic Backroad Adventures.* Stillwater, MN: Voyageur Press, 2004.

Blaney, Daniel E. *Old Orchard Beach (Postcard History Series).* Charleston, SC: Arcadia Publishing, 2007.

Bougerol, Elizabeth. *New England's Favorite Seafood Shacks: Eating Up the Coast from Connecticut to Maine.* Woodstock, VT: The Countryman Press, 2006.

Carson, Rachel. *The Edge of the Sea.* Gloucester, MA: Peter Smith Publisher Inc., 1999.

Corson, Trevor. *The Secret Life of Lobsters: How Fishermen and Scientists Are Unraveling the Mysteries of Our Favorite Crustacean.* New York, NY: HarperCollins Publishers Inc., 2004.

De Wire, Elinor. *The Field Guide to Lighthouses of the New England Coast: 150 Destinations in Maine, Massachusetts, Rhode Island, Connecticut, and New Hampshire.* Minneapolis, MN: Voyageur Press, 2008.

Johnston, James C., Jr. *The Yankee Fleet: Maritime New England in the Age of Sail.* Charleston, SC: The History Press, 2007.

Junger, Sebastian. *The Perfect Storm: A True Story of Men Against the Sea*, reissue edition. New York, NY: Harper Perennial, 2007.

Kaiser, James. *Acadia: The Complete Guide.* Destination Press, 2007.

Laberee, Benjamin W., et al. *America and the Sea: A Maritime History.* Mystic, CT: Mystic Seaport Museum Publications, 1998.

Linder, Chris. *The Photographer's Guide to Cape Cod & the Islands: Where to Find the Perfect Shots and How to Take Them.* Woodstock, VT: The Countryman Press, 2007.

Marcus, Jon, and Susan Cole Kelley (photographer). *Lighthouses of New England.* Stillwater, MN: Voyageur Press, 2001.

Nangle, Hilary. *Moon Handbooks Coastal Maine.* Berkeley, CA: Avalon Travel Publishing, 2008.

Patey, Stan, and Jake McGuire (photographer). *Flying Above the Coast of New England.* Rockport, MA: Twin Lights Publishers, 2007.

Philbrick, Nathaniel. *Mayflower: A Story of Courage, Community, and War.* New York, NY: Penguin Group Inc., 2006.

Pollack, Susan. *Gloucester Fishermen's Wives Cookbook: Stories and Recipes.* Rockport, MA: Twin Lights Publishers, 2005.

Railton, Arthur R. *The History of Martha's Vineyard.* Beverly, MA: Commonwealth Editions, 2006.

Robinson, J. Dennis. *Wentworth-By-The-Sea: The Life and Times of a Grand Hotel.* Portsmouth, NH: Peter E. Randall Publisher, 2004.

Russell, Howard S. *Indian New England Before the Mayflower.* Hanover, NH: University Press of New England, 1980.

Snow, Edward Rowe. *Women of the Sea: Snow Centennial Edition.* Beverly, MA: Commonwealth Editions, 2004.

Szelog, Thomas Mark, and Lee Ann Szelog. *Our Point of View: Fourteen Years at a Maine Lighthouse.* Rockport, ME: Down East Books, 2007.

Venn, Tamsin. *Sea Kayaking along the New England Coast.* Boston, MA: Appalachian Mountain Club Books, 2004.

Index

Abenaki Indians, 45
Acadia National Park, 15, 18–22
"America the Beautiful," 107
Amistad, 141, 143
Aquidneck Island, 124
Aquinnah, 118
Aquinnah Cliffs, 115, 118
Army Corps of Engineers, 48, 90, 132
Arnold, Benedict, 144, 145
Aselton Park, 106
Astor family, 10, 22, 126
Avery Point Lighthouse, 145
Bailey Island, 39
Bald Head Cliff, 46, 48
Bar Harbor (ME), 22, 23
Barnstable (MA), 93, 105
Barque *Eagle,* 140
Bass Harbor, 21
Bates, Katharine Lee, 107
Beavertail Light, 131
Belfast (ME), 24, 27
Belmont, August Jr., 90
Bethel (ME), 37
Blackbeard, 56
Blaney, Dan, 42, 43
Block Island (MA), 109, 110, 119–121, 132
Block Island Conservancy, 110
Block Island Historical Society, 119
Block Island North Light, 120
Blue Hill Peninsula, 23
Bluff Point State Park, 143
Bold Coast, 9, 16, 18
Boothbay (ME), 32, 33
Boothbay Harbor, 33
Boston (MA), 10, 54, 58, 63, 70–87, 90, 92, 93, 112, 125, 132
Boston Harbor, 10, 73, 75–78
Boston Light, 12, 79, 80
Boston & Maine Railroad, 42, 48
Boston Tea Party, 77
Bourne (MA), 86, 91, 94
Bradford, William, 12, 83
Brant Point Light, 112, 113
Breakwater Inn & Spa, 44
Brewster (MA), 93
Buchwald, Art, 113, 115, 118, 119
Bucksport (ME), 24
Bumpkin Island, 80
Bush, President George H. W., 44
Bushnell, David, 145
Buzzards Bay, 84–87, 90, 107
Cadillac Mountain, 21, 22
Calderwood Island, 16
Calendar Islands, 36
Camden (ME), 24, 26, 28, 33
Camden Hills State Park, 24
Cannon Square, 141, 142
Cape Ann, 63–67
Cape Cod, 12, 32, 63, 85, 87–107, 125, 151
 Bay, 93, 94
 Canal, 86, 90, 92
 Highland Light, 100, 101
 Maritime Museum, 90, 104, 106
 National Seashore, 99–103
 School of Art, 96
Cape Elizabeth, 36, 37, 39
Cape Neddick, 49–51
Cape Porpoise, 44
Cape Small, 36
Cape Wind, 119
Captain Fairfield Inn, 43, 44
Carson, Rachel, 31

Casco Bay, 36, 37, 39
Champlain, Samuel de, 21
Charles E. Wheeler Salt Marsh, 154, 155
Charles W. Morgan, 143, 144
Charlestown (RI), 135
Charlestown Navy Yard, 76
Chatham (MA), 91, 98–100, 103, 104
Chilmark, 118
Church, Frederic, 22
Cliff House Resort & Spa, 46, 48
Cliff Walk (ME), 49
Cliff Walk (RI), 126
Coastal Maine Botanical Gardens, 32, 33
Cole, Thomas, 22
Conanicut Island, 131
Connecticut Bureau of Aquaculture, 147
Connecticut River, 146
Connecticut's 9/11 Living Memorial, 152
Convention & Visitors Bureau of Greater Portland, 36, 41
Cook's Lobster House, 39
cummings, e.e., 99
Cutler (ME), 16
Dan'l Webster Inn, 92
Darien, 152
Deer Island, 80
Deer Isle, 23
DeMille, Nelson, 63
Dennis (MA), 91, 102
Derby Square Tours, 68
Dexter Grist Mill, 91
DiMillo's Floating Restaurant, 41
Dock Square, 43
Dorr, George B., 18, 19
Dover (NH), 61
Dressing Room Restaurant, 154
duBois Beach, 142
Duke, Doris, 128, 129
Durham (NH), 59
East Beach, 11, 123
East Boothbay, 33
Eastham (MA), 100
Eastham (ME), 12
Eden (ME), 22
Edgartown (MA), 116, 117
Electric Boat Corporation, 140, 145
Eliot, Charles W., 19
Elizabeth Islands, 86
Essex (MA), 63
Essex River, 64
Essex Shipbuilding Museum, 65
Falmouth (MA), 89, 102, 105–107
Falmouth Historical Society, 106, 107
Fenway Park, 76
Fenwick, 146
Fisherman's Museum, 30
Fishermen's Memorial Statue, 65
Fishers Island Sound, 137
Flo's Famous Steamed Hot Dogs, 49, 51
Forrest Gump, 31
Fort Andrew, 80
Fort Constitution, 57
Fort Dearborn, 59
Fort Griswold, 144, 145
Fort Hill, 101
Fort Phoenix State Reservation, 87
Fort Stark, 57
Fort Trumbull, 144
Fort Warren, 80
Fort William & Mary, 57
Fowler, William M., 74–77
Foxwoods Resort Casino, 143
Freedom Trail, 10, 74
Freeport (ME), 33, 36
Friends of Casco Bay, 37, 39
Galilee (RI), 132, 133

Galilee State Park, 134
Georges Bank, 32, 33
Gloucester (MA), 53, 64
Gold Coast, 9
Googins Island, 36
Grand Victorian, 43
Grape Island, 80
Great Island, 54, 57
Great Marsh Kayak Tours, 93
Green Hill Pond, 133
Greenwich (CT), 152, 154
Groton (CT), 142, 143–145
Guilford (CT), 149–151
Hammonasset Beach, 146, 148
Hampton Beach, 54, 60, 62
Hardy, Commodore Thomas, 141, 142
Harwich (MA), 102
Hawthorne, Charles, 96
Hawthorne, Nathaniel, 67, 68
Haystack Mountain School of Crafts, 23
Henry Whitfield House, 149
Hensche, Henry, 96
Hepburn, Katharine, 146
Hingham (MA), 78
Hodgdon Yachts, 33
Homegrown Herb & Tea, 41
Horseneck Beach State Reservation, 86, 87
Housatonic River, 153
House of Seven Gables, 67
Hoxie House, 91
Hudson River School, 23, 65
Hyannis (MA), 92, 104–107
Island Alliance, 78
Island Heritage Trust, 23
Isles of Shoals, 54–56
Jamestown (RI), 131
Jerusalem (RI), 132
John F. Kennedy Hyannis Museum, 106
John Lane's Ogunquit Playhouse, 49
Kate Gould Park, 103
Katharine Hepburn Cultural Arts Center & Theatre, 146
Kennebunk Beach, 43
Kennebunkport (ME), 35, 43–45
Kennedy
 Edward M., 106
 John F., 106
 Robert F. Jr., 119
Kerouac, Jack, 99
Kidd, Captain, 150
Kittery (ME), 36
L.L. Bean, 36
Lane, Fitz Henry, 65
Laudholm Farm, 44
Lewis R. French, 28
Lighthouse Preservation Society, 61
Little Brewster Island, 79, 80
Little Compton (RI), 124–126
Little Narragansett Bay, 137
Long Island Sound, 9, 139–141, 143, 146, 147, 152–155
Long Sands Beach, 49
Longfellow, Henry Wadsworth, 41
Lovells Island, 80
Lubec, 15, 16
Madison (CT), 147–150
Mailer, Norman, 99
Maine Coast Heritage Trust, 18
Maine College of Art, 41
Maine Island Trail Association, 16
Maine Windjammer Association, 29
Manchester-by-the-Sea (MA), 64
Manissean Indians, 121
Marblehead (MA), 68–70
Marblehead Light, 70

Marginal Way, 49
Marine Historical Association, 143
Maritime & Irish Mossing Museum, 81
Marshall Point Lighthouse, 31
Martha's Vineyard (MA), 9, 105, 107, 110, 113–119
Martha's Vineyard Campmeeting Association, 116, 117
Mashantucket Pequot Museum, 143
Massachusetts Historical Society, 76
Massachusetts Maritime Academy, 90
Massachusetts Water Resource Authority, 78
Massasoit, 84
Mayflower, 9, 93
Mayflower II, 82, 84
McKim, Mead & White, 85, 129
Meara, Anne, 110
Meigs Point Nature Center, 147
Melville, Herman, 74, 86, 87, 112
Menemsha, 118
Menuncatuck Indians, 150
Merrimack River, 63
Milford (CT), 153
Millay, Edna St. Vincent, 26, 28
Minot's Ledge Light, 73, 81
Misquamicut, 135
Moby Dick, 74, 86, 87, 112
Mohegan Indians, 121, 140
Mohegan Bluffs, 121
Money Island, 151
Monhegan Island, 33
Mount Desert Island, 19–24
Muscongus Bay, 29–31
Mystic (CT), 139, 141–143
Mystic Pizza, 142, 143
Mystic River, 142, 143
Mystic Seaport, 140, 142–144
Nantucket (MA), 10, 45, 105, 107, 109–114, 145
 Lightship Basket, 114
 Lightship Basket Museum, 114
 Sound, 115, 119
 South Shoal Lightship, 114
 Whaling Museum, 112
Napatree Point, 136
Narragansett (RI), 128–132
 Bay, 124, 127–132
 Indians, 84
 Town Beach, 129
National Estuarine Research Reserve, 44
Nauset Light, 12
Nauset Marsh, 99
New Bedford (MA), 86, 87, 145
New Bedford Whaling Museum, 87
New Bedford Whaling National Historical Park, 87
New Castle (NH), 54, 56–58
New England Soup Factory, 81
New Harbor (ME), 31
New Haven (CT), 140, 146
New London (CT), 140, 144, 145
New Shoreham (MA), 120
Newburyport (MA), 61
 Art Association, 61
 Harbor Light, 63
 Rear Range Light, 61
Newman, Paul, 154
Newport (RI), 9, 124–128
 Bridge, 127
 County Convention and Visitors Bureau, 124, 128
 Restoration Foundation (NRF), 126, 129
Nickerson's Fish Market, 103
Ninigret National Wildlife Refuge, 135
Ninigret Pond, 133
Nobska Light, 107
Norwalk, 154
Nubble Light, 50, 51
O'Neill, Eugene, 99
Oak Bluffs, 9, 115–117

Ocean House, 135
Ocean Park (ME), 42
Ocean Science Exhibit Center, 105
Oceanic House, 54
Odiorne Point, 59
Ogunquit (ME), 45–49
 House, 45
 River, 45, 48
 Summer School of Drawing and Painting, 45
Old Harbor Life-Saving Station, 98, 101
Old Orchard Beach (ME), 41–43
Old Port, 41
Old Saybrook (CT), 146
Old York Historical Society, 49
Orleans (MA), 100
Palace Playland, 42
Parker River National Wildlife Refuge, 62, 63
Parsons, William Barclay, 90
Passamaquoddy Bay, 16
Passamaquoddy Indians, 16
Pawtucket Indians, 63
Peddocks Island, 80
Pemaquid Point Lighthouse, 30, 31
Penobscot
 Bay, 24, 27–29
 Marine Museum, 24, 27
 Narrows Bridge, 24
Perfect Storm, The, 65
Perkins Cove, 45, 49
Perry (ME), 16
Pier Casino Ballroom, 43
Pilgrim Memorial State Park, 85
Piscataqua River, 54, 57, 58
Plimoth Plantation, 83, 84
Plum Island, 62, 63
Plymouth (MA), 65, 79, 80, 82–84, 90, 92
Plymouth Rock, 83, 85
Point Judith, 132–134
Point Judith Lighthouse, 132, 134
Port Clyde, 29
Porteous, 41
Portland (ME), 36, 37, 39–41, 43
Portland Head Light, 35
Portsmouth (NH), 53, 55, 56, 58
Portuguese Princess Excursions, 95
Prescott Park, 53, 59
Provincetown (MA), 94–100
Quincy (MA), 78
Quoddy Head (ME), 16
Quoddy Head State Park, 9
Quonochontaug Pond, 133
Rachel Carson Salt Pond Preserve, 31
Revere, Paul, 58, 74
Reyes, Jose, 114
Roberts, Julia, 143
Rockefeller, John D., 19, 20
Rockland (ME), 24, 28
Rockport (MA), 64
Rocky Neck Art Colony, 65
Rocky Neck State Park, 140
Roosevelt, Theodore, 57
Rose Island Lighthouse, 127
Rough Point, 126, 128, 129
Sachem's Head, 151
Saco Bay, 41
Sakonnet, 124, 125
Salem (MA), 9, 67–69, 112
 Maritime National Historic Site, 68
 Willows, 67
 Witch Museum, 68, 69
Salt Pond Visitor Center, 99
Salt Ponds Coalition, 133
Sandwich (MA), 91–93
Sandwich Glass Museum, 91
Sandy Neck Barrier Beach, 93

Scituate (MA), 80, 81, 83
Scituate Light, 73, 80, 81
Seacoast Science Center, 59
Searsport (ME), 24
Sherwood Island State Park, 152
Short Sands Beach, 49
Siasconset, 111
Simon, Carly, 118, 119
Singing Beach, 64, 65
Smith, Captain John, 9, 54
Snowman, Dr. Sally, 12, 79
Sohier Park, 50, 51
Southeast Light, 121
Southport Island, 31
Spectacle Island, 80
Stage Harbor Light, 103
Standish, Myles, 90
Star Island, 54, 56
Steamship Authority, 107
Stellwagen Bank, 95
Stephen Taber, 28, 29
Stiller, Jerry, 110
Stonington (CT), 141, 142
Stonington (ME), 23
Stonington Harbor Light, 141, 142
Strawbery Banke, 10, 56, 58, 59
Taylor, Sally, 119
Thames River, 144
Thimble Islands, 150, 151
Thomaston (ME), 29
Tocqueville, Alexis de, 85
Touro Synagogue, 127
Treaty Rock Farm, 125
Truro (MA), 100, 102
Trustom Pond, 133
Turner, Albert, 155
Turtle, 145
Two Lights State Park, 37, 39
USS *Constitution,* 76
USS *Nautilus,* 145
Vanderbilt family, 22, 126, 128
Veranda House, 45
Vinalhaven, 24
Vineyard Sound, 107, 115
Wampanoag Indians, 83
Washington, George, 69, 90
Watch Hill (RI), 11, 123, 133, 135, 136
Watch Hill Beach, 137
Waterford (CT), 139
Wellfleet (MA), 100
Wells (ME), 44, 45
West Tisbury (MA), 118
Westerly (RI), 123
Westport (CT), 151
Welch, Jack, 67
Wentworth by the Sea, 56, 57
West Quoddy Head Light, 16
Wheeler Wildlife Management Area, 153
White Barn Inn, 44
Whitfield, Reverend Henry, 150
Wickford (RI), 135
Winthrop, John, 74
Witch Dungeon Museum, 68
Wolfe's Neck Woods State Park, 36
Woodbury, Charles H., 45
WoodenBoat magazine, 144
Woods Hole (MA), 105, 107
World's End, 78, 80
Wyeth, N. C., and Andrew, 29
Yale University, 146, 150
Yale, Elihu, 145
Yarmouth (MA), 102
York (ME), 48–51
York Harbor (ME), 49

About the Author & Photographer

Kim Knox Beckius

Kim Knox Beckius grew up in New York's Hudson Valley, and her earliest impressions of New England were formed during family trips to the Connecticut shore and Cape Cod. She relocated to Connecticut in 1996 and soon began sharing the wonders of her new home with a global audience via the New England Travel website she produces for About.com, a *New York Times* Company. At http://gonewengland.about.com, she takes Internet users on virtual tours, offers candid reviews, and provides lively weekly commentary on travel and events in the region.

She is the author of Voyageur Press's *Backroads of New England* and *Backroads of New York*, as well as *The Everything Outdoor Wedding Book* and *The Everything Family Guide to New England*. Her writing and photography have also been featured on several other websites and blogs, as well as in magazines. She is frequently called on by television, radio, and print media outlets to discuss travel and events in New England.

Beckius lives in Avon, Connecticut, with her husband and six-year-old daughter, who don't mind being dragged along to beaches, lighthouses, and lobster shacks at all.

William H. Johnson

William H. Johnson is a native New Englander who lives in the Lakes Region of New Hampshire in an old restored farmhouse with his cat, Mittens. For over thirty years, his artistic landscapes have captured the spectacular New England countryside in all seasons. His work has been published in magazines, books, calendars, cards, puzzles, and advertising.

He studied photography at the Layton School of Art and Design in Milwaukee, Wisconsin, and the Doscher Country School of Photography in South Woodstock, Vermont. He was named Photographer of the Year by the New Hampshire Professional Photographer's Association and has earned several Court of Honor awards.

Johnson's camera equipment includes a medium-format Mamiya RZ 67, a large-format Arca Swiss 4x5 field-view camera, and a Fuji 617 for panoramas. His film of choice is Fuji Velvia 50. Johnson spends countless hours seeking his images, always looking for that perfect composition and magic light.

© Kristin Hand